CHRISTO

Marina Vaizey

CHRISTO

Ediciones Polígrafa, S. A.

Reproduction rights: Christo
Design Coordinator: Susan M. Astwood

I.S.B.N.: 84-343-0606-9
Dep. Legal: B. 13.785 - 1990 (Printed in Spain)

Color separation by Reprocolor Llovet, S. A., Barcelona
Printed and bound by La Polígrafa, S. A.
Parets del Vallès (Barcelona)

CONTENTS

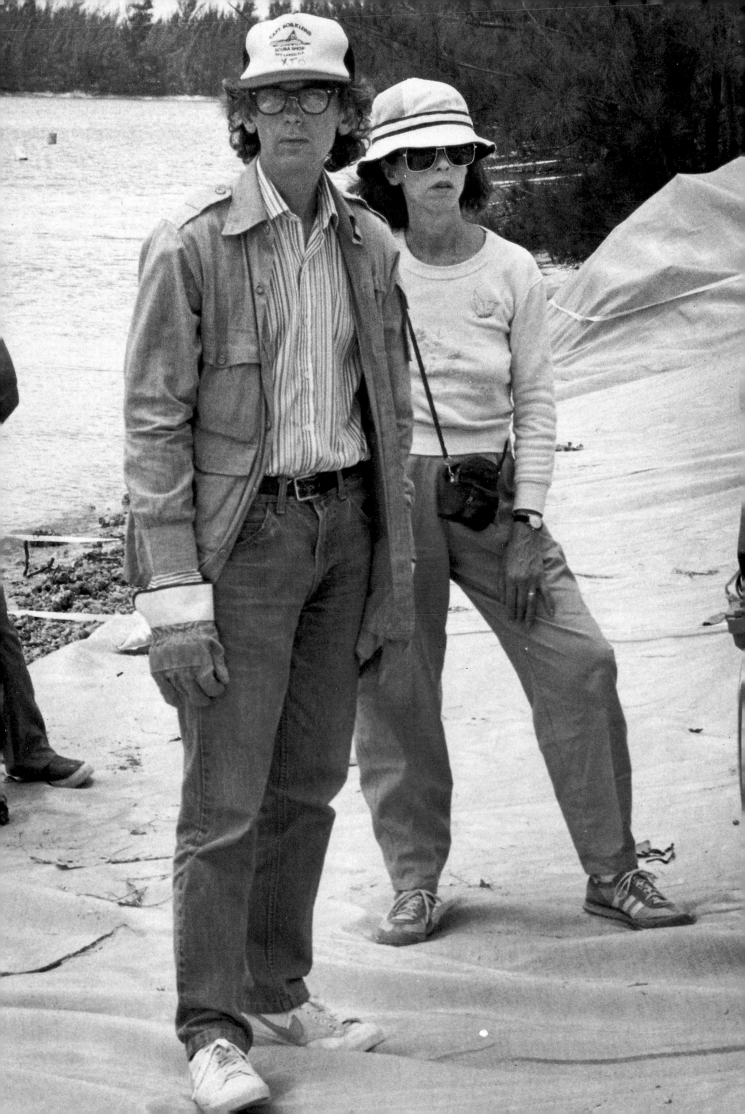

I

Running Fence, Surrounded Islands, Ocean Front, Wrapped Walk Ways, Valley Curtain, The Umbrellas, Le Pont Neuf Wrapped, Wrapped Coast, are but some of the massive, delicate, beautiful and vast pieces of art — for which there is as yet no adequate verbal description — created by Christo from 1958 to the present.

They are huge pieces which paradoxically appear delicate, evanescent, and even though made of the materials of the technological age — plastics and metals — with an enormous input of creative and intuitive engineering on the part of the artist and the professionals who work with him, are exquisite, apparently inevitable interventions in the "real" world.

That world includes cities from Chicago to Milan and Paris, countryside and communities from California to New England, Florida to Japan.

Christo is, among other attributes, courageous and fearless. He is genuinely courageous, because he above all others — as the most experienced in the making of Christos — knows the risks, effort and difficulty of his projects. He knows that he has to deal on many fronts at one and the same time.

The major Christo projects involve years of negotiations for permissions and rights to make enormous temporary structures and wrappings. Christo has to convince an audience before he can make the work of art, Christo is both architect and client in one, his is the brief. It is as though both architect and client had to convince all sectors of the public, not just the professional planners and authorities, of the aesthetic worth and interest of the project before beginning to realise the work off the drawing board and into three-dimensional actuality. Christo also has to convince on two other fronts, never tackled by artists. Christo, unlike other artists who work in the environment, does not work exclusively in the wilderness, wasteland, desert or forest. Most of his huge sculptures are created in the built environment, or in inhabited, used places. Thus, for example, *Valley Curtain at Grand Hogback, Rifle, Colorado* (1972) was an almost unimaginably huge translucent orange curtain. Its greatest width was 1368 feet, its greatest height 365 feet. As its location suggests, *Valley Curtain* was briefly suspended between two slopes in the Rocky Mountains, across a highway which had to remain open for traffic.

Four years later in 1976, *Running Fence*, in Sonoma and Marin Counties, California, made of the most beautiful, translucent mother of pearl woven nylon fabric which responded to the changing light of day and night, was a mere 18 feet high — but 24½ miles long. For the two week duration of its existence, *Running Fence* crossed open countryside, farms, villages, small towns, highways, and had to do all this without causing any environmental damage or interfering in any way with the daily practicalities of ordinary life in the locality.

In 1983, *Surrounded Islands* involved uninhabited islands of various sizes encircled with amazingly radiant pink petals floating over the waters of Biscayne Bay, Miami, Florida. Neither marine nor island life could be interfered with, or adversely affected during this mammoth project.

Christo and Jeanne-Claude at the site of **Surrounded Islands**. Miami, May 1983. Photo: Wolfgang Volz.

In 1985 the oldest bridge in Paris, the Pont-Neuf, was entirely wrapped in golden fabric, glistening like a baroque fantasy, euphoric, exuberant, magnificent. And its wrapping could not interfere in any way with the normally heavy amount of traffic on the bridge from both vehicles and pedestrians, or with the Seine flowing below. The dictionary definitions of genius meld ideas of originality, imagination, energy, enthusiasm and productivity. All of these qualities the artist Christo has in abundance. Moreover, in the course of five decades of unremitting activity, his work in several continents has substantially altered the relationship of art and technology, art in the environment, and the notion of what constitutes art. Christo has evolved a body of work which partakes of the innovations of twentieth century art — and technology — with high originality.

Christo has worked all over the world, often in the collaborative projects of which he is the first among equals, the architect, originator, "onlie begetter." His originality is diverse, his productivity prodigious. His art is simultaneously intensely sophisticated and complicated, strikingly simple, readily accessible and public.

His originality consists of combining the technical advances of the 20th century, and the industrial age, with the post industrial age, and the hunger for beauty and for nature.

Christos enhance the real world, and exist as art in themselves. They point out the varied, amazing, subtle and dramatic beauties of city and country, wilderness and cultivated farm and park, sea and coast, and they are beautiful in themselves. A Christo is both a part of the world, and apart from it.

His art as project uses advanced technology, and in the jargon of our time is user-friendly. In fact, the huge sculptures leave both literally and metaphorically plenty of room for the spectator. Extending through space and time, we can choose how to view, quite unlike visits to art galleries and museums. There is no curatorial story board, no correct sequence, no laid out art history, no labels, identifications, attributions. We can improvise our visit. This writer, for instance, has seen major Christos in several continents at all hours of the day and night, observed others observing, witnessed Christos on foot and by various modes of transport. When a Christo project is taking place for its brief period, there are no opening hours: sunset and sunrise are as acceptable as noon. There are often some of the conventions of galleries and museums, but amplified. Readily identified helpers are there with information, eager committed multi lingual students delighted to talk — if you want. The Christo identification T-shirts and badges may become collectors' items in their own right.

Christo has in fact invented not only a new art form, for which there is as yet no adequate vocabulary, but new ways of making art. His ways of working make him the most accessible of artists, yet his inspiration remains mysterious.

The process and progress of each individual project is an integral part of the final sculpture. The final work questions the whole notion of permanence in art, for Christo's vast environmental sculptures which take place in the real world have a deliberately limited life, for a few days, at the most two weeks. There will have been years of preparation: the search for the correct materials, fabrics, metals, the finding of factories and producers to make the elements of the work to the artist's specification. There will have been years of getting relevant permissions from public authorities and private owners, of crossing legal hurdles, to do, for example, with public safety and environmental health, and years of private and public discussions.

There will be the international work force: manufacturers, engineers, lawyers; there will be the scores of people, hundreds of people, helping to set up, to maintain, and to take down. And there will be the enormous public, those who come especially

to see Christos wherever they might be, and those who come upon a Christo as part of their daily life. For there have been Christos crossing public roads and highways, Christos covering bridges and public paths, Christos hugging the coastline, surrounding islands, wrapping columns of air, wrapping buildings. After the work has been prepared, and after the work has been put up and then taken down, it remains. It remains in the memory of the thousands who will have experienced it first hand; it remains in the memory of those who will have seen the work on film, on television, in the newspapers. And an integral part is Christo's own portable art, the magnificent sketches, drawings, collages and prints which are both his working drawings and works of art in their own right.

He has harnessed the methods of democratic capitalism to the making of art. His method is inseparable from his art, and the art is twofold. For the way in which Christo goes about setting up his projects, with methods which have developed over the past two decades, is unique in the history of art, although as is typical of artists throughout the history of art, Christo is to be understood in terms of the traditions of the past.

He and his work are at home in the centre of cities, and in remote countryside. He has made huge projects which have existed for only days or weeks, then to vanish forever, memorialised only by the media, and in the memories of those hundreds of people involved in the process of their making. As much of art this century has creatively occupied a huge area between what we conventionally call abstraction and representation, or figuration, so Christo makes structures which are both abstract but recall functional man-made structures: walls, borders, curtains, towers, paths.

Moreover, in an intensely varied body of work, which all nevertheless bears the hallmark of individual, idiosyncratic, inventive talent, Christo has involved the public in a way no artist has before or since. It is not just that there are scores of films, hundreds of books and catalogues, and thousands of articles about his work, and millions of photographs of his work.

Christo is a remarkable enthusiast, a communicator, who responds brilliantly to that post-war art form, the interview, on television, radio, in newspapers and magazines. The Christo presentation, the Christo interview, is itself a piece of Christo art.

The media exposure means that millions have had an indirect exposure to Christo's environmental sculptures. So through the media, thousands and millions of people have seen his work. His vast environmental projects have been reported as much by the news as the specialist art press.

And in ways which Christo has alone charted through the most technologically advanced period of human history, thousands and millions of people have been part of his work through direct participation and observation.

For Christo has evolved ways of involving society in the making of his art.

We are used to the notion of collaborative projects in art and technology in two different ways. In both art and design there is the notion of the studio, of apprentices, students, assistants, and specialists working under artistic direction. This is a practice well established in the early Renaissance, and which evolved from the ways in which craftsmen and artists were once indistinguishable philosophically, although each individual might have a speciality. For example, in northern Italy in the 14th century, the creation of devotional works of art required several skills, not necessarily all practised by the same person. Some prepared the panels, some were specialist gilders, some painters, and the person to whom the panel was ascribed was in charge of the overall design and composition, although he would not have made it entirely on his own.

Then in art we move to the idea of the individual, the single creator. Yet the idea of the studio persists, of others helping the artist in his preparations; and specialist equipment might be made by others. Nowadays painters, for example, buy ready-prepared paints. The technology of oil painting is well explored in studies of art, and how, say, the putting of ready-mixed paints into portable metal tubes might have affected the physical practice of art. The romantic idea of the artist working creatively on his own has some truth, but it is not the whole truth. In manufacturing, there have to be scientists, engineers and designers, but there is an enormous process in which hundreds, even thousands of workers are involved. Inspiration may be individual, but the application is often communal.

In so doing, Christo has moved from the traditional and conventional notion of Western art which has developed from the Renaissance, involving the making of portable objects which, discrete and separate, can be bought, sold, displayed domestically or in museums and galleries dedicated to the fine arts, or in the language of those museums and galleries, the material culture. Parallel to this display of art in such frameworks, there is also public art, with its notion of permanence: fresco, mural, public sculpture, memorial.

The assumption behind so-called permanent collections in public and private art galleries and museums, and behind the idea of the public monument, is the idea of permanence, of the survival of the object. With Christo, there is a corpus of work that is bought and sold, collected and kept: the discrete, separate objects which he made early in his career, wrapped boxes and store fronts; and the collages, drawings and prints that are a consistent element in his entire œuvre.

For, in his own words, the finance for all his temporary works of art, the vast projects which take years of time to prepare, but which are in place only for, at the most, three weeks, is raised through the sale of Christo's preparatory drawings, studies, collages, scale models and early works.

Christo's permanent work is both innovative, and firmly traditional in several ways. First of all, as reproductions in this book indicate, he is a superb draughtsman. Moreover, he is both designer and maker. While we have recalled the idea of the Renaissance studio, and contrasted that to the later romantic idea of the individual, it is also from the Renaissance on that we have the idea of the artist as polymath. From Leonardo to Rubens, for example, artists have been architects, designers, worked in a variety of media. The idea of the variety of media has been markedly extended in the 20th century, not only with the idea of collage, but with the ideas of using the real world as art.

Beyond that, in the 20th century, there has been since Marcel Duchamp the idea of the artist designating art. It is not what the artist makes, but what he points out, identifies, labels, categorises, that is art.

If in the 20th century the artist has used found materials, if sculptors have recycled the discarded junk found in city streets, if artists have made collages of newspapers and other ephemera, patchworks of paper scraps, other artists have ventured out into the wilderness and the landscape. Artists such as the British landscape sculptor Richard Long have made an art out of taking long walks, memorialising the experience in diagrams, maps, photographs, captions and poetry. Richard Long has also used natural materials: water, earth, mud, rocks, stones, wood, even pine needles to make in places near and far, within the art gallery and out in the landscape, monuments in natural materials: lines, paths, walks. He has ritualised intervention and manipulation, trusting to time to erode the marks of human effort in natural surroundings.

From the beginning of the century on, wildly arbitrary colour was used to heighten experience, and visual sensation, in, say, the paintings of the fauves, those

brilliant wild beasts of French art. Derain and Matisse, among others, painted hectic city scenes. They and the expressionists underlined the ways in which we find emotional responses in colour.

The cubists fractured single point perspective, attempting to suggest imaginatively how we might see things in the round, simultaneously from many angles, all at once. Russian suprematists and constructivists, echoed half a century later by minimalists and conceptualists, headed for an art of the real, the non-objective, a language of geometry invented by the imagination rather than yoked to observation of the real world. Surrealism evoked the real unrealities of dreams, surrealism's handmaiden, dada, the irrational and absurd. Reality, representation, marched side by side with abstraction, colour clouds, sharply defined, hard edged shapes and forms. Industrial materials were used for sculpture, steel beams echoing the skeleton of the skyscraper. Mondrian's asymmetrical grids were perhaps the most extreme of abstractions, yet the ability of the human mind and eye to freely associate can irresistibly recall maps and diagrams.

In the post-war period, what has become crystal clear during the course of the unprecedented growth of the art world, as museums, galleries, the art market grew and grew, and as there were more scholars, curators, writers, publications, and in fact artists than ever before in human history, is the unavoidable eclecticism, catholicism and pluralism of art. Scholars and dealers have reclaimed even those areas of art jettisoned by the whirl of fashion. Salon art has become intellectually fashionable. That which is not loved and studied for its aesthetic is essential material for its documentary value. What is not admired or accepted for its beauty is at the least quarried for information. Sociology has become an inescapable part of art and its history.

This means that context is as important as content, the frame and framework as essential as that which they contain.

And all this is in the context of the explosion of information, the access to more and more documentation, more and more objects. More people travel more than ever before, through the media they see more. The technology of information, from computers to fax machines, also means a speed of information dispersal hitherto unprecedented.

It is the age of information, and of propaganda, of advertising, packaging, presentation and wrapping.

We are inundated with images as never before.

It is an age of mass production, and of a longing for nature, the natural, the individual, the handmade.

In the late 20th century, people are acutely aware of an astonishing melange of contradictory hopes, dreams and desires, of many realities. And art is not only the physical embodiment of aspirations and faith, the way in which we can explain the world to ourselves, make patterns by which to grasp the unimaginable and incomprehensible, but also a commodity and a currency.

It is the contention of this writer, who has been observing the international activities of the art world during the course of Christo's career, that Christo is the artist who inimitably has come to combine in his art the force of the individual creator with the methods of industrial and post-industrial society: capitalism, democracy, enquiry, experiment, collaboration and co-operation. In the course of so doing, Christo has moved from eastern Europe, from Bulgaria, to a Europe that was temporarily neutral, to Austria, to France and Paris, the traditional capital of the avant-garde, and finally to New York, the post-war art capital, the essential consumerist, capitalist city.

Christo, as the sequence of his projects shows, has worked in a staggering variety of possible environments. He has created art in the centre of cities, in parks, on farms, through the wilderness, by highways, on water, in mountains, at the seaside, over rivers, with buildings and monuments.

He has changed landscapes temporarily, used hundreds of helpers, involved factories and production processes, and financed his projects with millions of dollars raised by his art. His portable objects, drawings and collages have in a sense been the tangible assets, as well as the stocks and shares, by which his visionary projects have been financed and realised.

For Christo, with his wife Jeanne-Claude, the daughter of a general, an administrator and organiser of genius, whose professional skills match the creative energies of the artist, is the CVJ Corporation. Christo has matched the passionate desire typical of the industrial and scientific temper of the times which demands to see how things work, the passion to observe and experiment, to go step by step and to take things apart, with the equally passionate if contradictory desire to see things whole. He has understood the desire to see how things are done, to go behind the scenes, to enter the laboratory. But he has also understood not just that desire to comprehend process and method, but to see something finished, the grand design. In the art of Christo, the plan is visible, and the project is completed. He makes visible the skeleton, the endo-skeleton, the collages, sketches, structure, the flesh — the living art, brought into being by collaborative effort — and the exo-skeleton, the carapace, the pressures of society which affect both the individual and the crowd. He simultaneously enables us to watch the cook in the kitchen, aid the preparations, and dine at the table.

Thus Christo accomplishes three things at once. He makes things of uncanny beauty which exist for a while in the real world. Christos are art: artificial, constructed, man made. Christos enhance the real world, sharpen our vision, make us more aware and observant, and finally, change the way we see things. He is particularly acute about boundaries; about fences, paths, bridges, where in the real world things change, the land becomes coastline and beach, bridges arch over water. And he uses the materials of the contemporary world, the oil-based product of plastics, fabrics of nylon, of woven polypropylene, of concrete, of steel cables and steel poles.

Moreover, Christos exist, if temporarily, in the real world and in real time. They are visible, during their temporary existence, throughout the natural cycle of the day and night, through twenty-four hours, at dawn, mid-morning, noon, afternoon, twilight and night. And the projects come into being after years of enquiries, studies, feasibility studies, plans, and judicial and municipal processes. Full-fledged Christos have to satisfy demands of public access and public safety, fulfil regulations of all kinds, be user-friendly as the real world goes about its business, its daily routine. Christos are backdrops, decor, and centre stage all at the same time, noticeable objects in the landscape and the city and part of the landscape and the city.

Christo is the quintessential artist of his time, and our time.

II

How did it all begin? Christo was born Christo Javacheff in Bulgaria, where he studied for four years at the fine arts academy in Sofia. Bulgaria was occupied by the Nazis, then by the Russians. The ideas of intervening in the landscape, however gently, the idea of packaging, of wrapping, of presenting, may stem, Christo has suggested himself, from an episode in his Bulgarian art-student youth. Students were drafted, perhaps conscripted, to "beautify" the railway embankment which formed the view for visiting Very Important People. It was art, environmental art, made of real materials in the real world.

Christo moved, somehow, west: to Czechoslovakia, to Prague, in 1956; and finally, to "neutral," occupied Austria, to Vienna in 1957, where he studied for a term at the Vienna Fine Arts Academy. And then in 1958, to Paris. He was to marry Jeanne-Claude de Guillebon, very bien élevée bon ton, capable, sensitive, strong, resilient. Christo and Jeanne-Claude are not the kinds of artists whose personal life is part of their art and the way they are presented, or present themselves. There is none of the fevered hecticness of some post-war artistic biographies and autobiographies.

Nevertheless, it is important to emphasise the partnership: Jeanne-Claude is as Christo is in a different way, a brilliant organiser, an administrator. It is surprising that they are not occasionally called on to give courses in the graduate business schools of the world, for between them they have evolved a venture-capital, entrepreneurial way of financing the staggeringly ambitious projects.

And it must be emphasised, too, that the ambition is staggeringly pure. Christo leaves, as we have seen, no permanent public monument. The vast projects are curiously gentle; they are in one sense sculptures, as they have finite form. In another sense they are theatre and performance: in the ways they are planned for, put together, tended during their "life" and taken down, and in the way people interact with the structures, the animate punctuating the inanimate. Moreover, there is something else about Christo's projects that is unique. For the visitor, and the spectator, they are free. There is of course no admission charge; you just have to be there, as millions were, say, in the centre of Paris in 1985, for Le Pont-Neuf, Paris. This had a particularly satisfying symbolism. Le Pont-Neuf is an old bridge, an artist's bridge, a bridge emblematic of Parisian life and culture. Moreover, the wrapping of the Pont-Neuf in its temporary golden cloak did not take a bit of public subsidy. It cost the CVJ Corporation, at a conservative estimate, $4 million.

This was raised as always by the selling of portable work by Christo: his drawings, collages, objects.

It was in Paris, and in Europe, that Christo emerged as a public artist. While he made things, packages, wrapping objects of all kinds, making mock and real store fronts, he also made temporary structures in public.

In 1961 he stacked oil barrels and dockside packages in Cologne Harbour, and created his first project for the packaging of a public building. In 1962 he created

the *Iron Curtain Wall of Oil Barrels*, blocking the Rue Visconti, in Paris, and postdating the Berlin Wall by a year. Christo's wall was, of course, temporary. During this period in Paris there were, of course, many demonstrations; it was the time of the Algerian war and there were also those favorites of the street life of Paris, the political barricades.

In 1964 the Christos moved to New York. Christo is now an American citizen.

The processes of migration, of changing countries and languages, and of changing from an individual artist working in isolation to an artist who works through society and with hundreds of people, financing vast projects which take years to come to fruition and are financed in ways common to big business, have been surprisingly swift. Christo recalls how the notion of working in the real world insinuated itself into his attitudes when he was an art student. It is almost impossible for us to remember now what the 1950s were like in much of Europe. Behind the *Iron Curtain*, there were drastic shortages, injured economies and wounded countries. Consumer goods were in short supply. Television had not taken hold, in either East or West. But in Western Europe, by the swinging sixties, hedonism and hippydom marched hand in hand, in brilliant colour, as did consumerism and flower power.

Revolutions, from 1956 to 1968, in east and west, had expired. But the west, in contrast to the east, was high on advertising, not propaganda. Packaging and presentation was all, Andy Warhol was to become the court artist of "society," and pop art was born. Christo meanwhile soberly and solemnly, wittily and beguilingly, wrapped and packaged. He packaged and wrapped in plastic, fabric and brown paper. He reminded people that packages had contents. He did not bluff. For Documenta, in Kassel, in 1968 in its fourth incarnation still the most important survey of the contemporary avant-garde in the world, he even wrapped the most invisible yet vital substance, air, in an *Air Package 280 feet high*.

Wrapping is an extraordinarily emotive activity. Babies are swaddled, corpses have shrouds. Mummies are wrapped. We are wrapped, in clothing. Bandages wrap. And, really, since Christo, many of us have come to see our cities in different ways, as life imitates art. Cities are constantly being torn down and built up, which means a lot of wrapping. Every time we see a giant building wrapped in plastic, our attention may well have been alerted because of Christo. It may be emptiness that is wrapped, even a vital emptiness suggestive of the universe, as when Christo wraps air. Or it may be something, a book, a box. Wrapping and packaging serves many functions. It may be protective; it may call attention to that which is packaged or wrapped; it may honour and signify status; it may identify or attract; it may disguise.

Christo has also made mastabas, in various countries, of empty oil barrels, themselves a suggestive element of the post-war economic and political situation. Oil signifies the Middle East. Oil is black gold. Oil and its ups and downs signals economic up turn and down turn. Oil is a pollutant. Oil is an organic material. Oil is a scarce resource. Oil is extracted from the ground, transported in pipes overland, in tankers over the sea. Oil barrels as a unit for sculpture, like — say — the bricks of Carl Andre, the stones and wood of Richard Long — is hardly a neutral choice. It is charged with meaning.

At the same time, the idea of a repeatable, mass produced unit is a neatly witty comment avant le lettre on what has come to be called minimal art, the art of the real, a b c art. Christo, as usual, anticipated.

In fact, Christo has three things strikingly in common with Picasso; prodigious energy and productivity; superb draughtsmanship; and an ability to anticipate and encapsulate any art movement going, although in neither case is that the point of their art.

But as Picasso was realist, fauve, cubist, dadaist, surrealist and neo-classical — and part of one of the movements he invented, cubism — so Christo has been conceptual, pop, minimalist, well before time, and has invented an art form that as yet has neither name nor imitator. Christo makes, as we have seen, and has made throughout his career, portable art objects which can be, and are, bought and sold.

There are Christos in over one hundred public galleries and museums throughout the world.

He shows in many galleries. He "belongs" to none, has no contractual arrangement with any commercial gallery, although the Christos obviously have excellent working relationships with several of them in different countries. As of the end of the 1980s, Christo had had 338 one-person shows of his work in public art galleries and commercial galleries.

Over 7 years, the Christos had raised some $18 million to finance the first-ever two country project. Nothing Christo chooses to do is accidental; so too with *The Umbrellas* which departs from previous patterns in several ways.

In the first place, it will occur at the same time in both Japan and California, uniting two vastly different places which have however several things in common. They are after all the opposite sides of the Pacific Rim, where many commentators feel the economic action will be in the 21st century. They are both places of high finance, high prosperity, high passions for gadgetry, and both, and this is not facetious, have large Asian populations. (California must have more oriental people than any other place outside Asia.)

In the second place, for the first time Christo will have objects — in this case the giant Umbrellas — made to his specifications. Hitherto he has had cloth woven to his specifications, and the elements of his sculptures made or ordered. But to design a whole separate discrete object, the umbrella, is a new departure. And of course, once again, the umbrella has both functional overtones and is totally useless. Umbrellas imply protection, and in the context of parasol, flirtation; it is agreeable to think of the same shape as protection against both sun and rain, the light and the wet, and in this instance, somehow as symbols for both east and west, west in the sense of northern industrial nations much rained upon, east in the sense of the parasol, the paper umbrella, so prominent in Hokusai prints.

Morover, the umbrellas process through farmland, through valleys, and by the sides of great motorways. They will be viewed from the automobile, the ubiquitous chariot of both California and Japan, and on foot.

Christo has been working since 1972 on a project for Berlin to wrap the former Parliament of Germany, the Reichstag, a building much destroyed, much rebuilt, and standing partially in limbo in that empty wasteland border between east and west. Berlin is the city whose wall for more than a quarter of a century symbolised metaphorically and was, literally, a terror-filled boundary between east and west. Now the Berlin Wall has gone; the Reichstag, a potent ghost, still stands.

The Roman Wall, a wall of quite a different set of symbols, was wrapped in 1974. It is over two thousand years old, was built by imperial edict, bordered the ancient city of Rome, and is now surrounded by traffic, which plunges through the arches at the end of the Via Veneto; and it borders the gardens of the Villa Borghese. Museums and galleries have been wrapped. The paths of public parks have been covered.

What is wrapped, bordered, fenced — and of course in any functional way *Running Fence* was not a real fence, for it did not keep in or keep out, or adhere to any border — punctuated, paraded, always has many levels, even if ambiguous or ambivalent, of meaning. Christo leaves room for our imagination to join his.

He makes borders and fences and walls that are not real — the Roman Wall, wrapped or unwrapped, is no longer protective or defensive. Everything that Christo makes is about joining together, crossing boundaries: boundaries between life and art, although both are still clearly defined.

Christo uses traditions and our memories of art history in his art; he uses the historic resonances of cities from Paris to Miami — Miami after all is in the state of Florida, discovered by the Spaniard Ponce de Leon in search of a fountain of youth, and is the port of entry for refugees from Cuba, and the geriatric home of the aged from the northern states: a melting pot of cultures, crimes, economies. It is hardly accident that Rome, Chicago, Cologne, Kassel, Milan, Berlin, Abu Dhabi, are cities that have figured large as either the site for Christos that have been realised, or as the place for projects yet to come. Colorado, the river red rock state, the state that symbolises for many the American wilderness, also resonates. Anywhere Christo chooses to work poses a question for us: why? The natural attractions of the sites and their history are bound together.

In essence, the massive yet delicate interventions of a temporary nature that Christo creates are abstract. When we see photographs of — say — *Running Fence*, what we see is a magical ribbon of white threaded by some unseen hand through miles and miles of countryside and village. It looks like a divine brushstroke.

Wrappings of all kinds make us look at sculptural shapes, disguise and transform the original, sharpen our eyes to textures, to colours. The paths of Wrapped Walk Ways in the park at Kansas City gleamed golden, a fanciful yellow brick road. Oh, yes, do remember that it was Kansas, state of, from which Dorothy was so magically whisked off to the land of Oz, that Missouri, state of, is bordered by the great Mississippi river, and Kansas City, the city, is on the Missouri, and that many place names in both states are North American Indian in origin.

It is among Christo's many gifts to meld in his art many cultural levels: that of the children's story and ancient history. He has wrapped monuments: in 1970, in Milan, the monuments to Vittorio Emanuele, and the one to Leonardo.

There is an echo of Alice in Wonderland, a children's story written after all by a university mathematician who was also a clergyman, and which while still fascinating children has long been appropriated by adults.

And Christo not only uses to such extraordinary ends the bases of art, form, shape, composition, texture, he also uses colour. Colour: pink for Miami, the water of the bay, the green of the islands; yellow and blue for the Umbrellas of Japan and California; orange for the mountains and brilliant blue sky of the red state of Colorado; the golden colour of stone, soft, old golden stone, for the Pont-Neuf. Moreover, the colour is intensely variegated. Instead of brush strokes and patina we have the gentle erosion, wear and tear, of the atmosphere, of weather, of water, of people. The plastic, nylon, synthetic is at times transparent, at times translucent, at times reflective.

Christo's projects leave behind the rarified and segregated world of art. They meet with all kinds of people. Like a business or corporation, his projects have over the years employed thousands of people. And the art of Christo has been prime-time news.

Like all lasting art, it lives in the memory, calls on the memory, has to resonate in the memory. Christos have acquired legendary, mythic status.

Christo and Jeanne-Claude moved countries and languages. They have worked in different cultures and continents. Christo has created in many idioms, and evolved his own language. His objects meld the language of tradition and the avant-garde.

His evanescent sculptures in the world have evolved new visual languages. Christos are non-functional. They are temporary. They use the materials of

technology. The shapes and compositions are architectural, geometric, abstract, but suggestive, of walls, fences, paths, encirclements. They are boundaries which are not defensive or impenetrable.

A Christo, whether it be a wrapped, mysterious package in a museum, his sculptural store fronts, bland, ironic, his bravura, compelling drawings and collages, or the temporary creation of a massive but impermanent functionless structure, is ambivalent and ambiguous... and resonates.

A Christo is gloriously visible, but curiously modest.

It can only exist with the co-operation of the people among whom it exists. Unlike other so-called public pieces of art, a Christo can never be imposed, but can only exist with permission, and that permission is not passive, but active.

Christo uses both the traditional materials and techniques of art — pen, paper draughtsmanship — and materials found, recycled and manufactured, that have only existed in modern times — concrete, plastics, steel. His art is often displayed, as is the convention, in museums and galleries, to people who go to see art. But he has involved thousands of people directly in his projects, and millions of people have either come upon his work directly — by walking across the Pont-Neuf when it was Christo-ised, say — or through the media.

Christo does remind us that the media is the message.

But what is the message?

It is as innocent and sophisticated as enjoyment and beauty. It is art for itself. Its rationale is, like life itself, that it is.

BIOGRAPHY

1935 Born Christo Javacheff, June 13, Gabrovo, Bulgaria.

1952-56 Studies at Fine Arts Academy, Sofia. 1956, arrival in Prague.

1957 One semester's study at the Vienna Fine Arts Academy.

1958 Arrival in Paris. Packages and *Wrapped Objects*.

1961 Project for the *Packaging of a Public Building*.
 Stacked Oil Barrels and *Dockside Packages* in Cologne Harbor.

1962 *Iron Curtain-Wall of Oil Barrels* blocking the Rue Visconti, Paris.
 Stacked Oil Barrels in Gentilly, near Paris.
 Wrapping a Girl, London.

1963 *Showcases*.

1964 Establishment of permanent residence in New York City.
 Store Fronts.

1966 *Air Package* and *Wrapped Tree*, Stedelijk van Abbemuseum, Eindhoven.
 42,390 cubic feet Package, Walker Art Center, Minneapolis School of Art.

1968 *Packed Fountain* and *Packed Medieval Tower*, Spoleto.
 Packaging of a public building *Packed Kunsthalle Berne*.
 5,600 Cubic Meters Package, Documenta 4, Kassel, an Air Package 280 feet high, 33 feet diameter, supported by cables anchored in six concrete foundations arranged in a 900 feet diameter circle.
 Corridor Store Front, total area: 1,500 square feet.
 1,240 Oil Barrels Mastaba, and *Two Tons of Stacked Hay*, Philadelphia Institute of Contemporary Art.

1969 *Packed Museum of Contemporary Art*, Chicago.
 Wrapped Floor, 2,800 square feet drop cloths, Museum of Contemporary Art, Chicago.
 Wrapped Coast, Little Bay, One Million Square Feet, Sydney, Australia, Erosion Control fabric and 36 mile ropes.

Project for stacked Oil Barrels *Houston Mastaba*, Texas, 1,249,000 barrels.
Project for *Closed Highway*.

1970 *Wrapped Monuments*, Milan: Monument to Vittorio Emanuele, Piazza Duomo; Monument to Leonardo da Vinci, Piazza Scala.

1972 *Wrapped Reichstag, project for Berlin*, **in progress.**
 Valley Curtain, Grand Hogback, Rifle, Colorado, 1970-72. width: 1,250-1,368 feet, height: 185-365 feet; 200,000 square feet of nylon polyamide; 110,000 lbs. of steel cables; 800 tons of concrete.

1974 *The Wall, Wrapped Roman Wall, Via V. Veneto and Villa Borghese, Rome*.
 Ocean Front, Newport, Rhode Island; 150,000 square feet of floating polypropylene fabric over the Ocean.

1976 *Running Fence, Sonoma and Marin Counties, California, 1972-76.* 18 feet high, 24½ miles long. Two million square feet of woven nylon fabric. 90 miles of steel cables. 2,050 steel poles (each: 3-½ inch diameter, 21 feet long).

1977-78 *Wrapped Walk Ways, Loose Park, Kansas City, Missouri, 1977-78.* 15,000 square yards of woven nylon fabric over 4.5 kilometers of walk ways.

1979 *The Mastaba of Abu Dhabi, project for the United Arab Emirates*, **in progress.**

1980 *The Gates, project for Central Park, New York City*, **in progress.**

1980-83 *Surrounded Islands, Biscayne Bay, Greater Miami, Florida, 1980-83.* 6½ million sq. ft. pink woven polypropylene fabric.

1985 *The Umbrellas, Joint project for Japan and the USA*, **in progress.**
 The Pont Neuf Wrapped, Paris, 1975-85. 440,000 sq. ft. woven polyamide fabric, 42,900 ft. of rope.

Married: Jeanne-Claude (de Guillebon). Son: Cyril, born 1960.

BIBLIOGRAPHY

BOOKS

1965 *Christo*. Texts by David Bourdon, Otto Hahn and Pierre Restany. Designed by Christo. Edizioni Apollinaire, Milan, Italy.

1968 *Christo: 5,600 Cubic Meter Package*. Photographs by Klaus Baum. Designed by Christo. Verlag Wort und Bild, Baierbrunn, West Germany.

1969 *Christo*. Text by Lawrence Alloway. Designed by Christo. Harry N. Abrams Publications, New York, USA. Verlag Gerd Hatje, Stuttgart, West Germany. Thames and Hudson, London, England.

1969 *Christo: Wrapped Coast, One Million Square Feet*. Photographs by Shunk-Kender. Designed by Christo. Contemporary Art Lithographers, Minneapolis, USA.

1970 *Christo*. Text by David Bourdon. Designed by Christo. Harry N. Abrams Publications, New York, USA.

1971 *Christo: Projeckt Monschau*. By Willi Bongard. Verlag Art Actuell, Cologne, West Germany.

1973 *Christo: Valley Curtain*. Photographs by Harry Shunk. Designed by Christo. Gert Hatje Verlag, Stuttgart, West Germany; Harry N. Abrams Publications, New York, USA; Pierre Horay, Paris, France; Gianpaolo Prearo, Milano, Italy.

1975 *Christo: Ocean Front*. Text by Sally Yard and Sam Hunter. Photographs by Gianfranco Gorgoni. Edited by Christo. Princeton University Press, New Jersey, USA.

1977 *Christo: The Running Fence*. Text by Werner Spies. Photographs by Wolfgang Volz. Harry N. Abrams, Inc., New York, USA; Éditions de Chène, Paris, France.

1978 *Christo: Running Fence*. Chronicle by Calvin Tomkins. Narrative text by David Bourdon. Photographs by Gianfranco Gorgoni. Designed by Christo. Harry N. Abrams, Inc., New York, USA.

1978 *Christo: Wrapped Walk Ways*. Essay by Ellen Goheen. Photographs by Wolfgang Volz. Designed by Christo. Harry N. Abrams, Inc., New York, USA.

1982 *Christo-Complete Editions 1964-82*. Catalogue Raisonne and Introduction by Per Hovdenakk. Verlag Schellmann and Kluser, Munich, West Germany, and New York University Press, New York, USA.

1984 *Christo: Works 1958-83*. Text by Yusuke Nakahara. Publication Sogetsu Shuppan, Inc., Tokyo, Japan.

1984 *Christo: Surrounded Islands, Biscayne Bay, Greater Miami, Florida, 1980-83*. Text by Werner Spies, photographs and editing by Wolfgang Volz. Dumont Buchverlag, Cologne, West Germany; Harry N. Abrams, Inc., New York, USA, 1985; Fondation Maeght, Saint-Paul-de-Vence, France, 1985; Ediciones Polígrafa, Barcelona, Spain, 1986.

1984 *Christo-Der Reichstag*. Compiled by Michael Cullen and Wolfgang Volz. Suhrkamp Verlag, Frankfurt, West Germany.

1985 *Christo*. Text by Dominique Laporte. Publication: Art Press/Flammarion, Paris, France. English edition by Pantheon Books, New York, USA, 1986.

1986 *Christo: Surrounded Islands, Biscayne Bay, Greater Miami, Florida, 1980-83*. Designed by Christo. Photographs: Wolfgang Volz. Introduction and Picture Commentary: David Bourdon. Essay: Jonathan Fineberg. Report: Janet Mulholland. 696 pages. Harry N. Abrams, Inc., New York, USA.

1987 *Le Pont-Neuf de Christo, Ouvrage d'Art, Œuvre d'Art, ou comment se faire une opinion*. By Nathalie Heinich. Photographs by Wolfgang Volz. A.D.R.E.S.S.E.

1988 *Christo: Prints and Objects, 1963-1987*. A Catalogue Raisonné edited by Jorg Schellmann and Josephine Benecke. Introduction by Werner Spies. Editions Schellmann, Munich, West Germany and Abbeville Press. New York, USA.

1990 *Christo: The Pont Neuf Wrapped, Paris 1975-85*. Photographs by Wolfgang Voltz. Texts by David Bourdon and Bernard de Montgolfier. Harry N. Abrams, Inc., New York, USA.; Adam Biro, Paris, France; Dumont Verlag, Cologne, West Germany.

CATALOGUES FOR EXHIBITIONS (selected)

1961 Galerie Haro Lauhus, Cologne, West Germany. Text by Pierre Restany.

1966 Stedelijk van Abbe Museum, Eindhoven, The Netherlands. Text by Lawrence Alloway.

1968 Museum of Modern Art, New York, USA. Text by Prof. William Rubin.

1968 I.C.A. University of Pennsylvania, Philadelphia, USA. Text by Stephen Prokopoff.

1969 National Gallery of Victoria, Melbourne, Australia. Text by Jan van der Marck.

1971 Haus Lange Museum, Krefeld, West Germany. Text by Dr. Paul Wember.

1973 Kunsthalle, Dusseldorf, West Germany. Text by John Matheson.

1974 Musée de Peinture et de Sculpture, Grenoble, France. Text by Maurice Besset

1975 Galeria Ciento, Barcelona, Spain. Text by Alexandre Cirici.

1977 Mimani Gallery, Tokyo, Japan. Text by Yusuke Nakahara.

1977 Annely Juda Fine Arts, London, England. Texts by Dr. Wieland Schmied and Prof. Tilmann Buddensieg.

1978 Galerie Art in Progress, Munich, West Germany. *Galerien Maximilianstrasse*. Text by Albrecht Haenlein.

1978 Rijksmuseum Kröller-Müller, Otterlo, The Netherlands. Introduction by R. Oxenaar and text by Ellen Joosten.

1979 Wiener Secession. Text by W. Spies. Introduction by H. J. Painitz.

1979 I.C.A., Boston, USA. Introduction by Stephen Prokopoff. Text by Pamela Allara, Stephen Prokopoff.

1981 Museum Ludwig, Cologne, West Germany. Introduction by Karl Ruhrberg and Klaus Gallwitz. Text by Evelyn Weiss and Gerhard Kolberg.

1981 Juda-Rowan Gallery, London, England. Texts by Christo and Anitra Thorhaug.

1981 La Jolla Museum of Contemporary Art, La Jolla, USA. *Christo: Collection on loan from the Rothschild Bank AG, Zurich*. Introduction by Robert McDonald and text by Jan van der Marck.

1984 Satani Gallery, Tokyo, Japan. *Christo-The Pont Neuf Wrapped, Project for Paris*. Text by Yusuke Nakahara, interview by Masahiko Yanagi.

1984 Annely Juda Fine Arts, London, England. *Christo: Objects, Collages and Drawings, 1958-83*.

1986 Satani Gallery, Tokyo, Japan. *Christo-Wrapped Reichstag, Project for Berlin*. Interview by Masahiko Yanagi.

1987 Museum of Contemporary Art, Gent, Belgium. *Surrounded Islands, Florida, 1980-83*, Documentation Exhibition. Text by Werner Spies, photographs by Wolfgang Volz.

1987 Seibu Museum of Art, Tokyo, Japan. *Christo: A Collection on Loan from the Rothschild Bank, Zurich*. Texts by Torsten Lilja, Yusuke Nakahara, Tokuhiro Nakajima, Akira Moriguchi. Interview by Masahiko Yanagi.

1987 Centre d'Art Nicolas de Staël, Braine-L'Alleud, Belgium. *Dessins, Collages, Photos*. Text by Prof. A. M. Hammacher and Interviews by Marcel Daloze and Dominique Verhaegen.

1988 Satani Gallery, Tokyo, Japan. *The Umbrellas, Joint Project for Japan and USA*, Documentation Exhibition. Introduction by Ben Yama and text by Masahiko Yanagi.

1988 Annely Juda Fine Art, London, U.K. *The Umbrellas, Joint Project for Japan and USA,* Documentation Exhibition, Interview and Text by Masahiko Yanagi.

1988 Taipei Fine Arts Museum, Taipei, Taiwan. *Christo: Collection on Loan From the Rothschild Bank AG, Zurich*. Preface by Kuang-Nan Huang. Texts by Werner Spies and by Joseph Wang.

1989 Guy Pieters Gallery, Knokke-Zoute, Belgium. *The Umbrellas, Joint Project for Japan and USA*. Photographs by Wolfgang Volz. Text by Masa Yanagi. Picture commentary by Susan Astwood.

1989 Musée d'Art Moderne et d'Art Contemporain, Nice, France. *Christo: Selection from the Lilja Collection*. Texts by Torsten Lilja, Claude Fournet, Pierre Restany, Werner Spies, M. Yanagi.

1989 Galerie Catherine Issert, Saint-Paul-de-Vence, France. *Christo: 1965-1988*. Text by Raphael Sorin.

1990 Henie-Onstad Art Center, Hovikodden, Norway. *Christo: Works 1958-1989, From the Lilja Collection*. Texts by Torsten Lilja, Per Hovdenakk. Interview by Jan Åman.

1990 Hiroshima City Museum of Contemporary Art, Japan. *Christo; Surrounded Islands, 1980-83*. Documentation Exhibition. Text by Prof. Jonathan Fineberg.

1990 The Art Gallery of New South Wales, Sydney, Australia. *Christo: Works from 1958-1990*. Text by Prof. Albert Elsen.

FILMS

1969 *Wrapped Coast*. Blackwood Productions.

1972 *Christo's Valley Curtain*. Maysles Brothers and Ellen Giffard.

1977 *Running Fence*. Maysles Brothers / Charlotte Zwerin.

1978 *Wrapped Walk Ways*. Blackwood Productions.

1985 *Islands*. Maysles Brothers / Charlotte Zwerin.

1990 *The Pont Neuf*. Maysles Brothers.

MUSEUM COLLECTIONS

Albright-Knox Museum, Buffalo, New York, USA
Art Gallery of Ontario/Musée des Beaux Arts de l'Ontario, Canada
Atkins Museum of Fine Arts, Kansas City, Missouri, USA
Boise Art Museum, Idaho, USA
Boymans van Beuningen Museum, Rotterdam, The Netherlands
Centre National d'Art Contemporain, Paris, France
Centre National d'Art et de Culture Georges Pompidou, Paris, France
City Museum, St. Louis, Missouri, USA
Corcoran Gallery of Art, Washington, D.C., USA
Dallas Museum of Art, Texas, USA
Dartmouth College Museum, Hanover, New Hampshire, USA
Des Moines Art Center, Iowa, USA
Detroit Institute of Art, Michigan, USA
Deutsches Architektur Museum, Frankfurt, West Germany
Fogg Museum, Boston, Massachusetts, USA
Fukuoka Art Museum, Japan
Greenville County Museum, North Carolina, USA
Housatonic Community College Museum, Bridgeport, Connecticut, USA
Hunter Museum of Art, Chattanooga, Tennessee, USA
Israel Museum, Jerusalem, Israel
Iwaki Art Museum, Japan
Kaiser Wilhelm Museum, Krefeld, West Germany
Kestner Gesellschaft, Hannover, West Germany
Kunst Museum, Hannover, West Germany
Kunstgewerbemuseum Der Stadt, Zurich, Switzerland
Kunsthalle Hamburg, West Germany
Kunsthaus, Zurich, Switzerland
Kunstmuseum, Basel, Switzerland
Kunstmuseum, Berne, Switzerland
Kunstverein, Stuttgart, West Germany
La Jolla Museum of Contemporary Art, California, USA
Le Musée de Nimes, France
Los Angeles County Museum of Art, California, USA
Louisiana Museum of Modern Art, Humlebaek, Denmark.
Lowe Art Museum, University of Miami, Florida, USA
Ludwig Museum, Cologne, West Germany
Milwaukee Art Museum, Wisconsin, USA
Minnesota Museum of Art. St. Paul, USA
Mississippi Museum of Art, Jackson, USA
Moderna Museet, Stockholm, Sweden
Mönchehaus Museum Für Moderne Kunst, Goslar, West Germany
Museum of Art, Bowdoin College, Maine, USA
Museum of Contemporary Art, Chicago, Illinois, USA
Museum of Modern Art, San Francisco, California, USA
Museum of Modern Art, Teheran, Iran
Museum of the Twentieth Century, Vienna, Austria
Musée Cantini, Marseille, France
Musée d'Art Moderne de la Ville de Paris, France
Musée d'Art Moderne et d'Art Contemporain de Nice, France
Musée de Grenoble, France
Musée de Toulon, France
National Galerie, Berlin, West Germany

National Gallery of Art, Canberra, Australia
National Gallery, Dublin, Ireland
National Gallery, Sydney, Australia
National Museum of Art, Osaka, Japan
Neuberger Museum, State University of New York, Purchase, USA
Neue Galerie Der Stadt Linz, Wolfgang Gurlitt Museum, Australia
Neue Galerie Der Stadt, Aachen, West Germany
Neue Pinakotek, Munich, West Germany
New Britain Museum of American Art, Connecticut, USA
Rheinisches Landesmuseum, Bonn, West Germany
Rijksmuseum Kröller-Müller, Otterlo, The Netherlands
Santa Barbara Museum, California, USA
Sara Hildenin Taidemuseo, Tampere, Finland
Smith College Museum of Art, Northampton, Massachusetts, USA
Staads Galerie, Stuttgart West Germany
Städtisches Museum Abteiberg, Mönchengladbach, West Germany
Stedelijk Museum, Amsterdam, The Netherlands
Stedelijk Van Abbemuseum, Eindhoven, The Neterlands
Takanawa Museum, Karuizawa, Japan
The Allen Memorial Art Museum, Oberlin, Ohio, USA
The Art Institute of Chicago, Illinois, USA
The Art Institute, Cleveland, Ohio, USA
The Art Museum of Santa Cruz County, Soquel, California, USA
The Cleveland Museum, Ohio, USA
The Hara Museum of Contemporary Art, Tokyo, Japan
The Henie-Onstad Art Center, Hovikodden, Norway.
The Menil Collection, Houston, Texas
The Museum of Albuquerque, New Mexico, USA
The Museum of Fine Arts, Houston, Texas, USA
The Museum of Fine Arts, Philadelphia, Pennsylvania, USA
The Museum of Modern Art, Hiroshima City, Japan
The Museum of Modern Art, New York City, USA
The Museum of Modern Art, Shiga, Japan
The Museum of Modern Art. Toyama, Japan
The Ohara Museum, Kurashiki City, Okasayama Prefecture, Japan
The Power Institute of Fine Arts, Sydney, Australia
The Seibu Museum of Art, Tokyo, Japan
The Sogetsu Art Museum, Tokyo, Japan
The Takamatsu City Museum, Japan
The Tate Gallery, London, England
The University of Michigan Museum of Art, Ann Arbor, Michigan, USA
The Whitney Museum of American Art, New York City, USA
University Museum, Lund, Sweden
Vancouver Art Gallery, B.C., Canada
Victoria and Albert Museum, London, England
Virginia Museum of Fine Arts, Richmond, USA
Walker Art Center, Minneapolis, Minnesota, USA
Wilhem-Lehmbruck-Museum, Duisburg, West Germany
Worcester Art Museum, Massachussetts, USA
Yale University Museum, New Haven, Connecticut, USA
Yamanashi Prefectural Museum of Art, Kofu, Japan

ILLUSTRATIONS

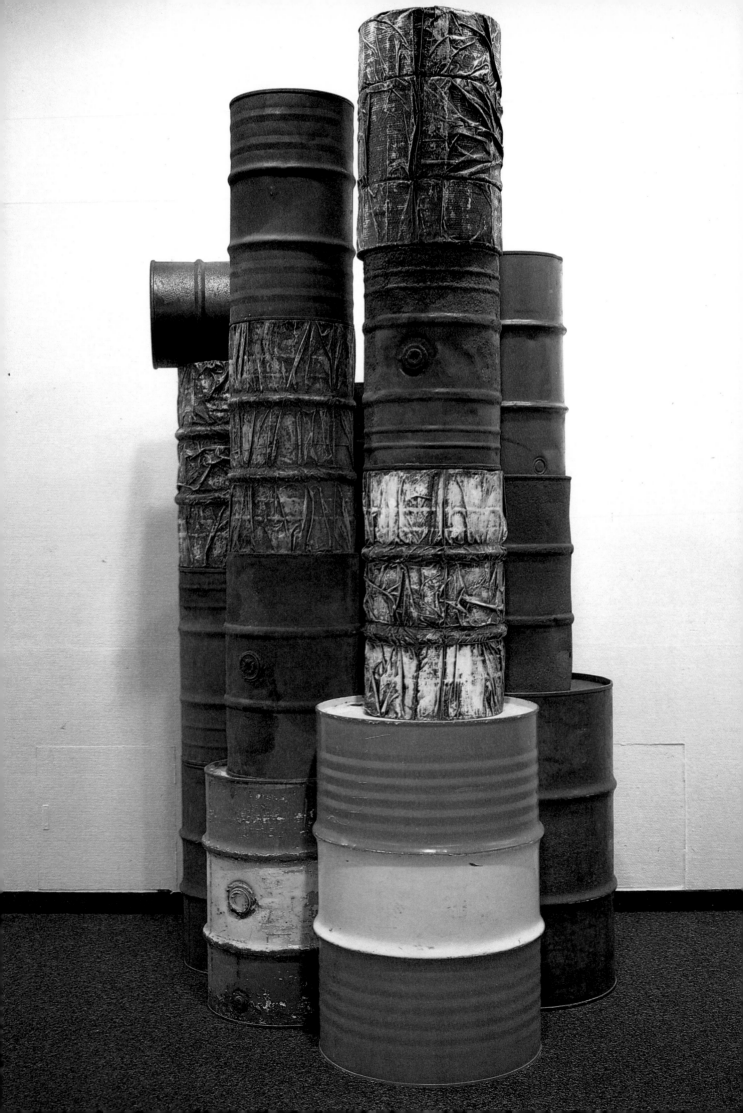

1. **Wrapped Oil Barrels.** 1958-1959.
 Fabric, enamel paint, steel wire and barrels,
 4 wrapped: 25¼ × 14½ in. (64 × 36.5 cm), two;
 24½ × 14½ in. (62 × 36.5 cm),
 23¾ × 15 in. (60 × 38 cm).
 14 barrels not wrapped.
 Jeanne-Claude Christo Collection, New York.
 Photo: Wolfgang Volz.

2. **Package.** 1958.
 Lacquered fabric and rope,
 14½ × 10½ × 6¼ in. (37 × 26 × 16 cm).
 Jeanne-Claude Christo Collection, New York.
 Photo: Eeva-Inkeri.

3. **Wrapped Bottles and Cans.** 1958-1959.
 Cans, bottles, lacquered canvas and twine,
 11 × 29 × 11 in. (28 × 74 × 28 cm).
 Jeanne-Claude Christo Collection, New York.
 Photo: Eeva-Inkeri.

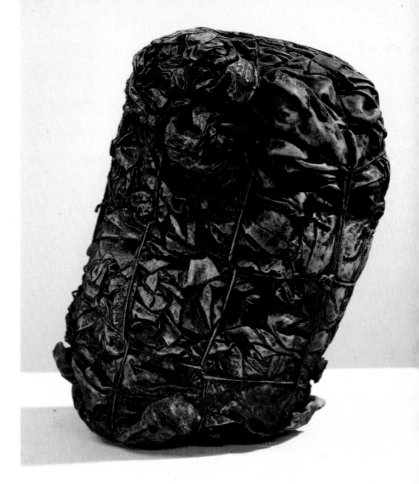

1

2

3

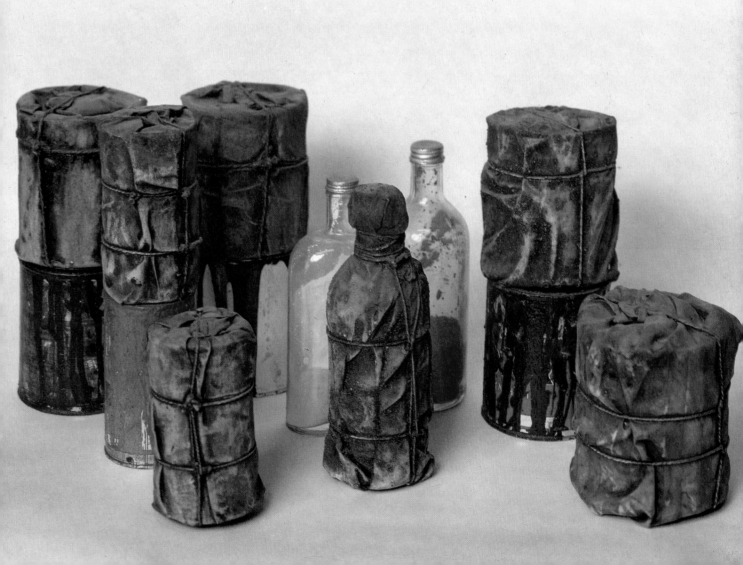

4. **Package.** 1961.
Fabric, rope and twine,
49¼ × 8½ × 8½ in. (125 × 21 × 21 cm).
Jeanne-Claude Christo Collection, New York.
Photo: Eeva-Inkeri.

5. **Package.** 1961.
Fabric, rope, plastic and wood,
32⁷⁄₈ × 29½ × 10⁶⁄₈ in. (83.5 × 74.5 × 27 cm).
Lauffs in the Kaiser Wilhelm Museum, Krefeld.
Photo: Sigwart Korn.

6. **Package.** 1960.
Fabric, rope and twine,
29½ × 13½ × 8 in. (75 × 34.3 × 20.2 cm).
Jeanne-Claude Christo Collection, New York.
Photo: Eeva-Inkeri.

7. **Dockside Package (Cologne Harbor).** 1961.
 Rolls of paper, tarpaulin and rope,
 16×6×32 ft. (480×180×960 cm).
 Photo: S. Wewerka.

8. **Wall of Oil Barrels - Iron Curtain, Rue Visconti, Paris.**
 June 27, 1962.
 240 oil barrels: 14 ft.×13 ft.×5 ft. 6 in. (4.3×3.8×1.7 m).
 Photo: Jean-Dominique Lajoux.

7

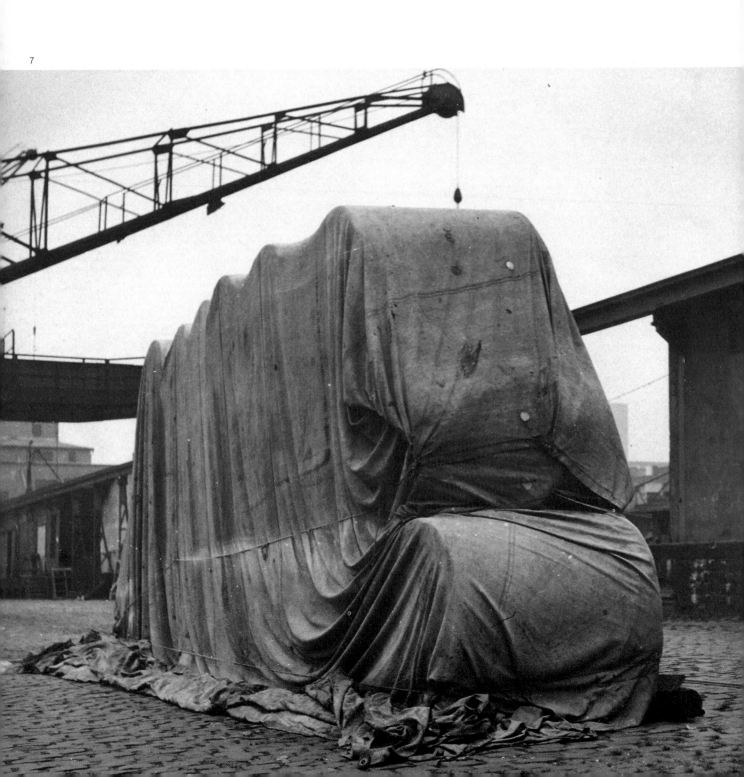

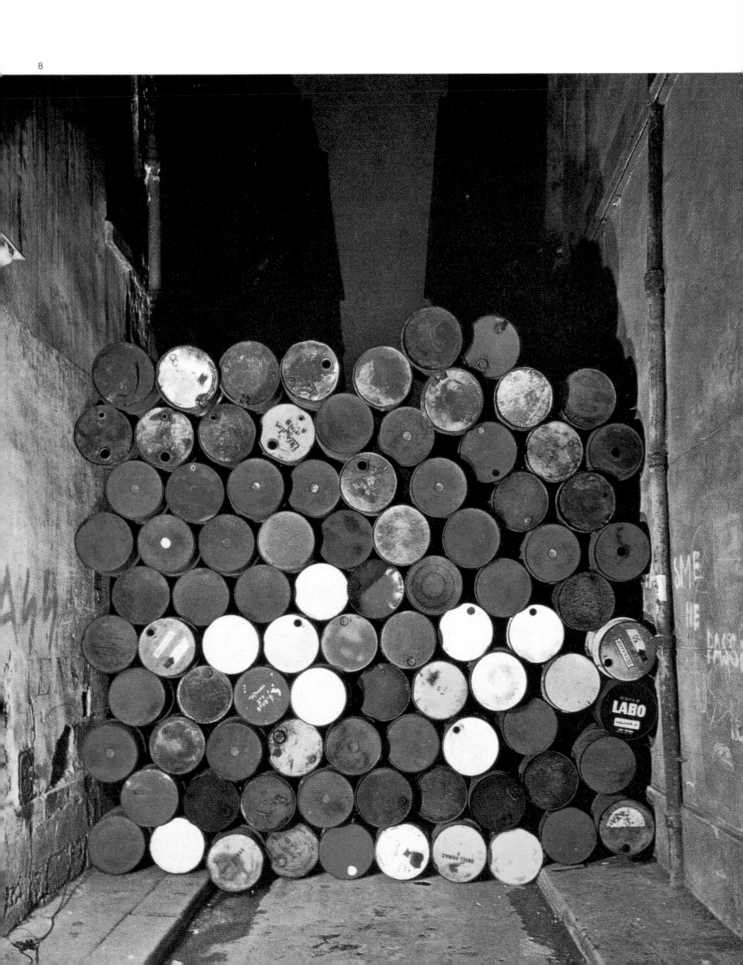

Project for a Packaged Public Building

The building should be situated in a vast and regular space. The edifice should be freestanding and have a rectangular base. It will be completely closed up, packed on every side. The entrances will be underground, placed about 50 to 65 feet from the building.

The packaging of this building will be done with rubberized tarpaulin and reinforced plastic, averaging 33 to 65 feet in width and with steel cables and ordinary rope. Using steel cables, it will be possible to secure the strong points needed for the packaging of the building.

To obtain the desired result will require about 90,000 square feet tarpaulin, 6,000 feet of steel cable, and 25,000 feet of rope.

The packaged public building can be used as:

1) Stadium with swimming pools, football field, Olympic arena, or hockey and ice-skating rink.
2) Concert hall, conference hall, planetarium, or exhibition hall.
3) Historical museum of ancient and modern art.
4) Parliament or prison.

CHRISTO
Paris, October, 1961

9. **Packaged Public Building. Project.** 1961.
Collaged photographs (detail).
Jeanne-Claude Christo Collection, New York.
Photo: Harry Shunk.

10. **Packaged Building. Project.** 1963.
Photomontage.
Jeanne-Claude Christo Collection, New York.
Photo: Harry Shunk.

10

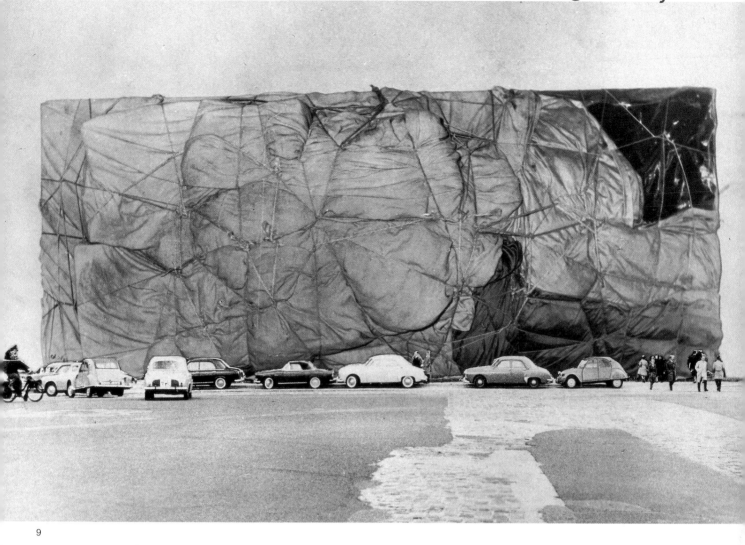

9

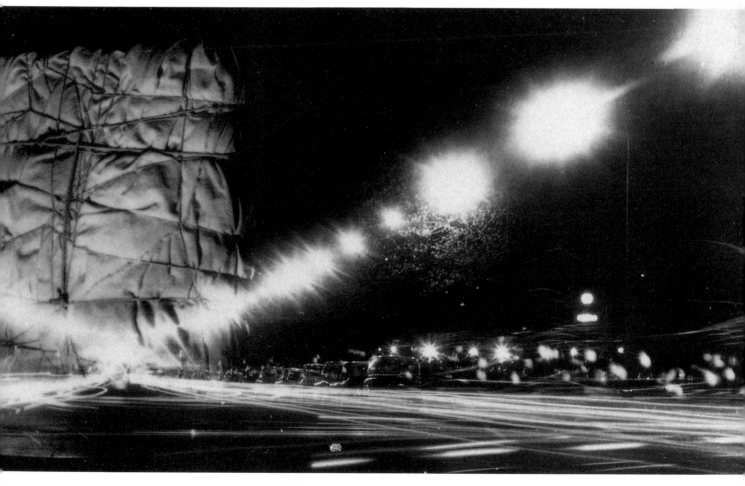

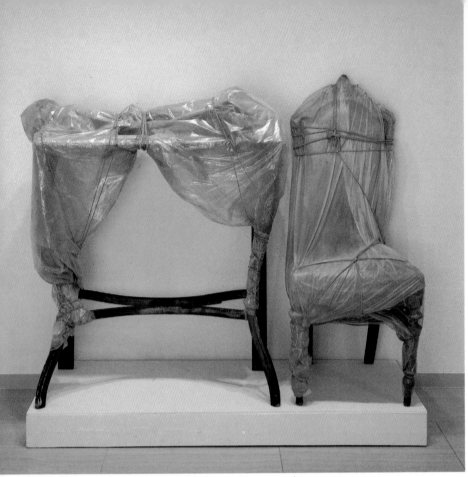

11. **Wrapped Table and Wrapped Chair.** 1963.
Wooden console table, chair, crystal candelabra,
polyethylene, rope and twine,
42 × 60 × 18⅛ in. (106.6 × 152.5 × 40.6 cm).
Jeanne-Claude Christo Collection, New York,
with Sabina and Giovanni Camuffo, Venice.
Photo: S. Anzai.

12. **Wrapped Armchair.** 1965.
Plastic, fabric, armchair and twine,
38 × 31 × 32 in. (96.5 × 78.8 × 81.3 cm).
Stedelijk Van Abbe Museum, Eindhoven.
Photo: F. Boesch.

13. **Wrapped Table.** 1961.
Table, objects, fabric, rope and lacquer,
54 × 16½ × 16½ in. (107.2 × 42 × 42 cm).
Musée National d'Art Moderne,
Centre Georges Pompidou, Paris.
Photo: Eeva-Inkeri.

11

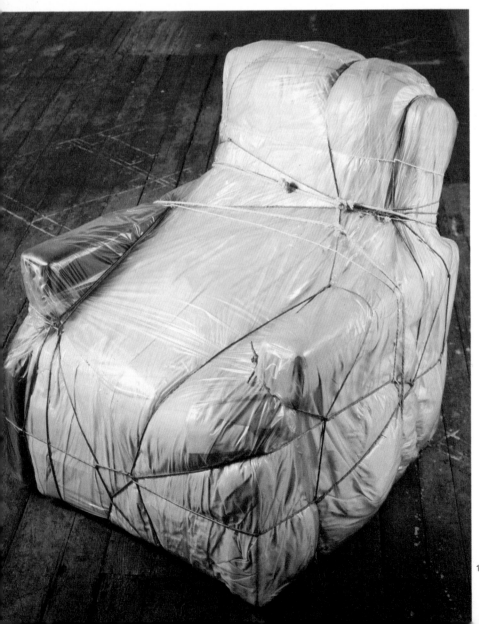

12

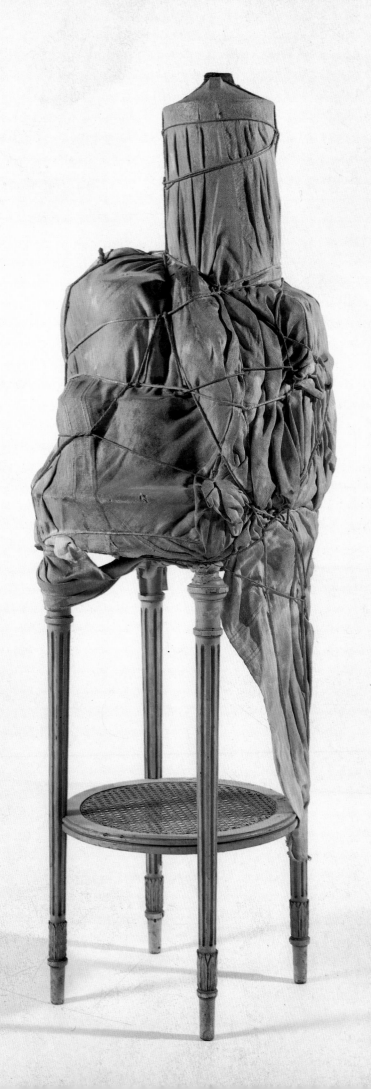

13

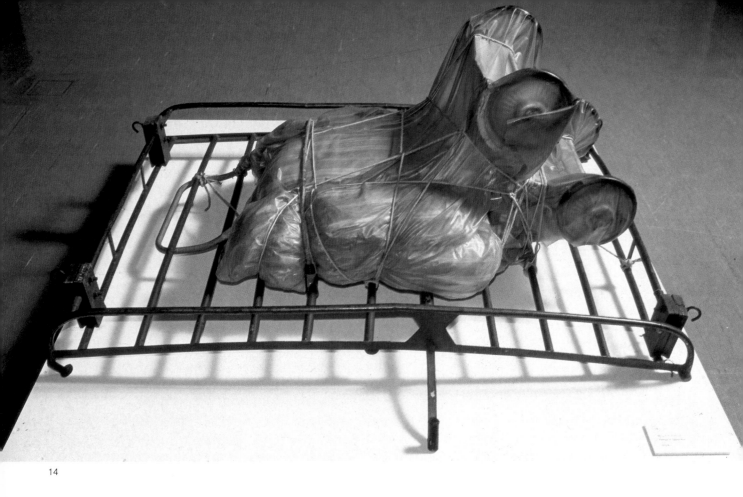

14

14. **Package on Luggage Rack.** 1962.
Metal, stroller, fabric, polyethylene, rope and rubberized cord,
25 × 53½ × 37½ in. (63.5 × 135.9 × 95.2 cm).
Bob Lilja Collection, London.
Photo: Wolfgang Volz.

15. **Wrapped Motorcycle.** 1962.
Motorcycle, plastic, steel, rubber and rope,
30¼ × 76 × 16 in. (76.2 × 193 × 41.1 cm).
Mr. and Mrs. Philippe Durand-Ruel Collection, Paris.
Photo: Raimond de Seynes.

15

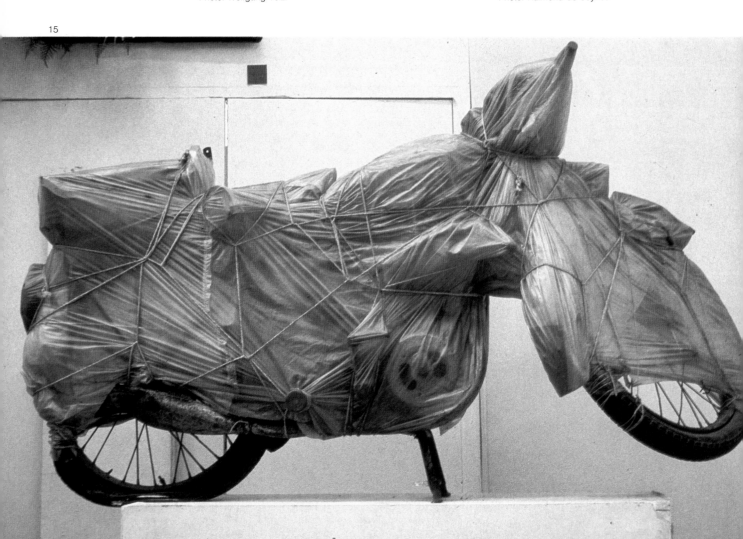

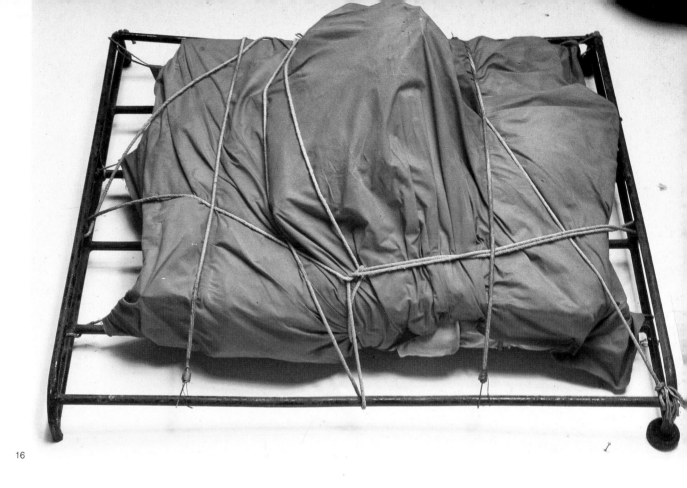

16

16. **Package on Luggage Rack.** 1962.
Metal, tarpaulin, rubberized cord and rope,
72 × 42 × 18 in. (182.9 × 106.6 × 45.7 cm).
Jeanne-Claude Christo Collection, New York.
Photo: Eeva-Inkeri.

17. **Package on Wheelbarrow.** 1963.
Cloth, wood, rope, metal and wheelbarrow,
35 × 60 23 in. (89 × 152.2 × 58.5 cm).
The Museum of Modern Art, New York.
Photo: Eeva-Inkeri.

17

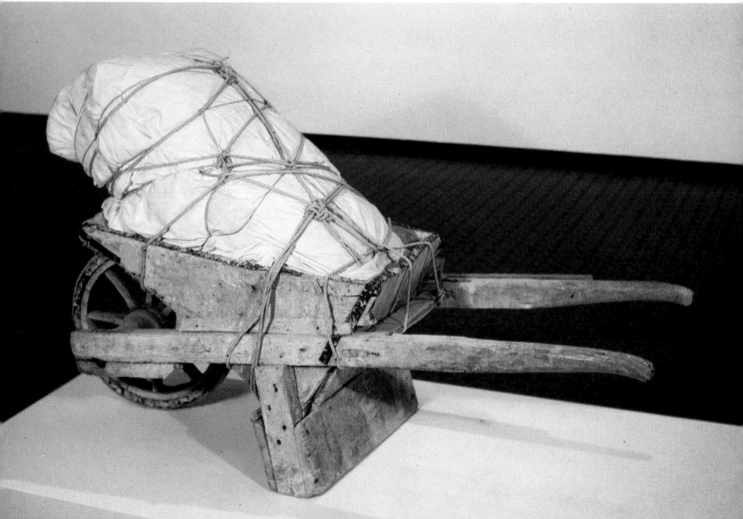

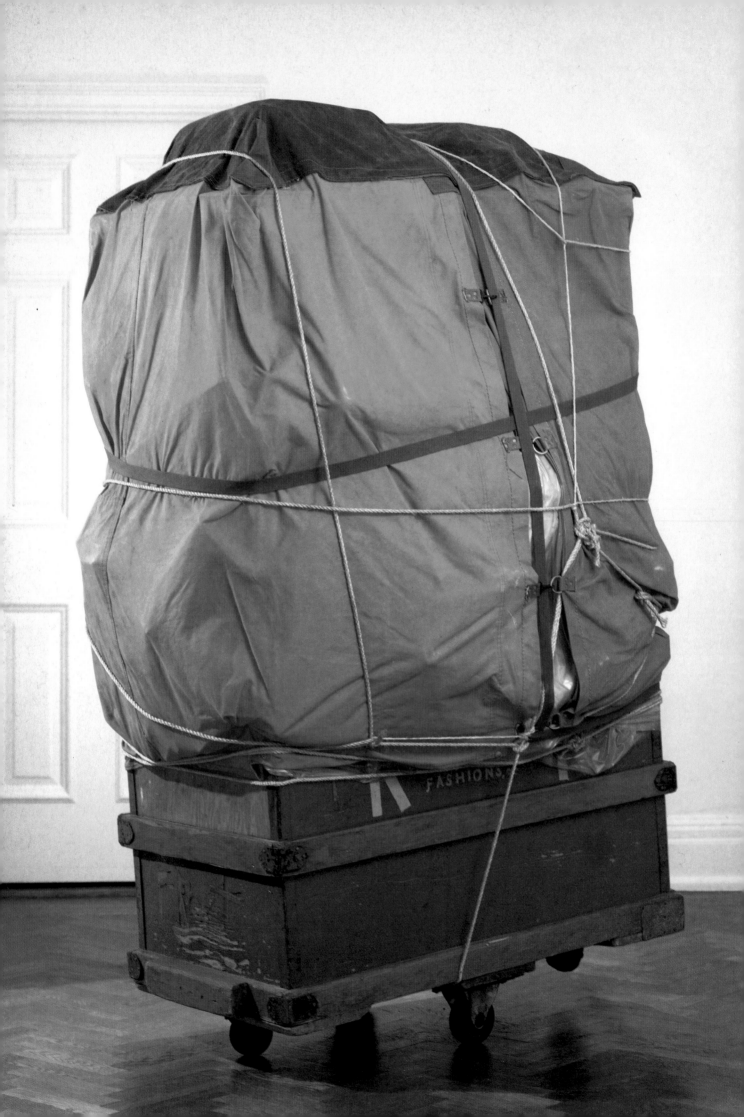

18.
Dolly. 1964.
Wooden box, tarpaulin, rope,
plastic and girth,
72 × 40 × 32 in. (183 × 101.5 × 82 cm).
Jeanne-Claude Christo Collection,
New York.
Photo: Eeva-Inkeri.

19.
Wrapped Road Signs. 1963.
Wooden road signs, steel stand,
lantern, chain,
fabric, rope and jute,
71¼ × 24½ × 18½ in.
(181 × 62.5 × 47 cm).
Jeanne-Claude Christo Collection,
New York.
Photo: Harry Schunk.

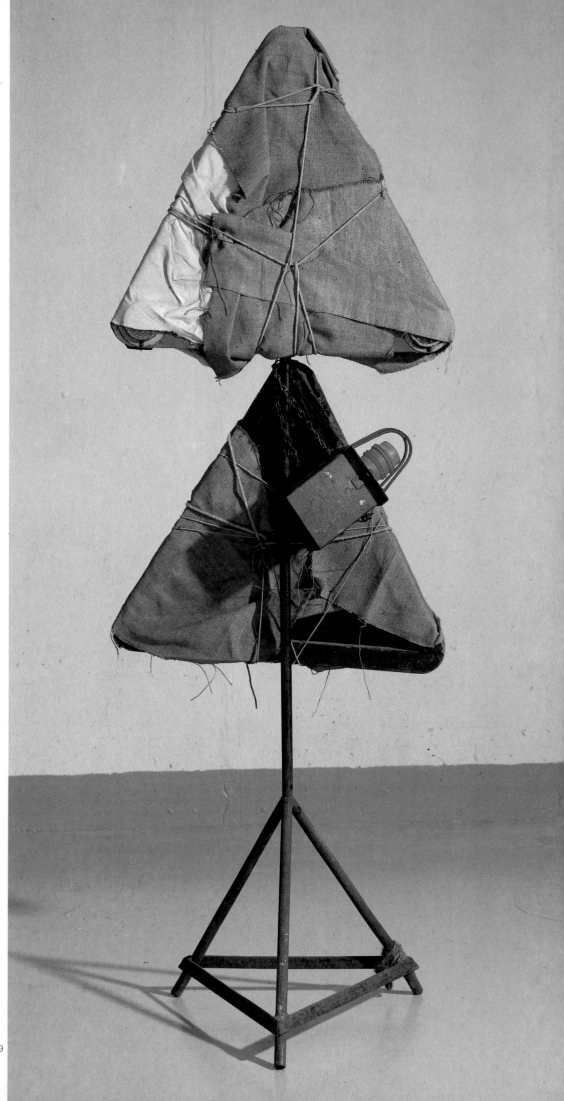

19

20. **Store Front. Project.** 1965.
Wood, plexiglass, fabric, wrapping paper, metal, electric
light, charcoal, pencil and cardboard,
48 × 37⅝ × 3⅛ in. (122 × 95.5 × 8 cm).
Kaiser Wilhelm Museum, Krefeld.
Photo: Sigwart Korn.

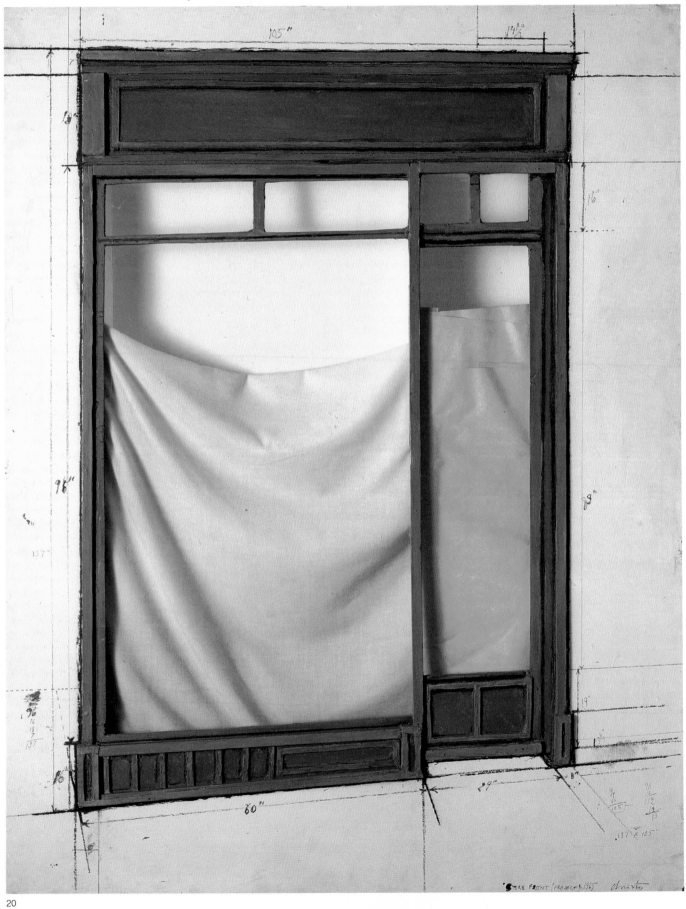

21. **Yellow Store Front.** 1965.
Wood, plexiglass, fabric, brown paper, galvanized metal,
pegboard and electric light,
98 × 88¼ × 16 in. (249 × 224 × 40.5 cm).
Mr. and Mrs. Horace Solomon, New York.
Photo: Courtesy Holly Solomon Gallery.

22. **Red Store Front. Project.** 1965.
Pencil, charcoal, crayon, wood, paint, fabric, plexiglass and
electric light,
40 × 48⅛ × 2 in. (101.6 × 122.3 × 5.1 cm).
Jeanne-Claude Christo Collection, New York.
Photo: Eeva-Inkeri.

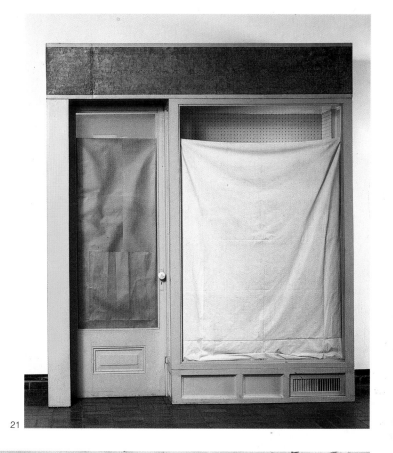

21

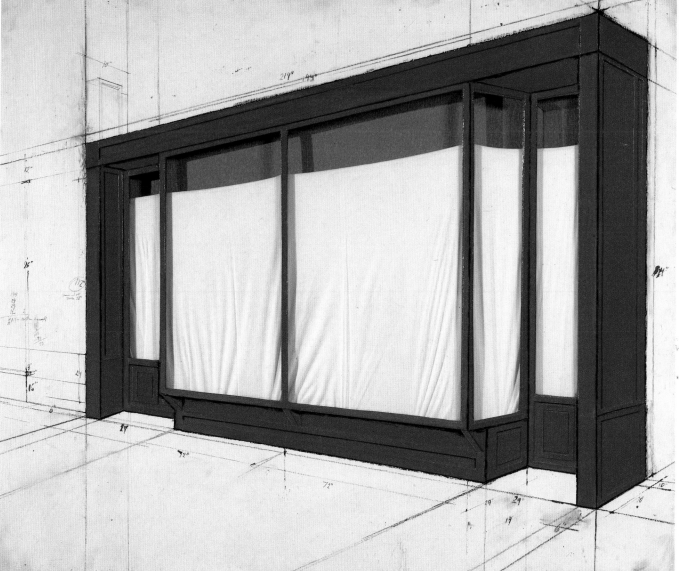

22

23. **Show Window.** 1965-1966.
Metal, wood, plexiglass and fabric,
84 × 48 × 3½ in. (213 × 122 × 9 cm).
Jeanne-Claude Christo Collection, New York.
Photo: Ferdinand Boesch.

24. **Store Front. Project.** 1964.
Wood, masonite, plexiglass, fabric, wrapping paper, pencil,
steel wire netting, charcoal, electric light and enamel paint,
63 × 49½ × 4 in. (160 × 125.7 × 10 cm).
Bob Lilja Collection, London.
Photo: Eeva-Inkeri.

25. **Store Front.** 1964.
Wood, plexiglass, enamel paint, metal, fabric and electric light,
82³/₄ × 88½ × 13³/₄ in. (210 × 225 × 35 cm).
Jeanne-Claude Christo Collection, New York, with Madeleine
and Dominik Keller, Zurich.
Photo: Wolfgang Volz.

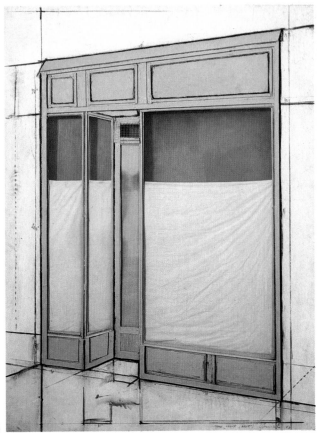

24

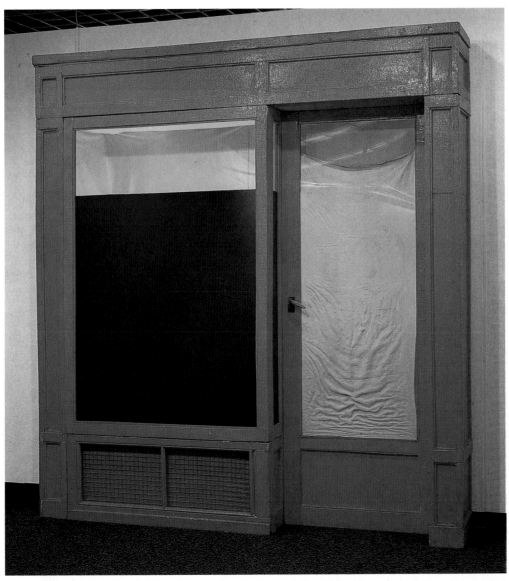

25

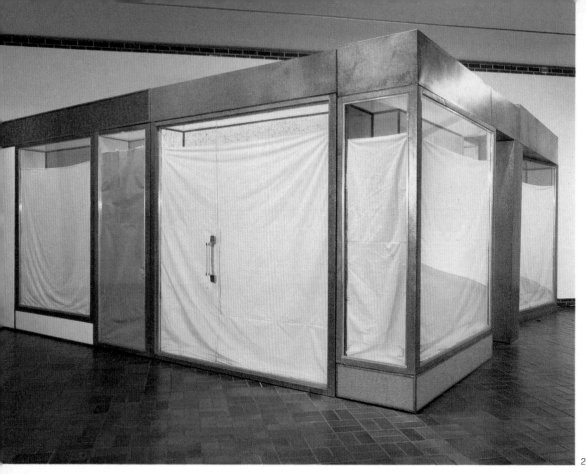

26.
Four Store Fronts Corner.
1964-1965.
Parts: 1, 2, 3, 4.
Galvanized metal, clear and
colored plexiglass, masonite,
canvas and electric light,
8 ft.1½ in. × 18 ft. 8 in. × 2 ft.
(248 × 569 × 61 cm).
Jeanne-Claude Christo
Collection, New York.
Photo: Eeva-Inkeri.

27.
Corridor - Store Front. 1967-1968.
Aluminum, wood,
plexiglass and electric light.
The entire work covers
an area of 1,513 sq. ft. (134 m²).
Jeanne-Claude Christo
Collection, New York, with Daniel
Varenne, Geneva.
Photo: Ferdinand Boesch.

28.
Three Store Fronts. 1965-1966.
Galvanized metal, plexiglass,
masonite, fabric and electric light,
8 ft. × 46 ft. × 17 in.
(244 × 1,402 × 43 cm).
Jeanne-Claude Christo
Collection, New York.
Photo: Ferdinand Boesch.

26

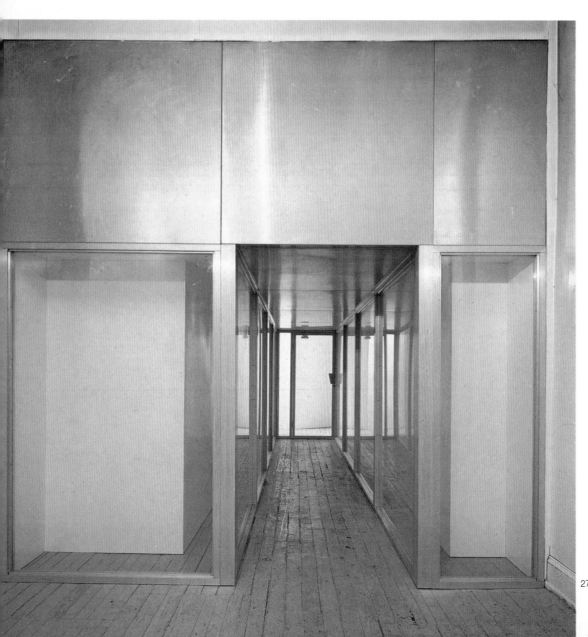

27 28

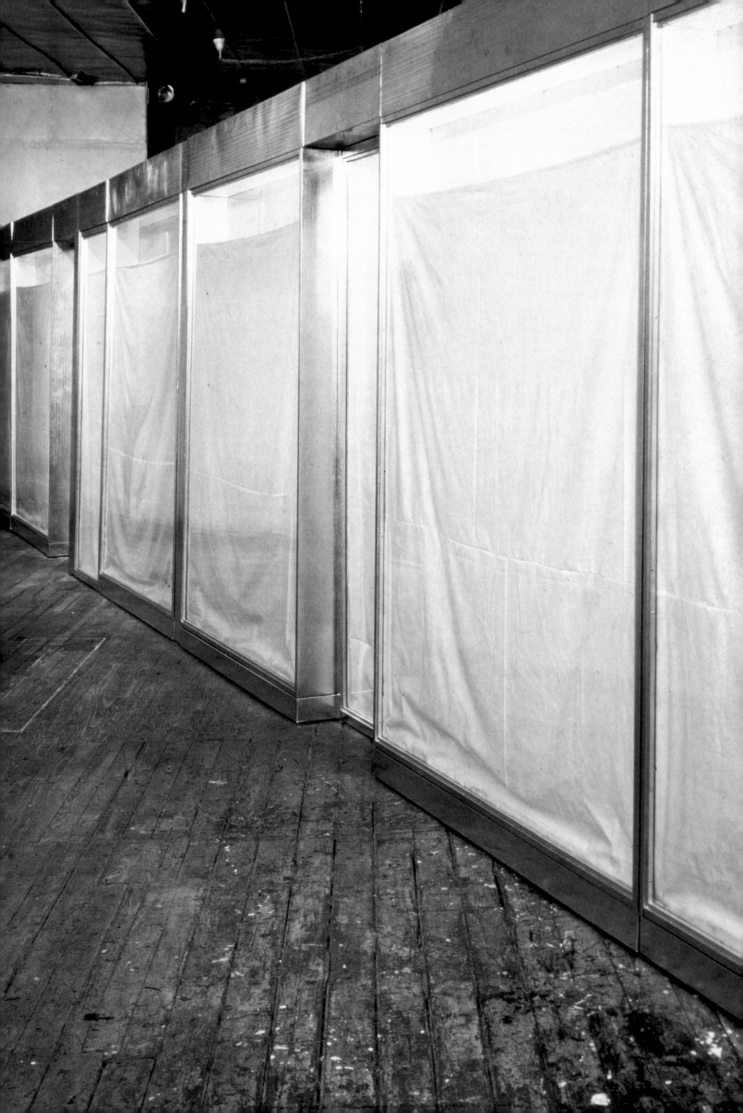

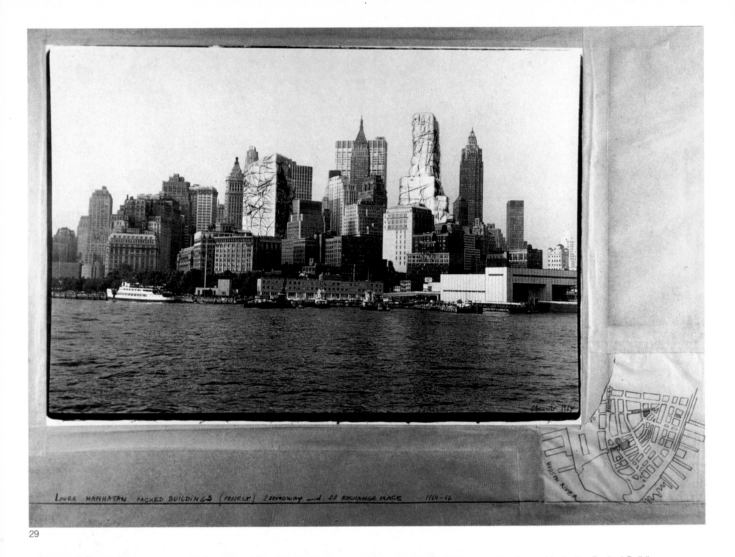

Lower Manhattan Packed Buildings (Project) Zerrowny and 28 Exchange Place — 1964-66

29

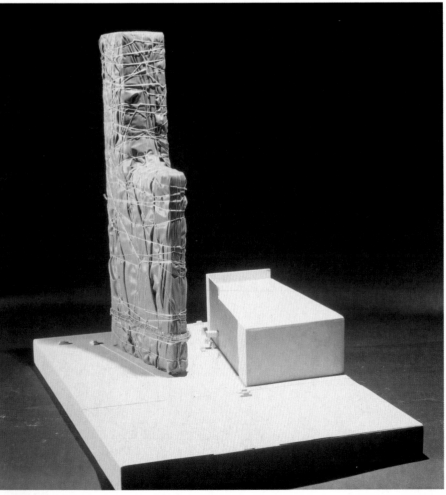

29. **Lower Manhattan Packed Buildings.**
 Project for No. 2 Broadway
 and 20 Exchange Place. 1964-1966.
 Photomontage and drawing:
 collaged photographs, pencil, tracing paper,
 charcoal and tape.
 20½ × 29½ in. (52 × 75 cm).
 Mr. and Mrs. Horace Solomon, New York.
 Photo: Harry Shunk.

30. **Wrapped Building. Project for Allied Chemical**
 Tower, Number One Times Square,
 New York. 1968.
 Scale model: fabric, twine, rope, polyethylene,
 wood and paint.
 27 × 20 × 31 in. (68.6 × 50.8 × 78.5 cm).
 Jeanne-Claude Christo Collection, New York.
 Photo: Eeva-Inkeri.

31. **Wrapped Building. Project for Allied Chemical**
 Tower, Number One Times Square,
 New York. 1968.
 Collaged photographs: pencil, charcoal, crayon,
 tape, map and photographs by Harry Shunk,
 18 × 10 in. (45.7 × 25.4 cm).
 Jeanne-Claude Christo Collection, New York.

30

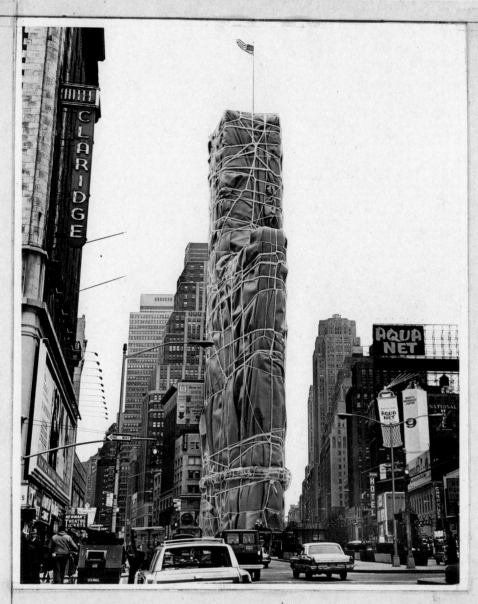

PACKED BUILDING (PROJECT FOR 1 TIMES SQ. ALLIED CHEMICAL TOWER) Christo 1968

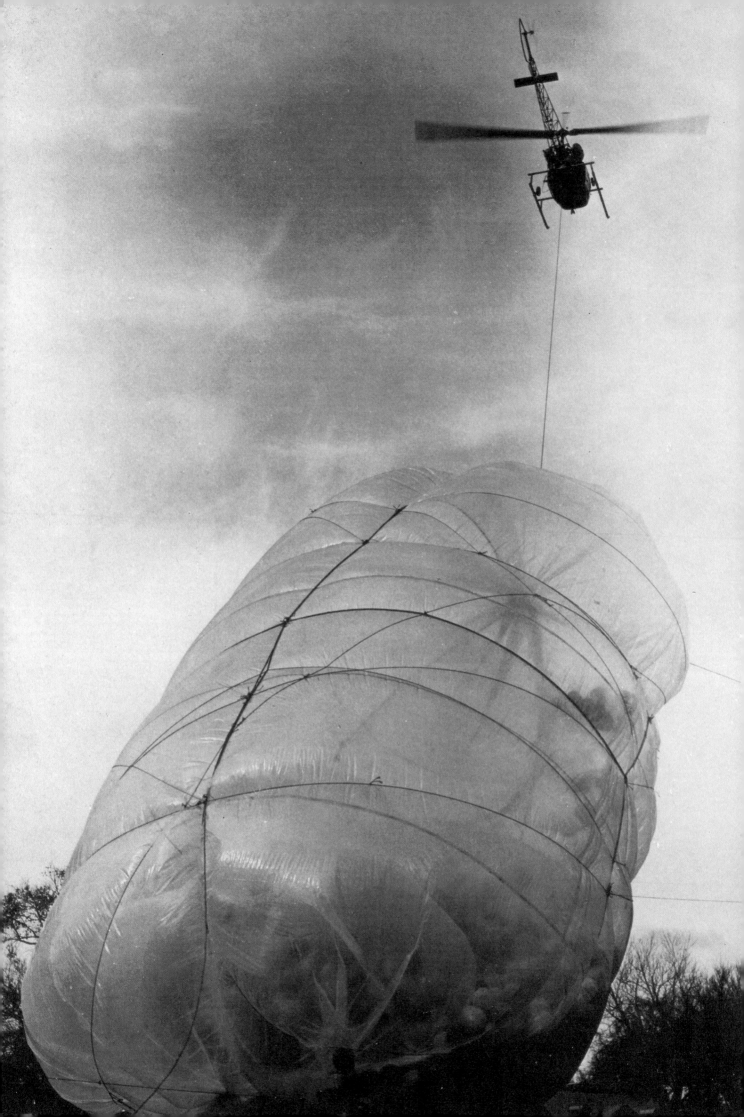

32. **42,390 Cubic Feet Package.** 1966.
 60 ft. by 21 ft. diameter (18.3 × 6.5 m).
 Minneapolis School of Art.
 Photo: Carroll T. Hartwell.

33. **Wrapped Whitney Museum of Modern Art.
 Project for New York.** 1967.
 Scale model: fabric, twine, polyethylene,
 wood and paint,
 18¼ × 19⅛ × 21⅝ in. (46.5 × 48.5 × 54.8 cm).
 Jeanne-Claude Christo Collection, New York.
 Photo: Eeva-Inkeri.

34. **The Museum of Modern Art Wrapped.
 Project for New York.** 1968.
 Collaged photograph (detail).
 The Museum of Modern Art, New York.
 Photo: Harry Shunk.

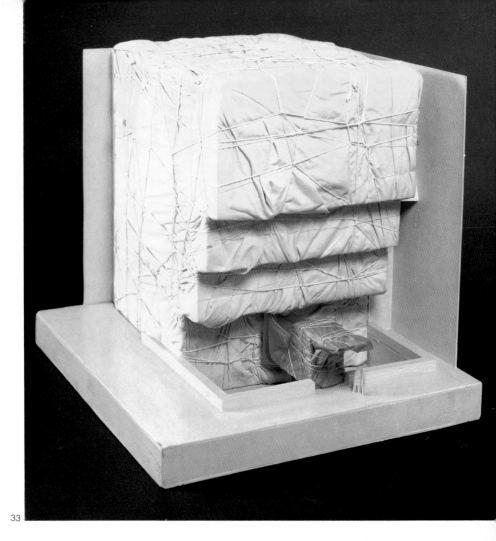

33

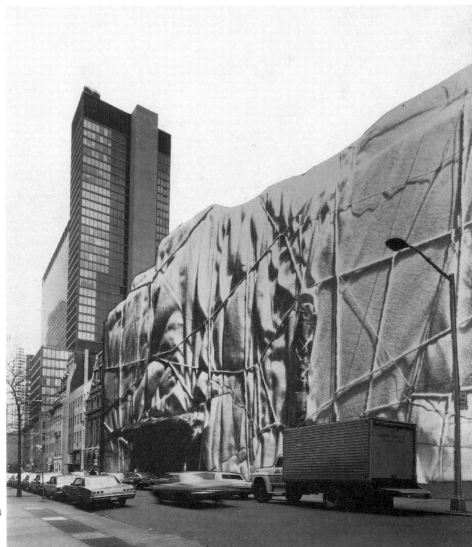

32 34

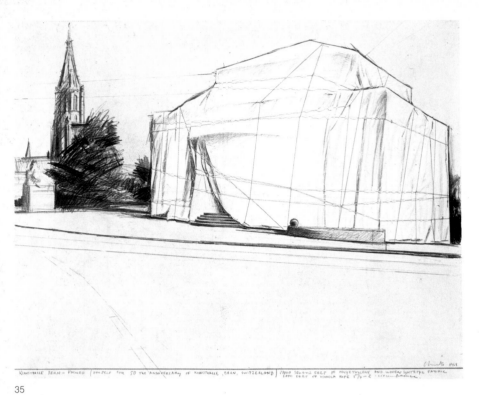

35. Kunsthalle Bern Packed.
Project for the 50th Anniversary
of the Kunsthalle,
Bern, Switzerland. 1968.
Collage: pencil, charcoal,
fabric and twine,
22×28 in. (56×71 cm).
Jeanne-Claude Christo Collection,
New York.
Photo: Eeva-Inkeri.

36 and 37. Wrapped Kunsthalle, Bern,
Switzerland. 1968.
27,000 sq. ft. (2,500 m²)
of synthetic fabric and
10,000 ft. (3,000 m) of rope.
Photo: Thomas Cugini, fig. 37.
Photo: Balz Burkhard, fig. 36.

35

36

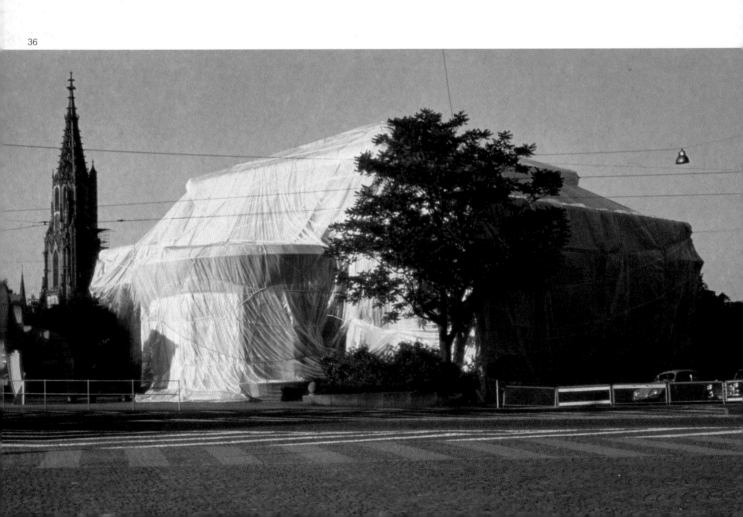

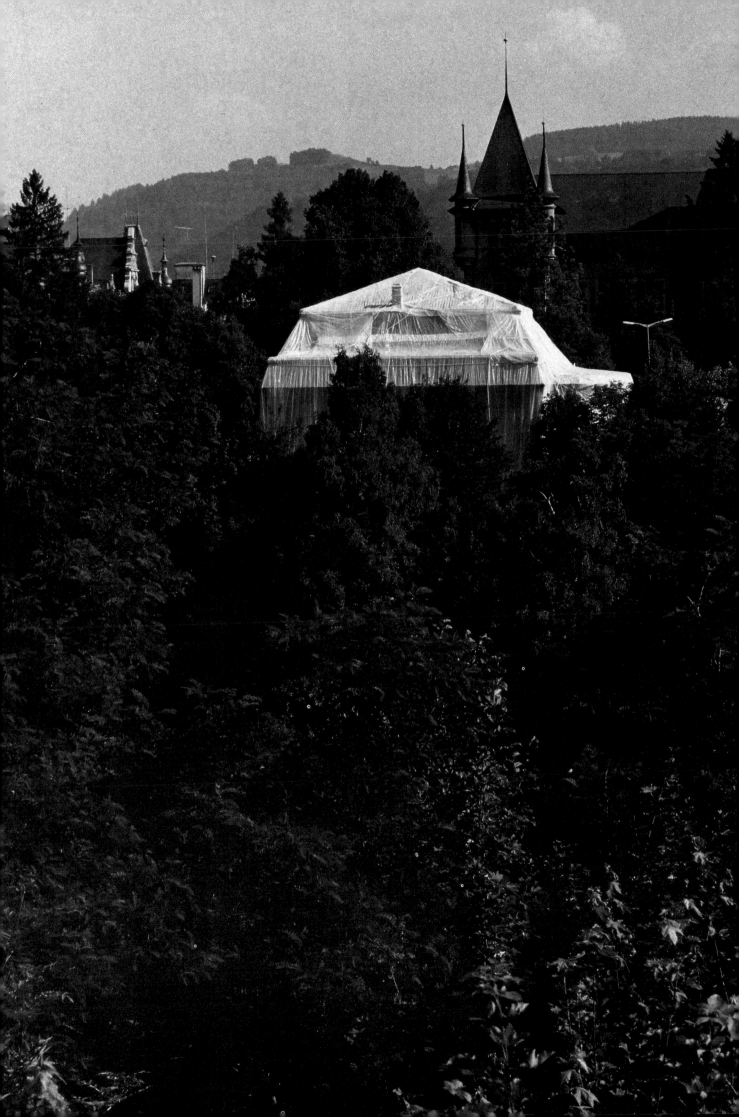

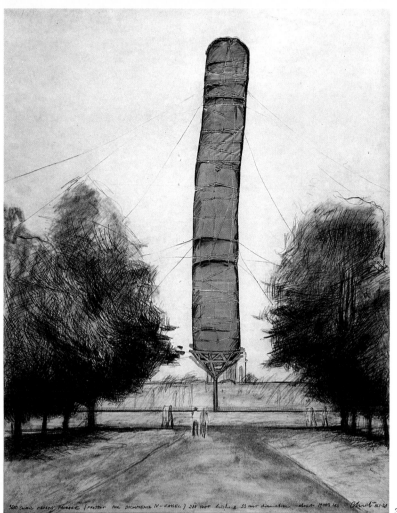

38

38. **5,600 Cubic Meter Package. Project for Documenta IV, Kassel.** 1967-1968.
Collage: plastified fabric, twine, pencil, charcoal, chalk and cardboard,
28 × 22 in. (71 × 56 cm).
Daniel Varenne Collection, Geneva.
Photo: Eeva-Inkeri.

39. **5,600 Cubic Meter Package. Project for Documenta IV, Kassel.** 1968.
Collage: plastified fabric, twine, pencil, bic pen and cardboard,
28 × 22 in. (71 × 56 cm).
Bob Lilja Collection, London.
Photo: Eeva-Inkeri.

40 to 42. **5,600 Cubic Meter Package. Documenta IV, Kassel.** 1967-1968.
(During erection)
Height: 280 ft. (82 m). Diameter: 33 ft. (10 m).
22,000 sq. ft. (2,000 m²) of fabric and 12,000 ft. (3,500 m) of ropes. Weight: 14,000 lbs. (6,000 Kg).
Photos: Klaus Baum.

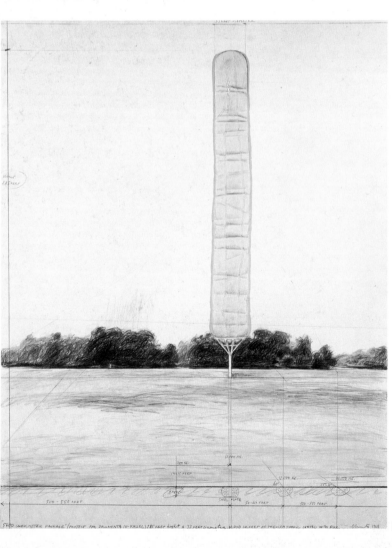

39

40

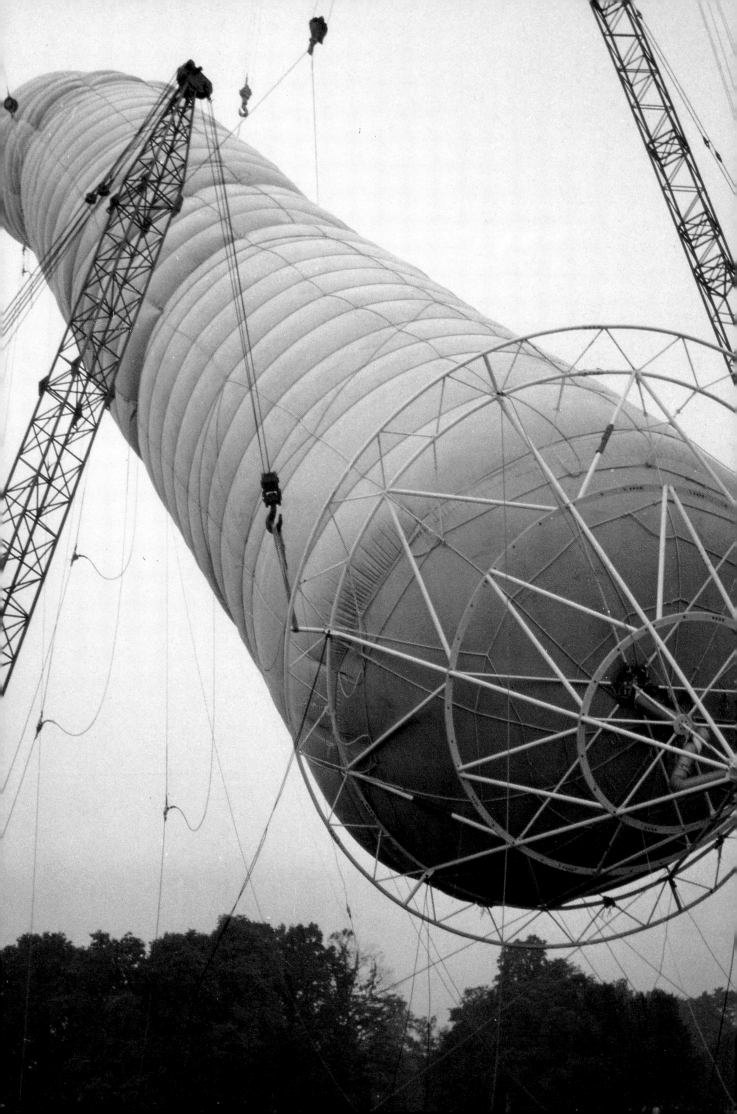

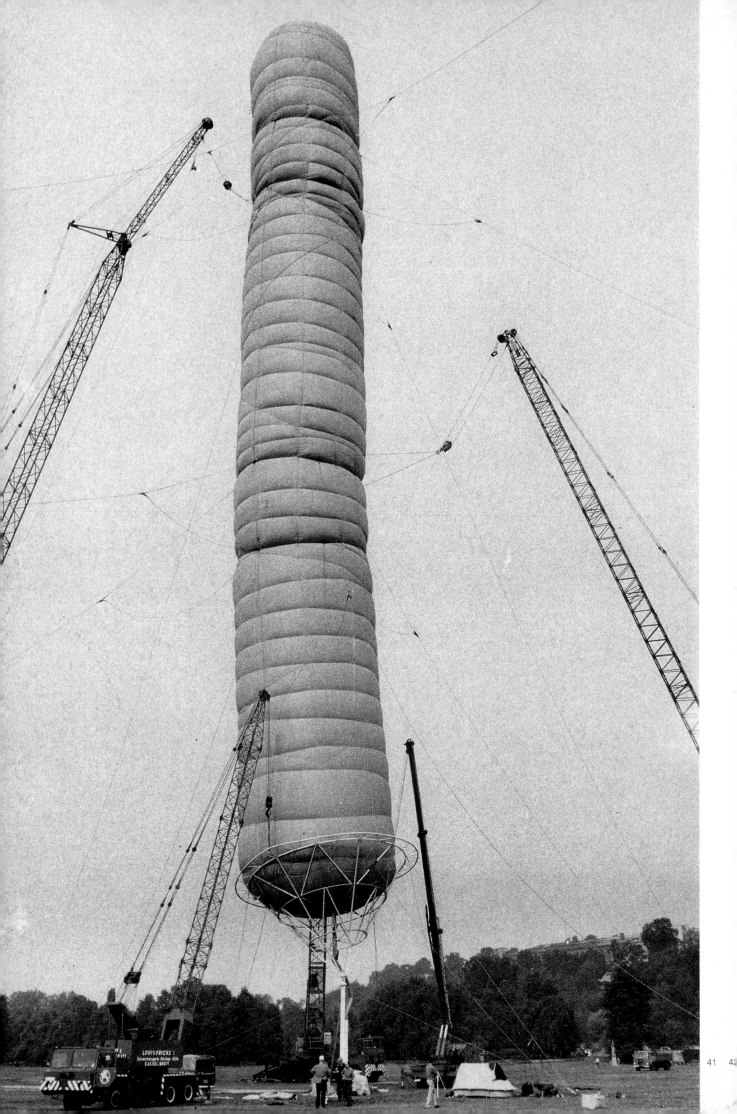

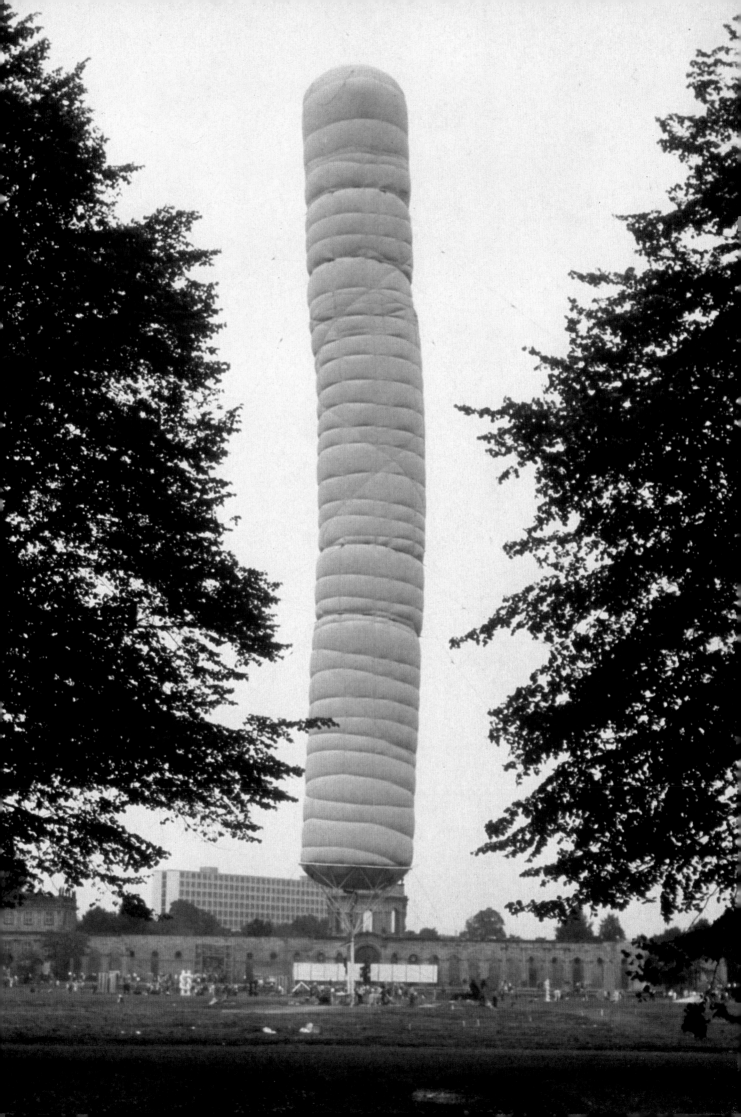

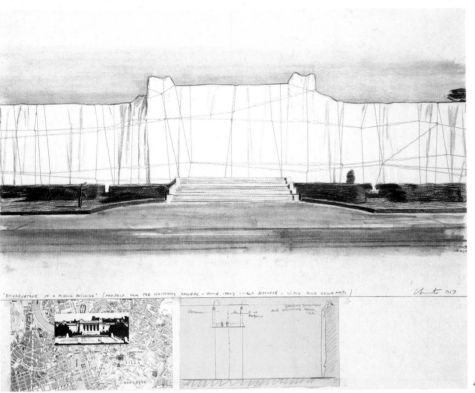

43

43. **Packaged Public Building. Project for the National Gallery, Rome Italy.** 1967.
Collage: fabric, twine, pastel, charcoal, pencil, paper, map and photograph,
22 × 28 in. (56 × 71 cm).
Bob Lilja Collection, London.
Photo: Eeva-Inkeri.

44. **Wrapped Fountain. Project for Festival of the Two Worlds, Spoleto.** 1968.
Collage: pencil, charcoal, fabric, twine, crayon and pastel,
28 × 22 in. (71 × 56 cm).
Bob Lilja Collection, London.
Photo: Eeva-Inkeri.

45. **Wrapped Tower (Detail). Spoleto.** 1968.
Woven polypropylene and rope,
82 × 24 × 24 ft. (25 × 7.3 × 7.3 m).
Photo: Jeanne-Claude.

46. **Packed Fountain. Spoleto.** 1968.
Woven polypropylene and nylon rope,
46 ft. (14 m).
Photo: Jeanne-Claude.

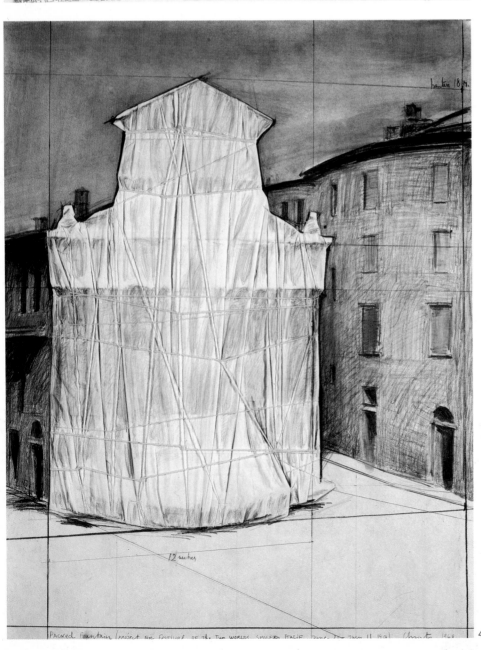

44

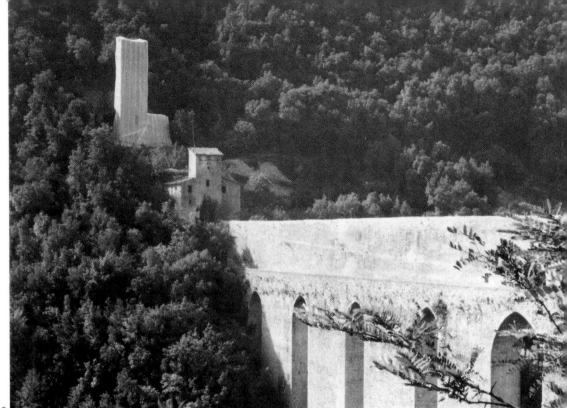

45

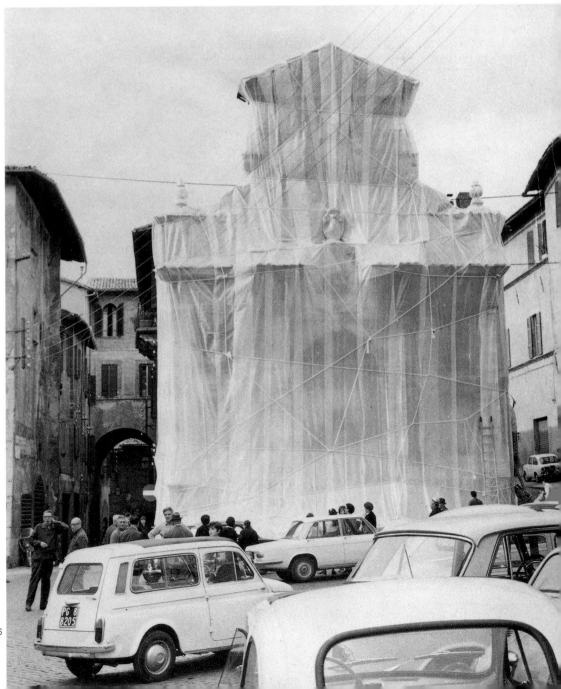

46

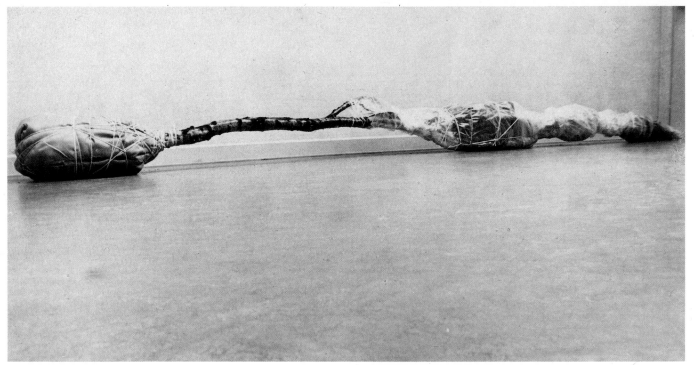

47. **Wrapped Tree.** 1966.
Tree, polyethylene, fabric and rope,
Length: 33 ft. (10 m).
Photo/Collection: Christophe Vowinckel, Cologne.

48. **Three Wrapped Trees. Project for the Museum of Modern Art, New York.** 1968.
Scale model: branches, polyethylene, fabric, twine, wood and paint,
2 × 46 × 21¼ in. (5 × 117 × 54 cm).
Bob Lilja Collection, London.
Photo: Eeva-Inkeri.

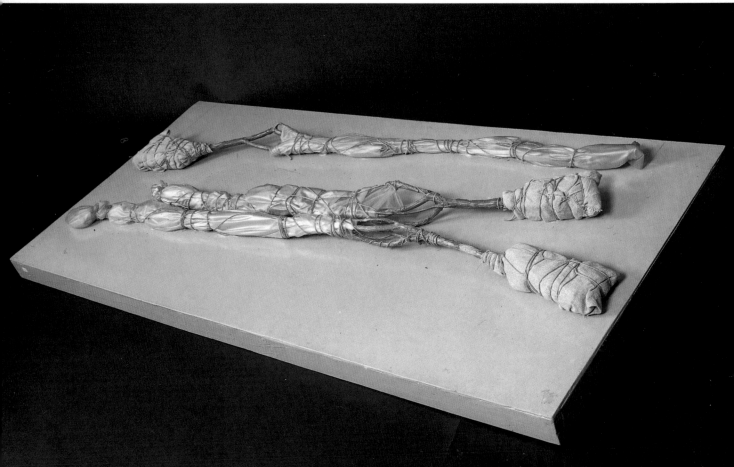

49. **Wrapped Girl. Project for the Institute of Contemporary Art, University of Pennsylvania, Philadelphia.** 1968.
Collage: pastel, charcoal, pencil, polyethylene, crayon, twine, cardboard and rope,
22 × 28 in. (56 × 71 cm).
Bob Lilja Collection, London.
Photo: Eeva-Inkeri.

50. **Wrapped Magazines.** 1963.
Polyethylene, rope, twine, magazines on wooden support,
63 × 19³/₄ in. (160 × 50 × 5 cm).
Private collection, Stockholm.
Photo: Eeva-Inkeri.

51. **Wrapped Woman. Charles Wilp Studio, London.** 1963.
Photo: Anthony Haden-Guest.

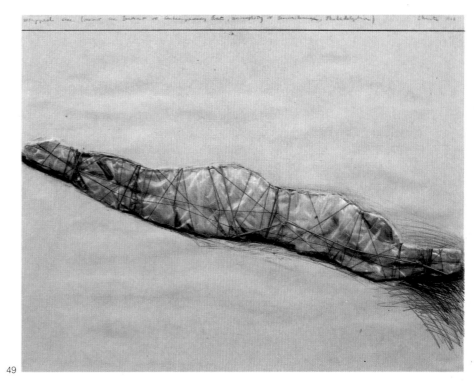

49

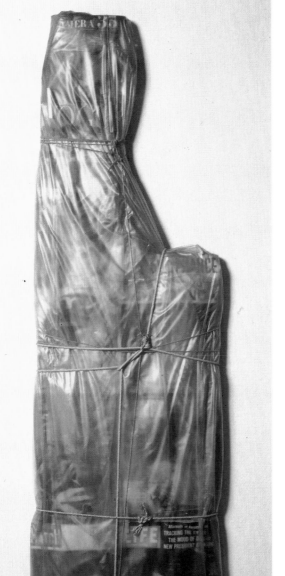

50

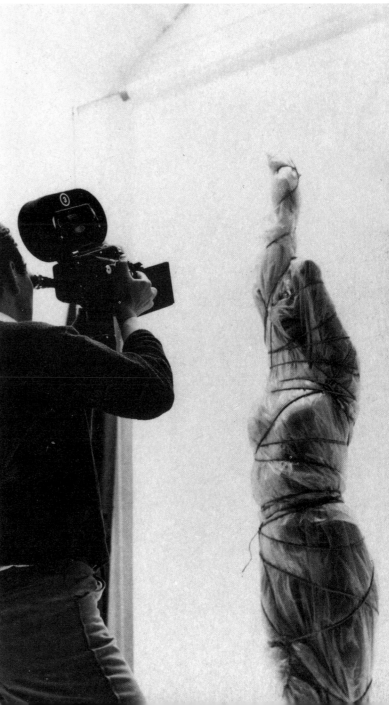

51

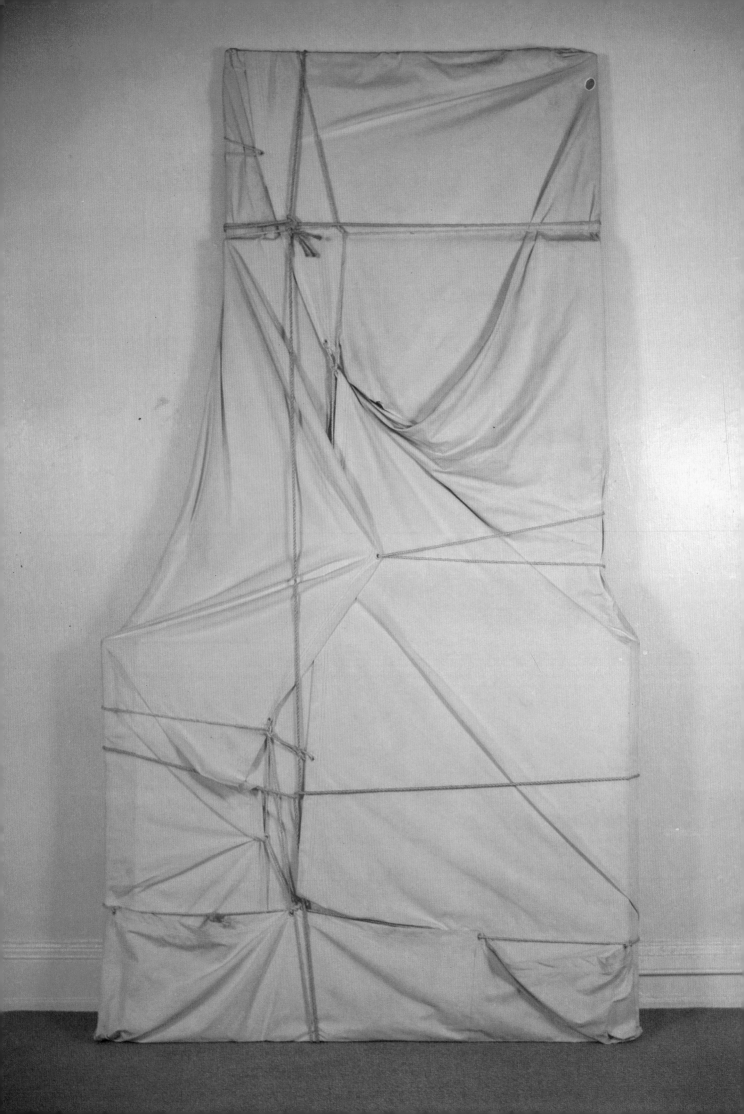

52. **Wrapped Painting.** 1968.
Tarpaulin and rope,
120 × 64 × 7 in. (304.8 × 162.6 × 17.8 cm).
John Kaldor Collection, Sydney.
Photo: Wolfgang Volz.

53. **Wool Bales Wrapped. Project for Keith Murdoch Court, National Gallery of Victoria, Melbourne.** 1969.
Collage: pencil, fabric, twine, cotton, enamel paint and charcoal,
22 × 28 in. (56 × 71 cm).
Jeanne-Claude Christo Collection, New York.
Photo: Eeva-Inkeri.

54. **Package 1969.** 1969.
Wood, tarpaulin and rope,
67½ × 90 × 118 in. (171.5 × 229 × 300 cm).
Jeanne-Claude Christo Collection, New York.
Photo: Eeva-Inkeri.

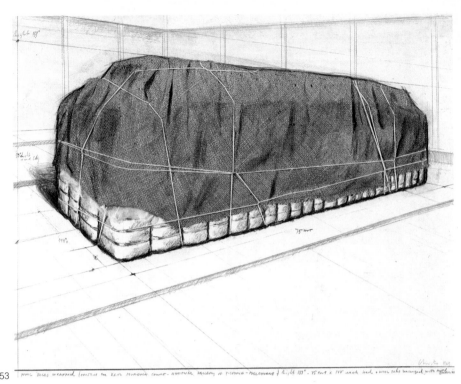

52

53

54

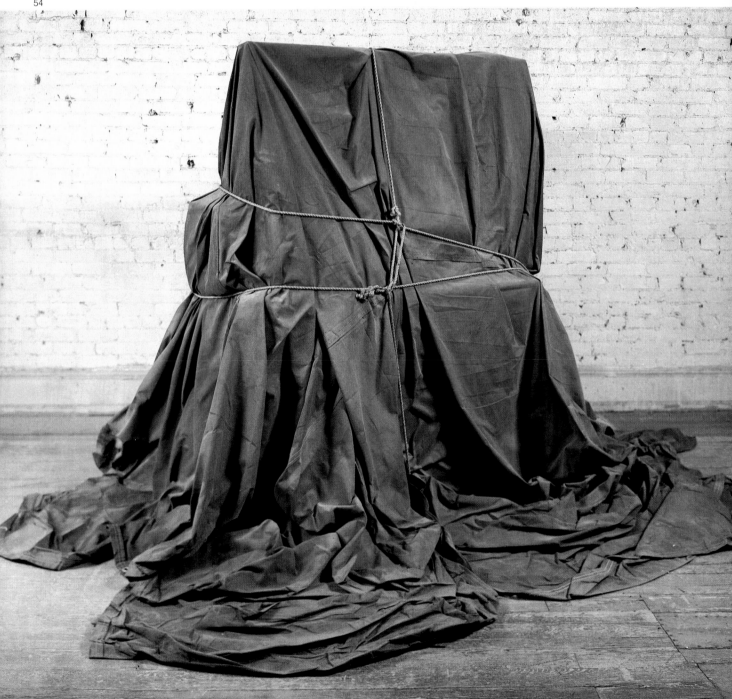

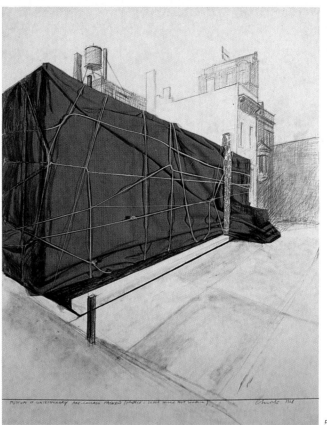

55

55. **Museum of Contemporary Art, Chicago. Wrapped.** 1968.
Collage: pencil, fabric, twine, pastel and polyethylene,
28 × 22 in. (71 × 56 cm).
Jeanne-Claude Christo Collection, New York.
Photo: Eeva-Inkeri.

56. **Wrapped Floor. Project for the Museum of Contemporary
Art, Chicago.** 1968.
Collage: pencil, charcoal, fabric, enamel paint, crayon,
pastel and floor plan,
28 × 22 in. (71 × 56 cm).
The Willi Smith Estate Collection, New York.
Photo: Harry Shunk.

57. **Museum of Contemporary Art, Chicago. Wrapped.** 1969.
10,000 sq. ft. (930 m^2) of tarpaulin and 3,600 ft. (1,100 m)
of rope.
Photo: Harry Shunk.

58. **Wrapped Floor. Museum of Contemporary Art, Chicago.** 1969.
25,000 sq. ft. (2,324 m^2).
Photo: Harry Shunk.

56

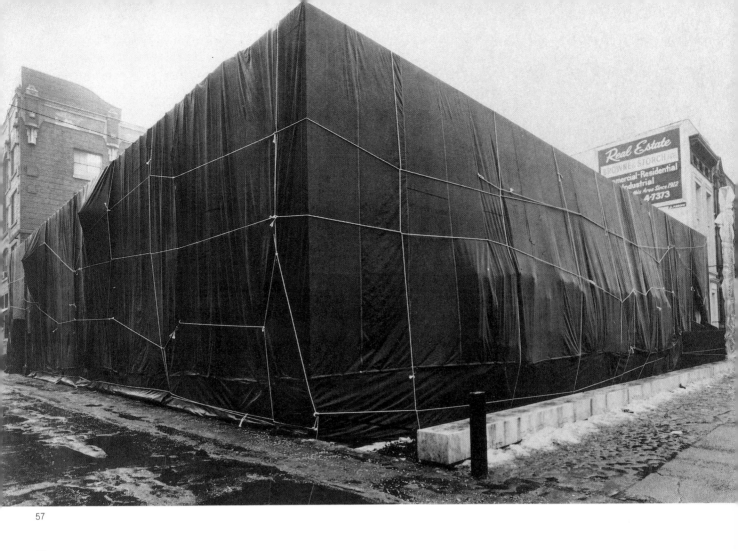

57

58

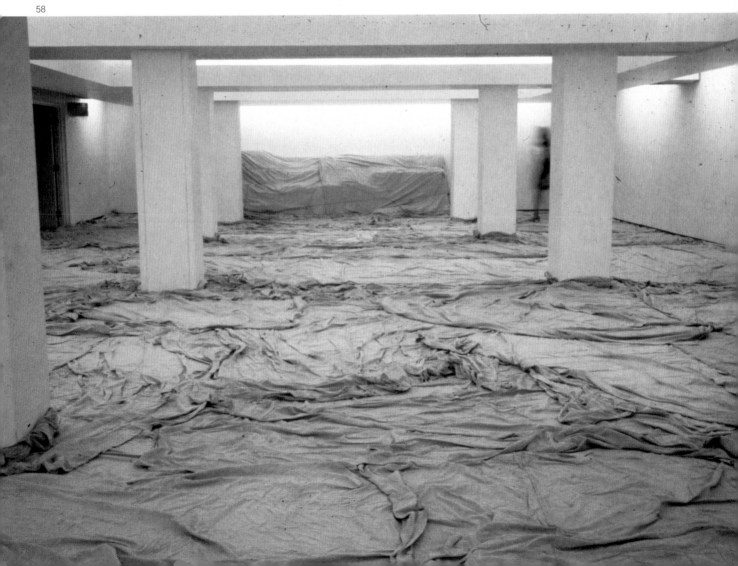

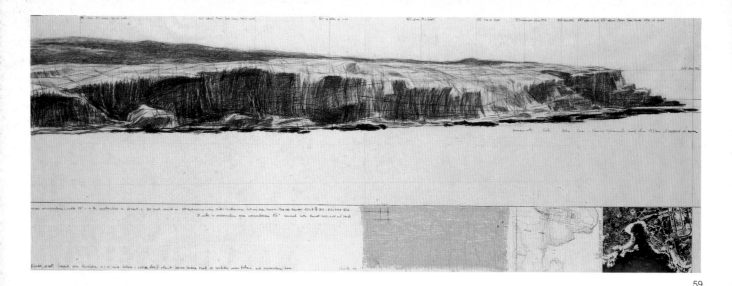

59. **Packed Coast. Project for Little Bay, Australia.** 1969.
Drawing: pencil, crayon, photograph, map and fabric sample,
36 × 96 in. (91 × 244 cm).
Jeanne-Claude Christo Collection, New York.
Photo: Eeva-Inkeri.

60. **Wrapped Coast. Project for Little Bay, Australia.** 1969.
Collage: pencil, fabric, twine, charcoal, crayon, bic pen and
aerial photograph,
28 × 22 in. (71 × 56 cm).
Weston Collection, Toronto, Canada.
Photo: Eeva-Inkeri.

61 to 65. **Wrapped Coast, Little Bay, Australia.** 1969.
(Detail during installation)
1 million sq. ft. (100,000 m²) of erosion control fabric.
35 miles (60 Km) of rope.
Coordinator: John Kaldor.
Photo: Harry Shunk.

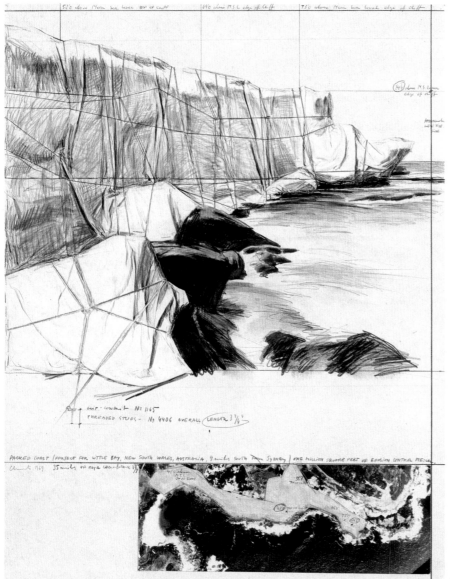

Wrapped Coast, Little Bay, Australia, One Million Square Feet, 1969

Co-ordinator: John Kaldor

Little Bay, property of Prince Hospital, is located 9 miles Southeast of the center of Sydney. The cliff-lined shore area that was wrapped was approximately one and a half miles in length, 150 to 800 feet in width, 85 feet in height at the northern part cliffs, and at sea level at the southern part sandy beach.

One million square feet of Erosion Control Mesh (synthetic woven fiber usually manufactured for argricultural purposes), were used for the Wrapping. 35 miles of Polypropylene rope, 1"1/4 circumference, tied the fabric to the rocks.

Ramset guns fired 25,000 charges of fastenings, threaded studs and clips to secure the rope to the rocks.

Mr. N. Melville, a retired Major in the Army Corps of Engineers, was in charge of the construction site.

17,000 man power hours, over a period of 4 weeks, were executed by: 15 professional Mountain Climbers, 110 Labourers, Students from Sydney University and East Sydney Technical College, as well as some Australian Artists and Teachers.

The project was financed by Christo, through the sale of his drawings and collages.

The Coast remained Wrapped for a period of 10 weeks, then all materials were removed and the site restored to its original condition.

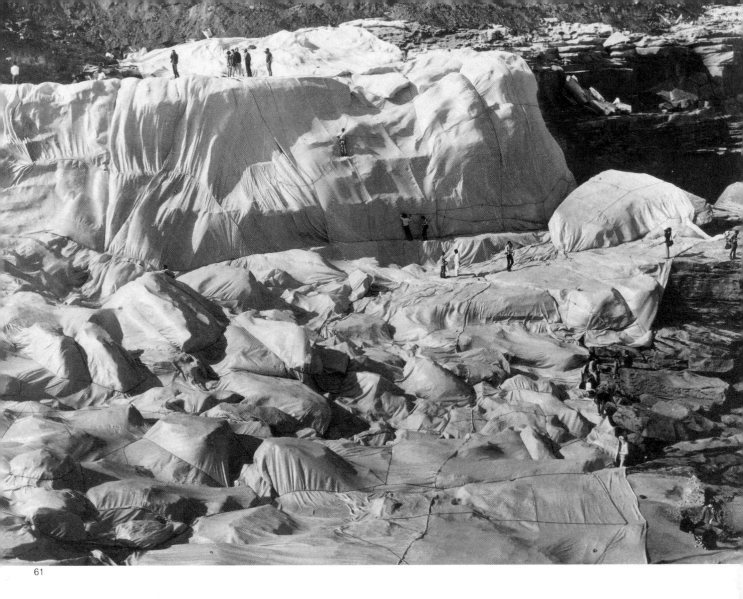

61

62

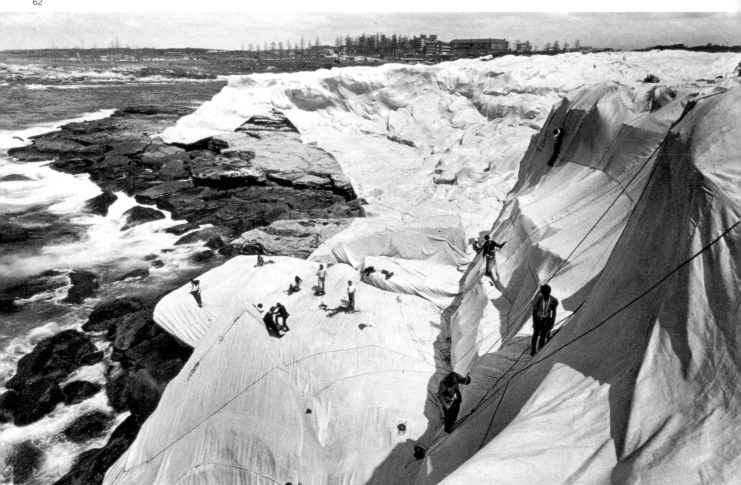

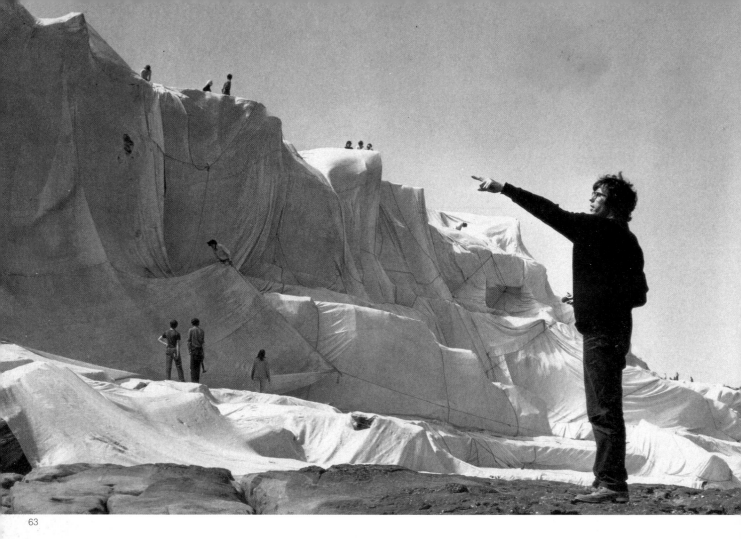

63

64

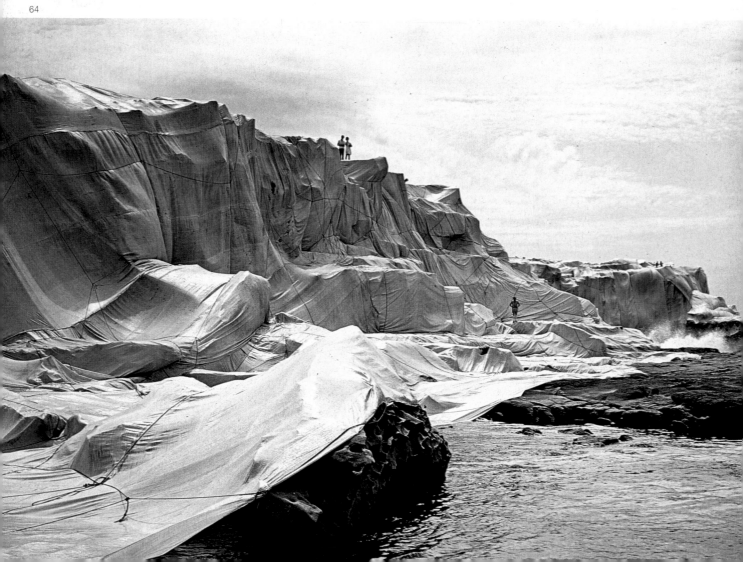

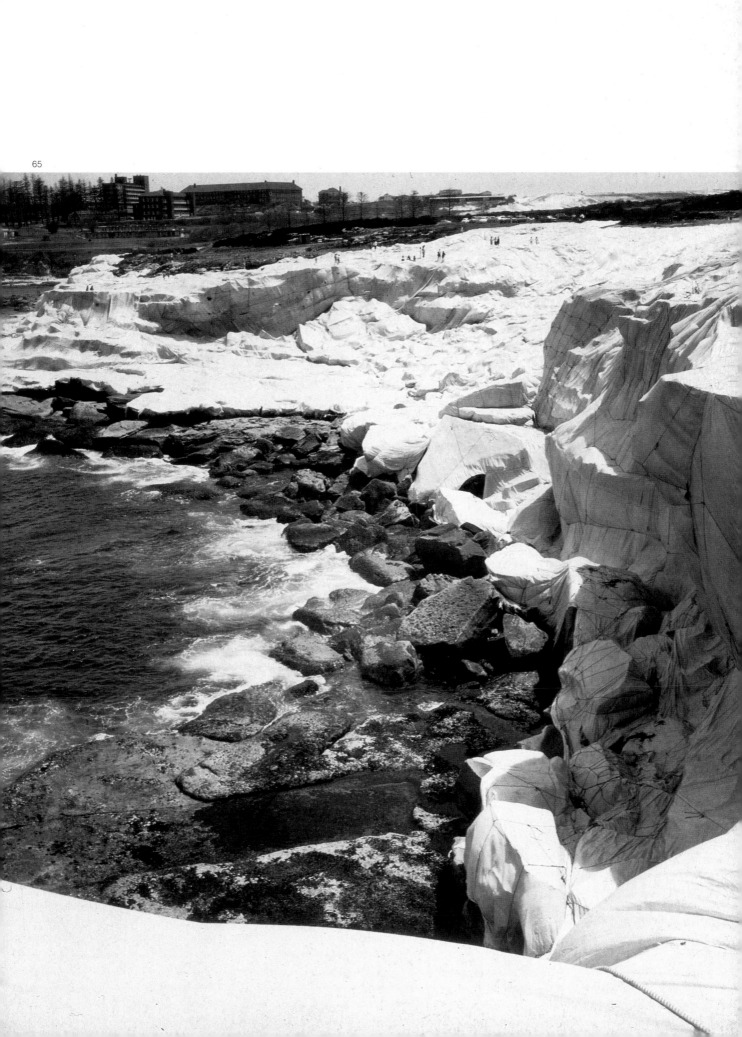

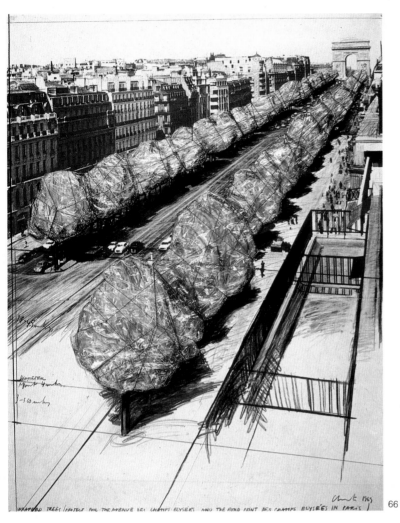

66. **Wrapped Trees. Project for the Avenue des Champs-Elysees, Paris.** 1969.
Collage: pencil, polyethylene, twine, photostat and crayon, 28 × 22 in. (71 × 56 cm).
Private collection, Paris.
Photo: Wolfgang Volz.

67. **Wrapped, Ponte San Angelo. Project for Rome.** 1969.
Collage: pencil, fabric, twine, pastel and crayon, 22 × 28 in. (56 × 77 cm).
Simon and Elsa Bonnier Collection, Philadelphia.
Photo: Eeva Inkeri.

66

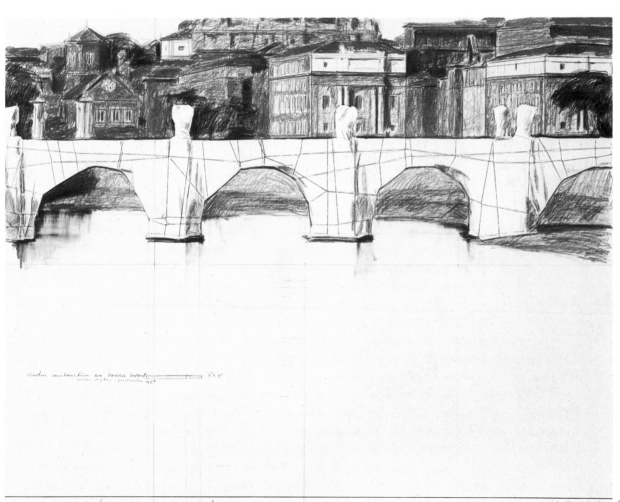

67

68. **Package on Hand Truck.** 1973.
Tarpaulin, handtruck and rope,
52×30×31 in. (132×76×78.8 cm).
Whitney Museum of American Art. Gift of Agnes Gund.
Photo: Eeva-Inkeri.

69. **Wrapped Carozza.** 1971.
Horse carriage, fabric and rope,
10×4×16 ft. (305×122×488 cm).
Collection/photo: Annibale Berlingieri, Milan.
Photo: Guido Le Noci.

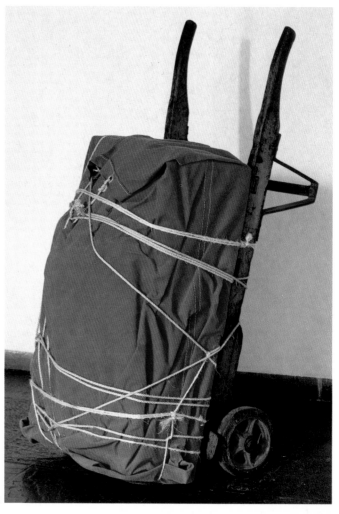

68

69

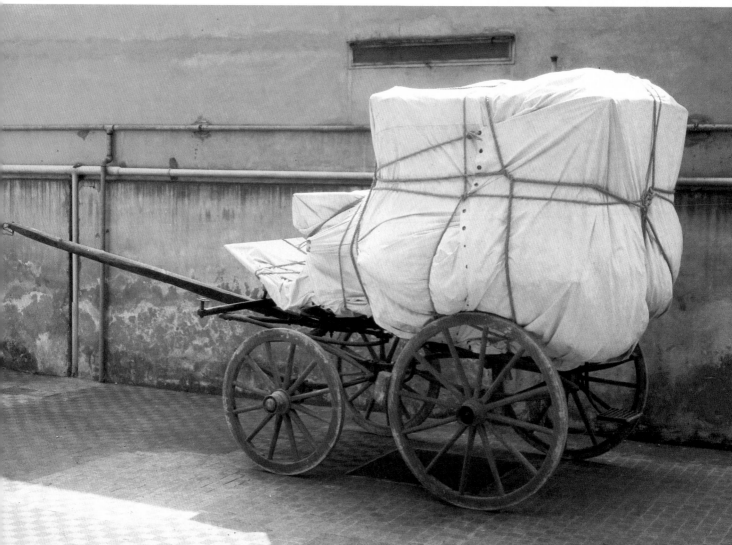

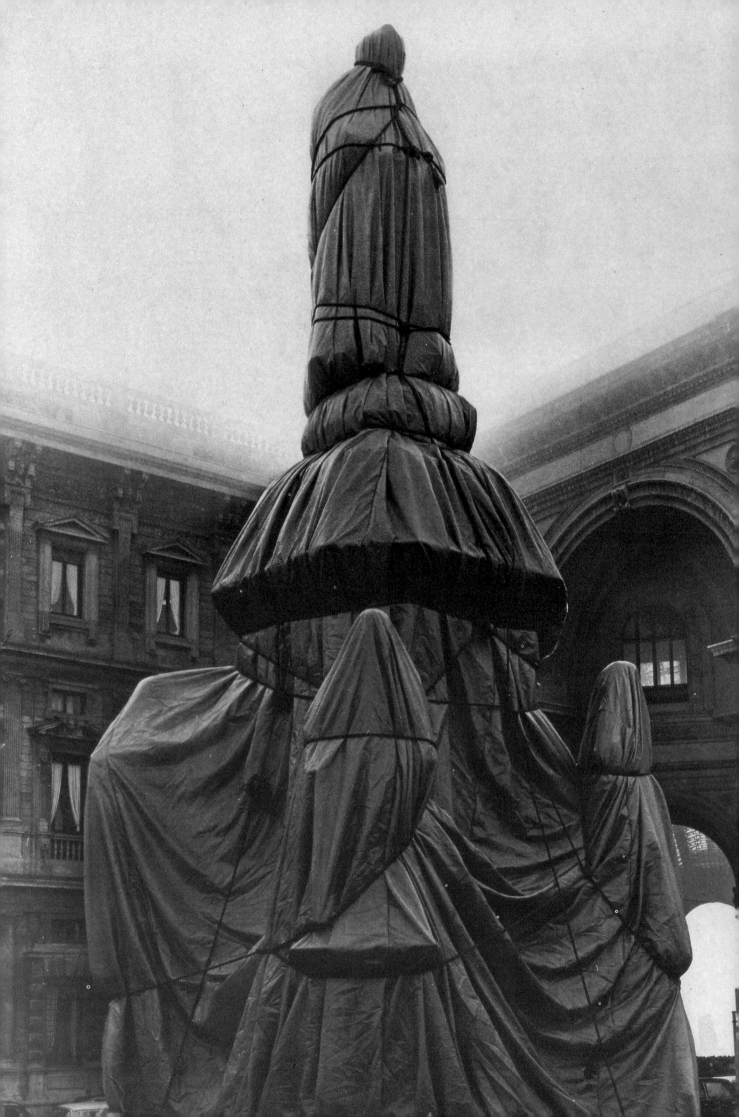

70. **Wrapped Monument to Leonardo, Piazza Scala, Milan.** 1970.
Woven synthetic fabric and rope.
Photo: Harry Shunk.

71. **Wrapped Monument to Vittorio Emanuele. Project for Milan.** 1970.
Collage: pencil, charcoal, fabric, twine, pastel, crayon, photostat and map,
28 × 22 in. (71 × 56 cm).
Jeanne-Claude Christo Collection, New York.
Photo: Eeva-Inkeri.

72. **Wrapped Monument to Vittorio Emanuele, Piazza Duomo, Milan.** 1970.
Woven synthetic fabric and rope.
Photo: Harry Shunk.

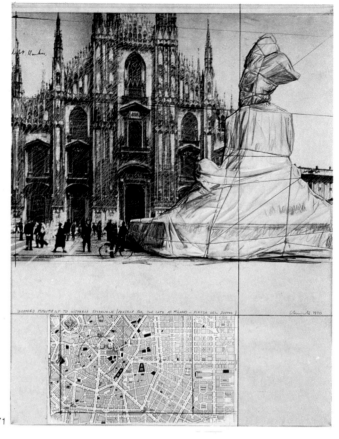

71

0

72

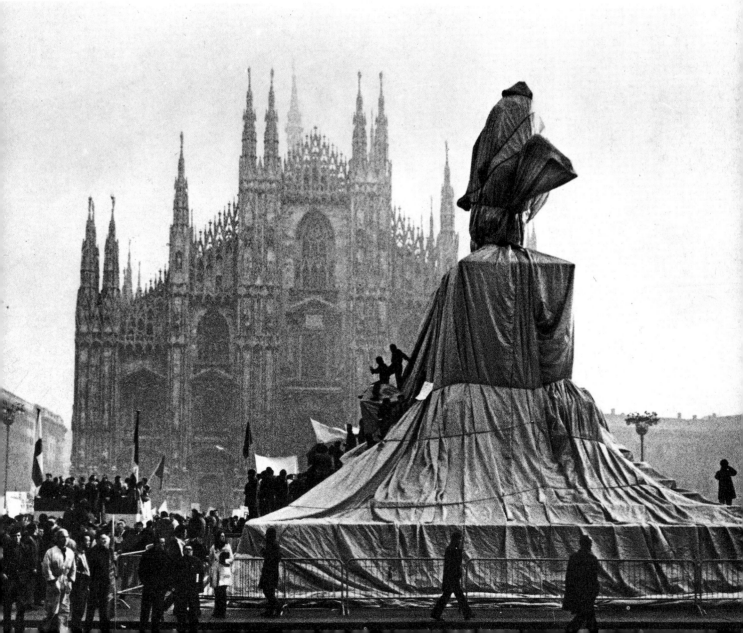

Valley Curtain, Rifle, Colorado, 1970-1972

On August 10, 1972, in Rifle, Colorado, at 11 a.m., a group of 35 construction workers and 64 temporary helpers, art schools, college students, and itinerant art workers tied down the last of 27 ropes that secured the 200,000 square feet of woven nylon fabric orange Curtain to its moorings at Rifle Gap, 7 miles north of Rifle, on Highway 325.

Valley Curtain was designed by Unipolycon of Lynn, Massachusetts, and Ken R. White Company of Denver, Colorado. It was built by A & H Builders Inc. of Boulder, Colorado, under the site supervision of Henry B. Leininger.

By suspending the Curtain at a width of 1,313 feet and a height curving from 365 feet at each end to 182 feet at the center, the Curtain remained clear of the slopes and the Valley bottom. A 10 feet skirt attached to the Curtain visually completed the area between the thimbles and the ground.

An outer cocoon was put around the fully fitted Curtain for protection during transit and at the time of its raising into position and securing to the 11 cable clamps connections at the 4 main upper cables.

An inner cocoon, integral to the Curtain, provided added insurance. The bottom of the Curtain was laced to a 3 inch diameter dacron rope from which control and tie-down lines ran to the 27 anchors.

Valley Curtain project took 28 months to complete.

The project was financed by Christo.

On August 11, 28 hours after completion of the Valley Curtain, a gale estimated in excess of 60 mph. made it necessary to start the removal.

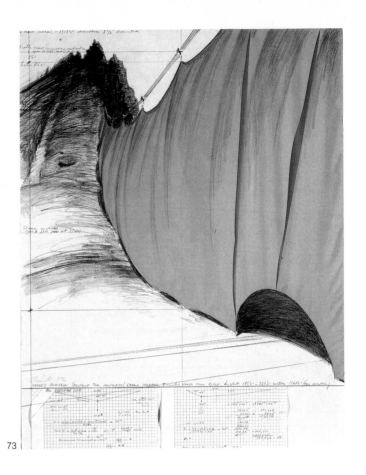

73

73. **Valley Curtain. Project for Rifle, Colorado.** 1972.
Collage: pencil, fabric, crayon, pastel, technical data and bic pen, 28 × 22 in. (71 × 56 cm).
Jeanne-Claude Christo Collection, New York.
Photo: Eeva-Inkeri.

74

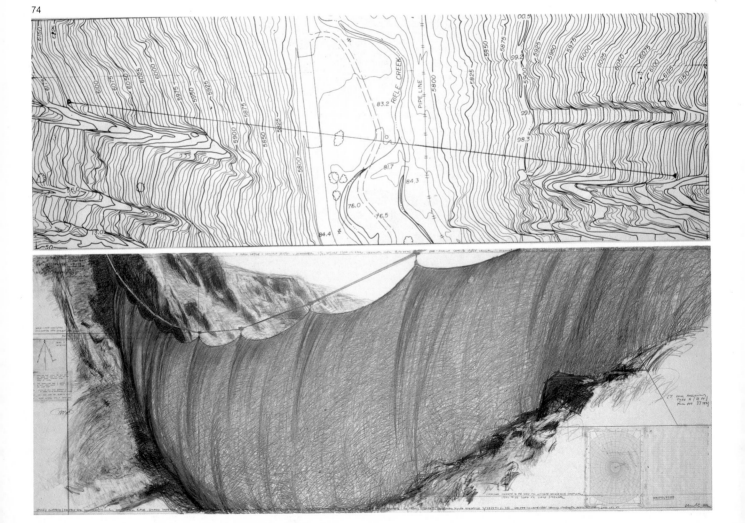

74. **Valley Curtain. Project for Rifle, Colorado.** 1972.
Drawing in 2 parts: crayon, pencil, bic pen, graph paper,
charcoal, map and technical data,
32 × 96 in. (81.3 × 244 cm), 36 × 96 in. (91.4 × 244 cm).
Judy Robins Collection, Denver.
Photo: Eeva-Inkeri.

75. **Valley Curtain. Project for Rifle, Colorado.** 1972.
Collage: fabric, pastel, pencil, crayon, photostat from a
photograph by Harry Shunk, fabric sample and technical data,
28 × 22 in. (71 × 56 cm).
Katarina Quant Collection, Beverly Hills.

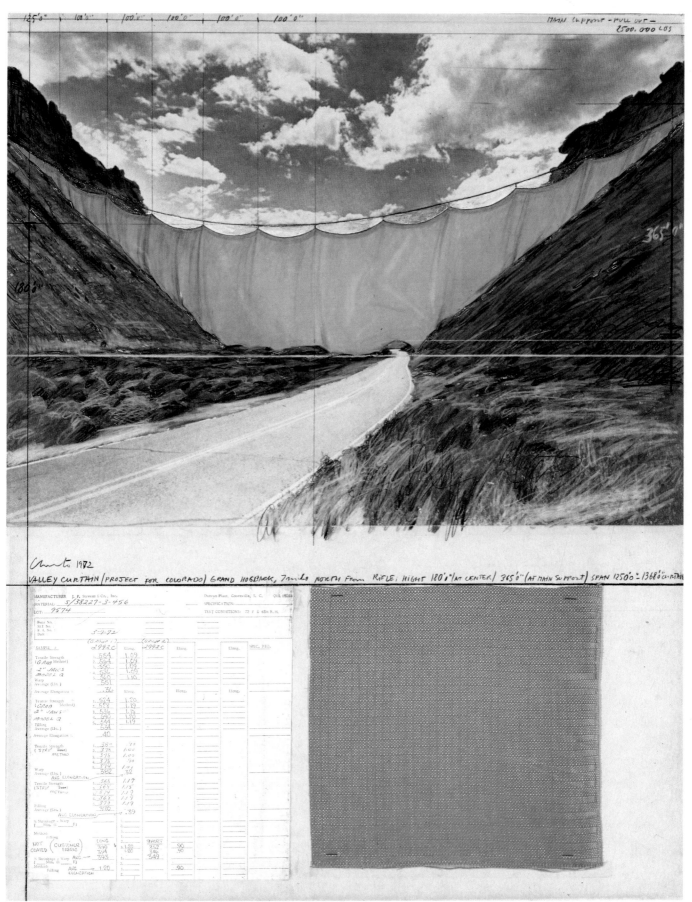

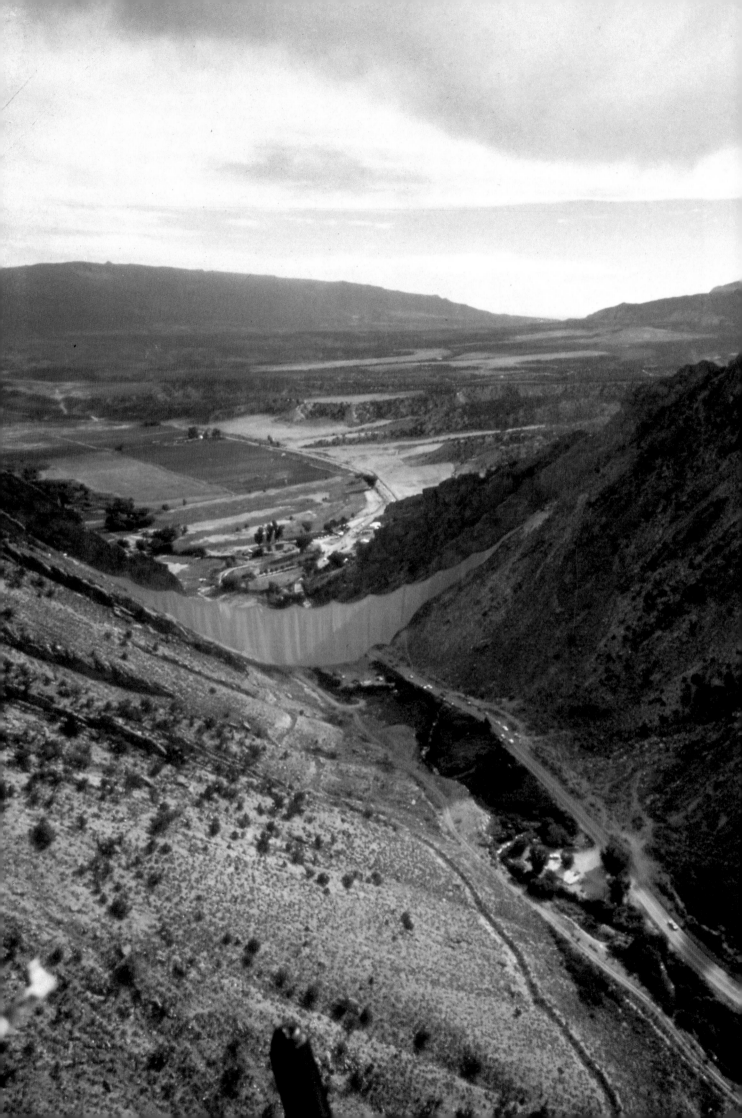

76 to 81. **Valley Curtain. Grand Hogback, Rifle, Colorado.**
1970-1972.
Span: 1,250 ft. (394 m). Height: 185-365 ft. (56-111 m).
200,000 sq. ft. (18,500 m²) of nylon polyamide fabric.
110,000 lbs. (49,500 Kg) of steel cables.
Project Director: Jan van der Marck.
Photos: Harry Shunk.

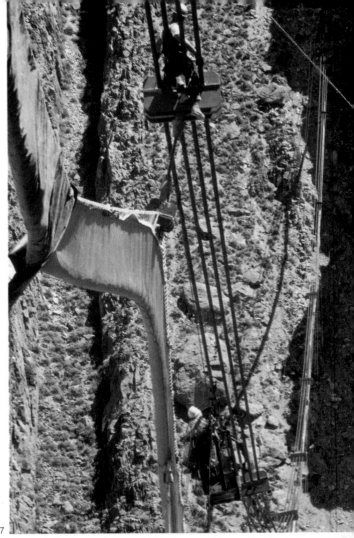

76

77

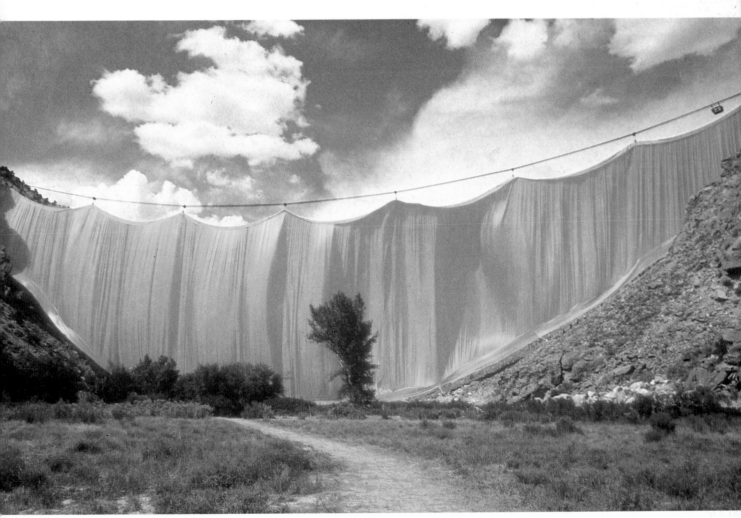

78

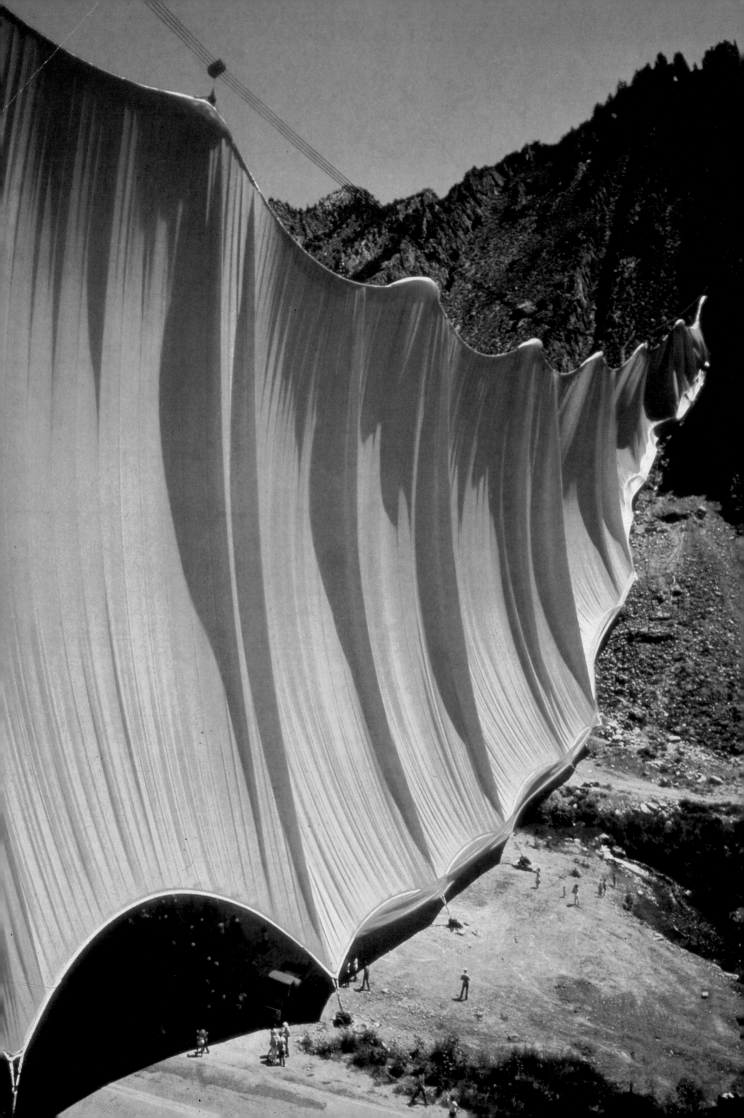

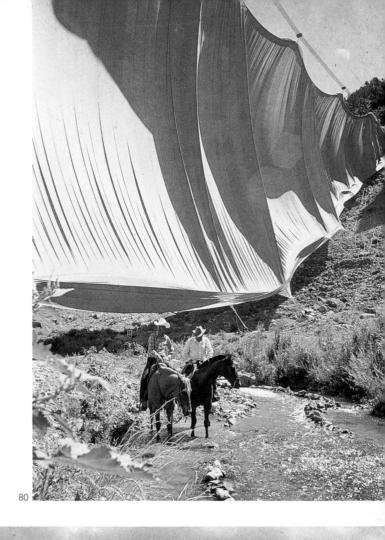

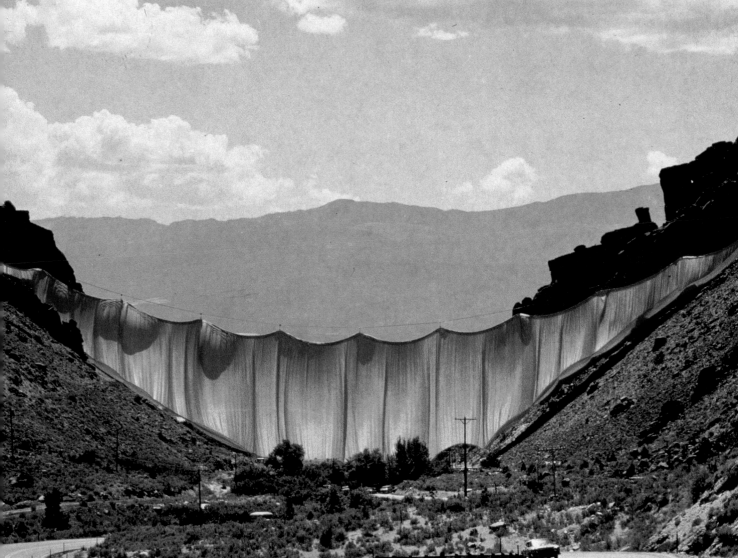

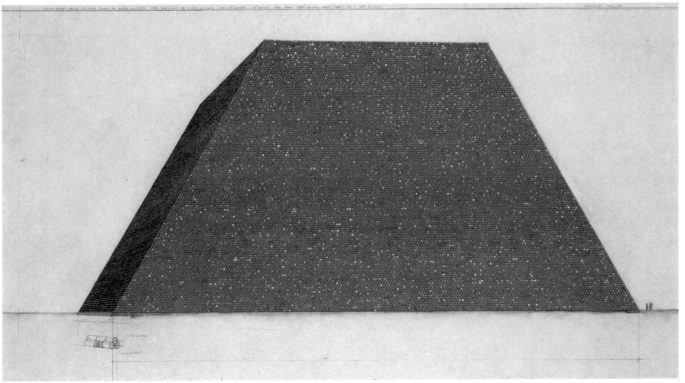

82

83

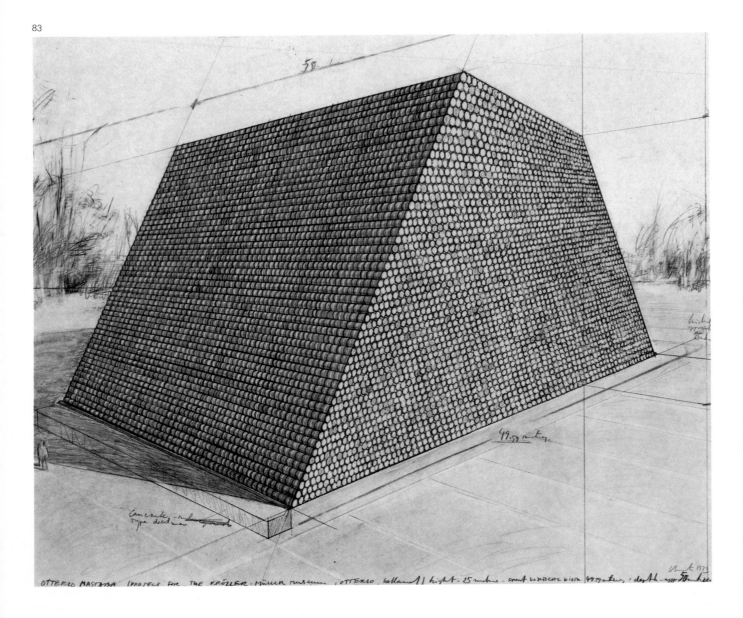

OTTERLO MASTABA (PROJECT FOR THE KRÖLLER-MÜLLER MUSEUM, OTTERLO, HOLLAND) height 25 metre - front vertical width 49.59 metre, depth 50 metre

82. **Houston Mastaba. Project for Houston-Galveston Area, Texas.** 1969-1970.
Drawing: pencil, charcoal, crayon and pastel,
36¼ × 65 in. (92.1 × 165 cm).
Jeanne-Claude Christo Collection, New York.
Photo: Eeva-Inkeri.

83. **Otterlo Mastaba. Project for the Kröller Müller Museum, Otterlo.** 1973.
Drawing: pencil, charcoal, crayon and enamel paint,
22 × 28 in. (56 × 71 cm).
Jeanne-Claude Christo Collection, New York.
Photo: Eeva-Inkeri.

84. **Otterlo Mastaba. Project for the Kröller Müller Museum, Otterlo.** 1975.
Drawing: pastel, charcoal, pencil, enamel paint and crayon on cardboard,
14 × 17 in. (35.6 × 43.2 cm).
Graham Gund Collection, Boston.
Photo: Greg Heins.

85. **1,566 Oil Drums. Project for I.C.A., Philadelphia.** 1968.
Drawing: pencil, charcoal, enamel paint, crayon on cardboard,
22 × 28 in. (56 × 71 cm).
Lousie Ferrari Collection, Corpus Christi.
Photo: Harry Shunk.

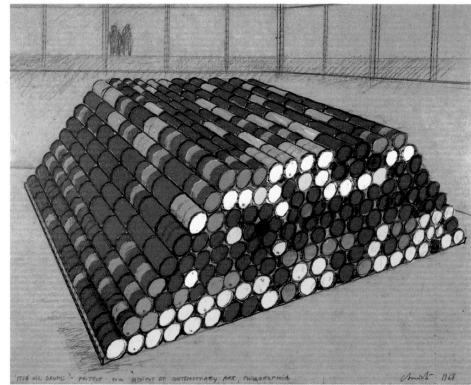

84

85

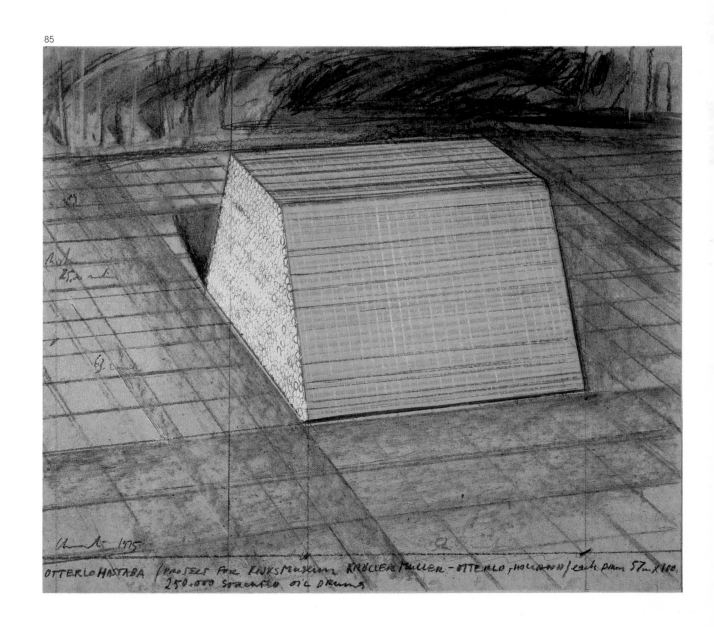

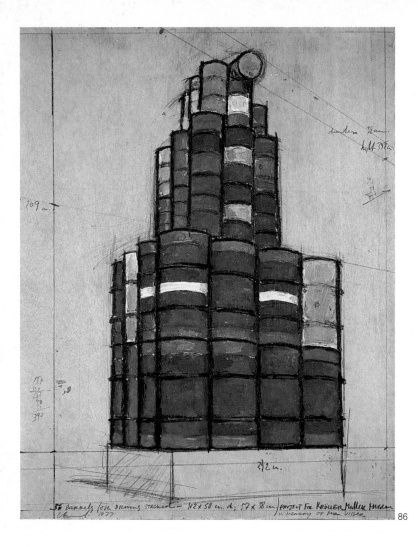

86

86. **56 Stacked Oil Barrels. Project for the Kröller Müller Museum, Otterlo, in Memory of Mia Visser. 1977.** Drawing: enamel paint, photostat, pencil and charcoal, 28 × 22 in. (71 × 56 cm). Rijks Museum, Kröller Müller, Otterlo. Photo: Eeva-Inkeri.

87. **56 Stacked Oil Barrels. Project for the Kröller Müller Museum, Otterlo, in Memory of Mia Visser. 1977.** Drawing: enamel paint, pencil, crayons and charcoal on wood, 28 × 22 in. (71 × 56 cm). Rijks Museum, Kröller Müller, Otterlo. Photo: Eeva-Inkeri.

88. **56 Oil Barrels. 1966-1967.** 15½ × 8 × 8 ft. (465 × 240 × 240 cm). Rijks Museum, Kröller Müller, Otterlo. Donated by Martin and Mia Visser. Photo: Eeva-Inkeri.

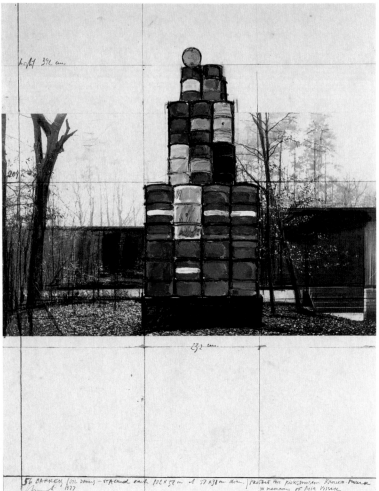

87

8

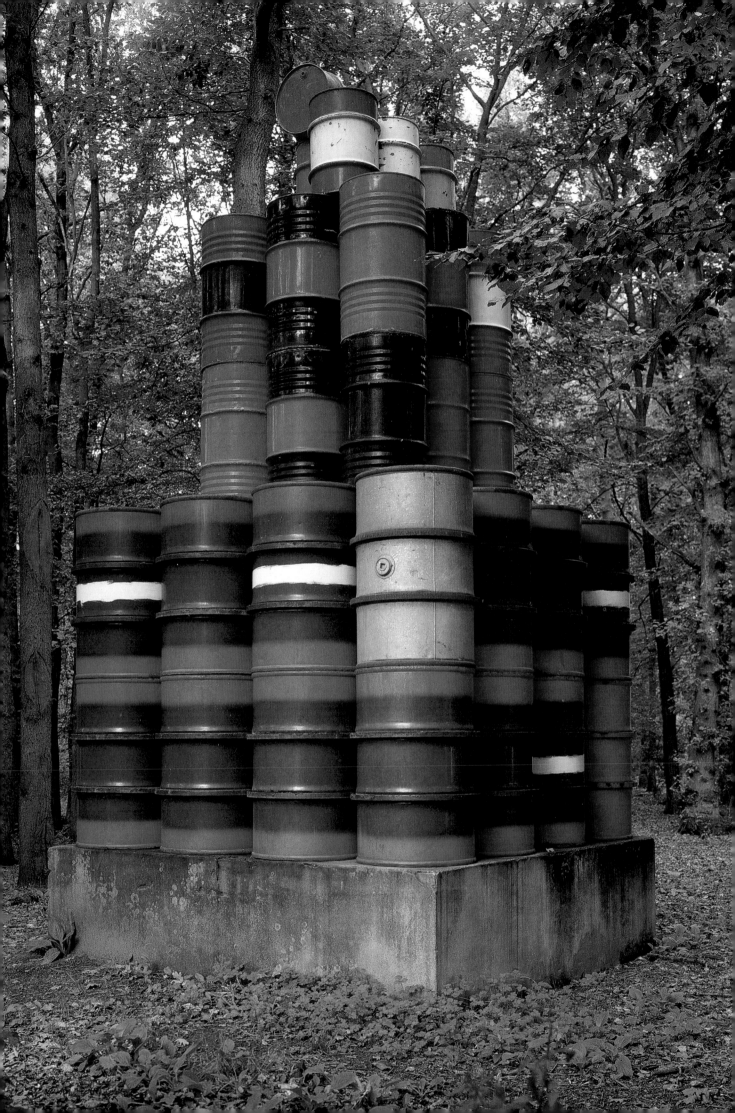

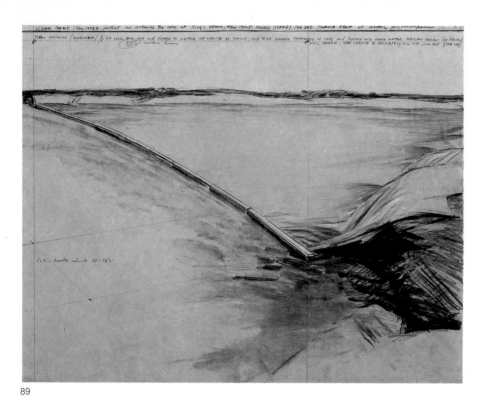

Ocean Front, Newport, Rhode Island, 1974

Width: 420 feet.
Length: 320 feet.

For a period of eight days, 150,000 square feet of white woven polypropylene fabric covered the surface of the water of a half-moon shaped cove at King's Beach, located on the southern exposure of Ocean Drive, facing that portion of the Long Island Sound that meets the Atlantic.

The Ocean Front project was financed by Christo. Unipolycon engineers Mitko Zagoroff and Jim Fuller designed the project and supervised its construction for Christo.

Work began at 6:00 a.m. on Monday, August 19, 1984. The bundled fabric was passed from the truck to pairs of helpers, wearing life jackets. They carried the 6,000-pound load of fabric to the water on two-by-fours stretched between them. The fabric was laced to a 420-foot-long wooden boom, secured with twelve Danforth anchors, holding in place the frontal edge of the floating fabric. Forty-two rebar stakes were driven into the shoreline rocks to secure the inland edges of the fabric that extended to the beach and rocks.

Installation time: 8 hours.

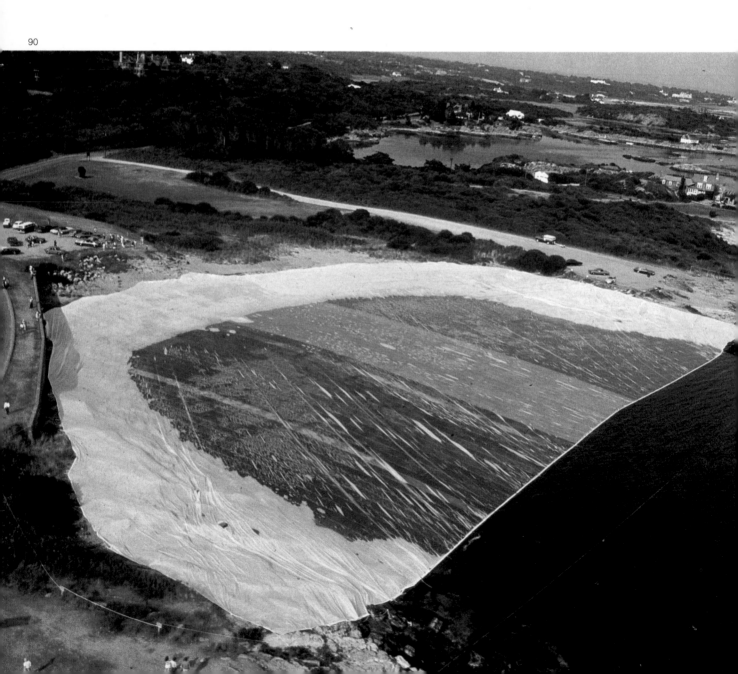

89. Ocean Front, Bay Cover. Project for King's Beach, Newport, Rhode Island. 1974.
Collage: fabric, pencil, charcoal, crayon and cardboard, 22 × 28 in. (56 × 71 cm).
Bob Lilja Collection, London.
Photo: Eeva-Inkeri.

90. Ocean Front. Newport, Rhode Island. 1974.
150.000 sq. ft. (13,934 m^2) of polypropylene, width: 420 ft. (128 m), length: 320 ft. (97.5 m).
Photo: Gianfranco Gorgoni.

91. Wrapped Floors. Project for Haus Lange Museum, Krefeld. 1971.
Collage: pencil, charcoal, crayon, pastel, brown paper and fabric,
28 × 22 in. (71 × 56 cm).
Judith Maysles Collection, New York.
Photo: Eeva-Inkeri.

92. Wrapped Floors. Haus Lange Museum, Krefeld. 1971.
1,687 sq. ft. (150 m^2) of drop cloth on the floors, brown paper on the windows.
Photo: Wolfgang Volz.

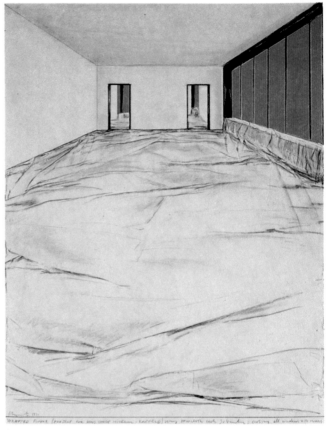

91

92

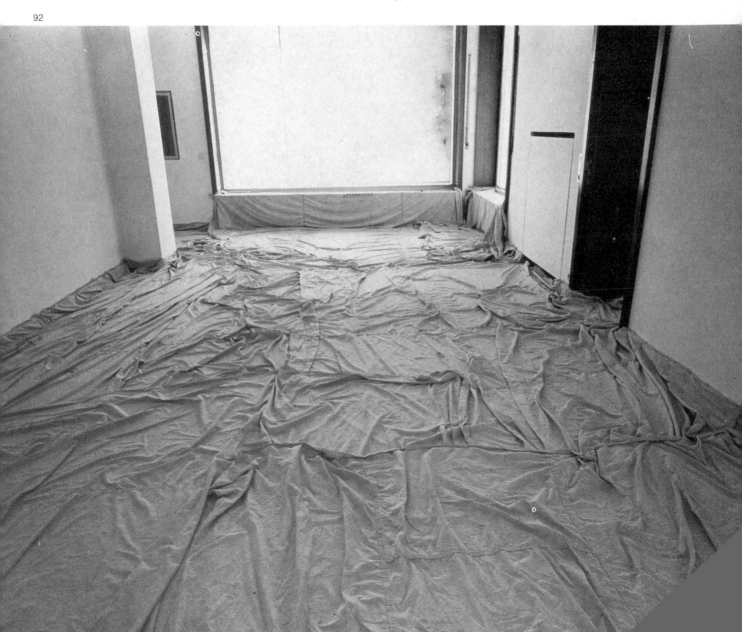

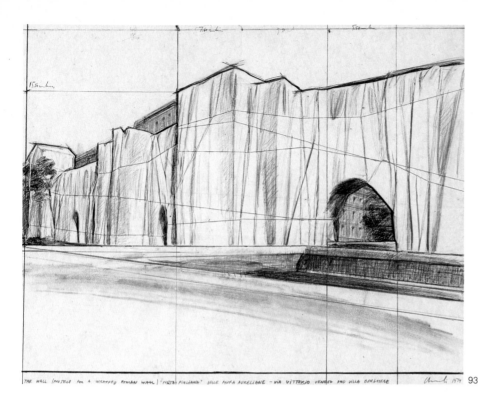

THE WALL (PROJECT FOR A WRAPPED ROMAN WALL) "PORTA PINCIANA" DELLE MURA AURELIANE - VIA VITTORIO VENETO AND VILLA BORGHESE Christo 1974 93

The Wall, Wrapped Roman Wall, 1974

Height: 50 feet.
Length: 850 feet.
Width: varying between 14 and 19 feet.
Materials: woven polypropylene fabric and dacron rope.

Situated at the end of the Via Veneto, one of the busiest avenues of Rome, and at the edge of the gardens of the Villa Borghese, the two thousand year old Wall was built by the Emperor Marcus Aurelius and used to surround the City of Rome.

The *Wrapped Roman Wall* was financed by Christo. In February/ March 1974, for a period of forty days, the Wall was wrapped in polypropylene and rope, covering both sides of the Wall, the top and the arches.

Out of the four arches that were wrapped, three arches are heavily used by car traffic and one arch is reserved for pedestrians.

93. The Wall. Project for a Wrapped Roman Wall, Porta Pinciana, Rome. 1974.
Collage: pencil, fabric, twine, pastel and bic pen,
22 × 28 in. (56 × 71 cm).
Jeanne-Claude Christo Collection, New York.
Photo: Eeva-Inkeri.

94. The Wall. Project for a Wrapped Roman Wall, Porta Pinciana, Rome. 1974.
Drawing: charcoal, pencil, color pencil and bic pen,
42 × 59¾ in. (106.6 × 152 cm).
Rothschild Bank AG Zurich Collection.
Bob Lilja Collection, London.
Photo: Eeva-Inkeri.

95. The Wall. Project for a Wrapped Roman Wall, Porta Pinciana, Rome. 1974.
Pencil, charcoal and colour crayon,
60 × 36 in. (152.5 × 91.5 cm).
Jeanne-Claude Christo Collection, New York.
Photo: Mimmo Capone.

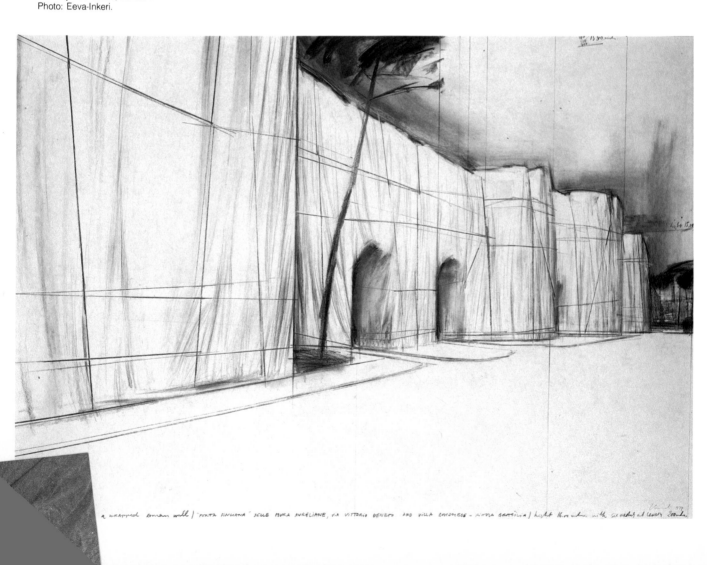

a wrapped roman wall / "PORTA PINCIANA" DELLE MURA AURELIANE, VIA VITTORIO VENETO AND VILLA BORGHESE - ROMA GRATTINA / light through with scratches at lower border

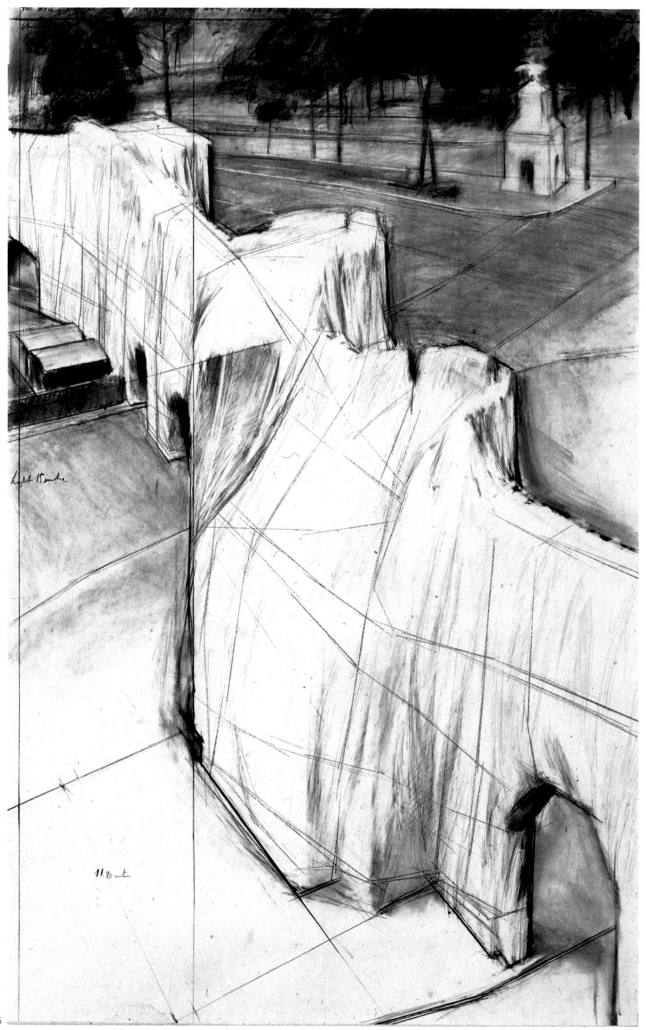

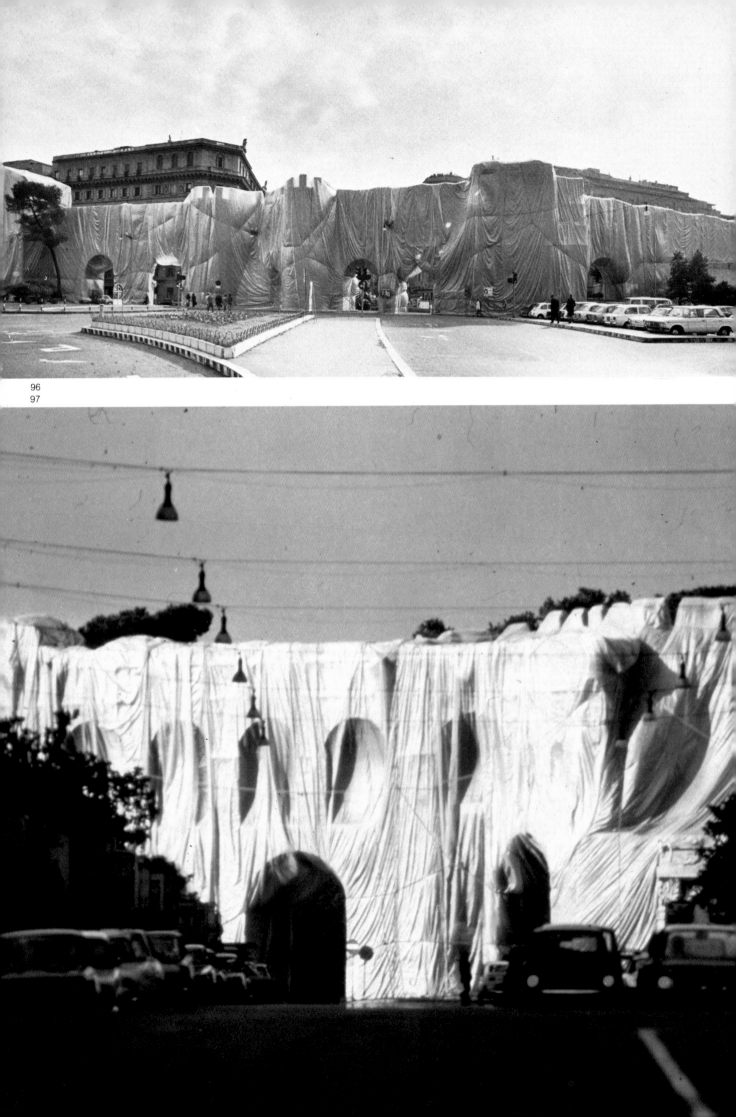

96
97

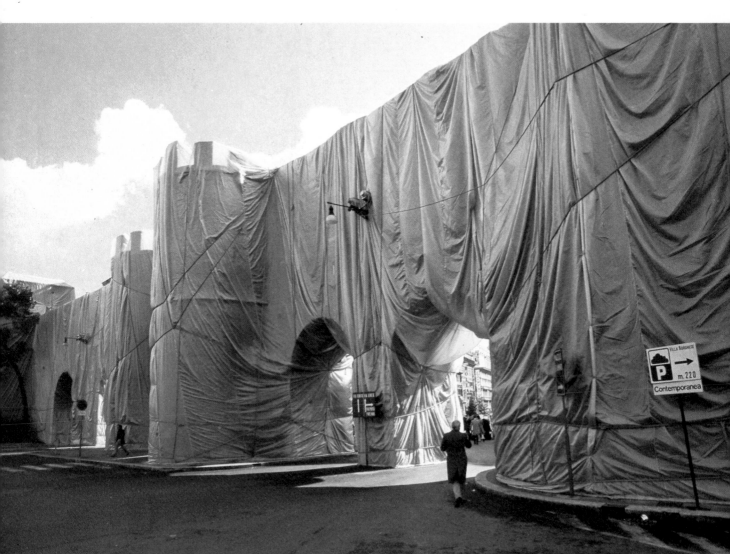

98

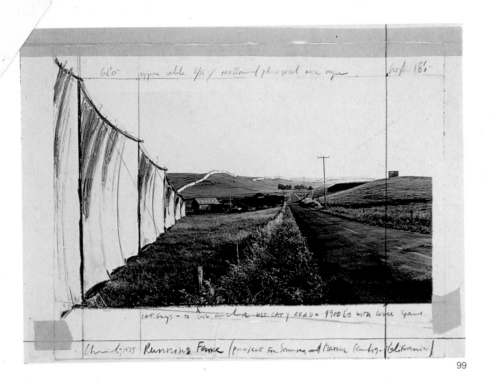

99. **Running Fence. Project for Sonoma and Marin Counties, California.** 1975.
Painted photograph: pencil, charcoal, crayon, photograph by Gianfranco Gorgoni, tape and enamel paint,
14 × 11 in. (35.5 × 28 cm).
Cyril Christo Collection, New York.

100. **Running Fence. Project for Sonoma and Marin Counties, California.** 1975.
Collage: pencil, fabric, pastel, photograph by Wolfgang Volz, charcoal and crayon,
22 × 28 in. (56 × 71 cm).
Jeanne-Claude Christo Collection, New York.

Running Fence, Sonoma and Marin Counties, 1972-1976

Running Fence, eighteen feet high, twenty-four and a half miles long, extending East-West near Freeway 101, north of San Francisco, on the private properties of fifty-nine ranchers, following the rolling hills and dropping down to the Pacific Ocean at Bodega Bay, was completed on September 10, 1976.

The art project consisted of: forty-two months of collaborative efforts, the ranchers' participation, eighteen Public Hearings, three sessions at the Superior Courts of California, the drafting of a four-hundred and fifty page Environmental Impact Report and the temporary use of the hills, the sky and the Ocean.

Conceived and financed by Christo, Running Fence was made of 165,000 yards of heavy woven white nylon fabric, hung from a steel cable strung between 2,050 steel poles (each: 21 feet long, 3½'' in diameter) embedded three feet into the ground, using no concrete and braced laterally with guy wires (90 miles of steel cable) and 14,000 earth anchors. The top and bottom edges of the 2,050 fabric panels were secured to the upper and lower cables by 350,000 hooks. All parts of Running Fence's structure were designed for complete removal and no visible evidence of Running Fence remains on the hills of Sonoma and Marin Counties.

As it had been agreed with the ranchers and with County, State and Federal Agencies, the removal of Running Fence started fourteen days after its completion and all materials were given to the ranchers. Running Fence crossed fourteen roads and the town of Valley Ford, leaving passage for cars, cattle and wildlife, and was designed to be viewed by following forty miles of public roads, in Sonoma and Marin Counties.

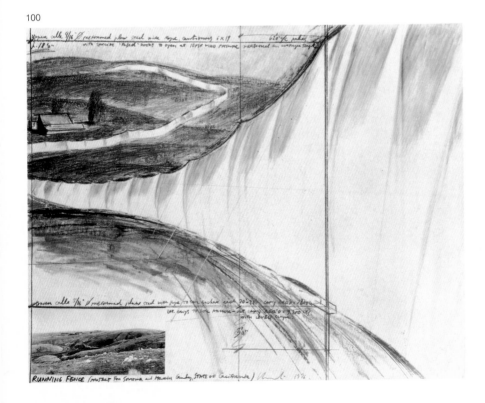

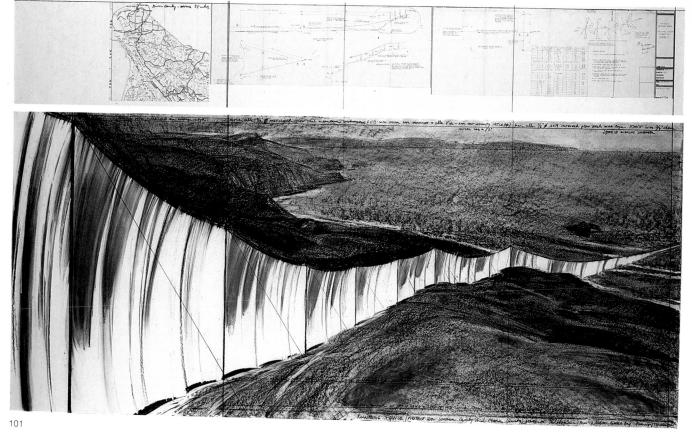

101

101. **Running Fence. Project for Sonoma and Marin Counties, California.** 1975.
Drawing in 2 parts: pencil, charcoal, crayon, pastel, map and technical data,
15×96 in. (38×244 cm) and 42×96 in. (106.6×244 cm).
Bob Lilja Collection, London.
Photo: Eeva-Inkeri.

102. **Running Fence. Project for Sonoma and Marin Counties, California.** 1975.
Drawing in 2 parts: pastel, charcoal, technical data, bic pen and map,
15×96 in. (38×244 cm) and 42×96 in. (106.6×244 cm).
The Allen Memorial Art Museum, Oberlin, Ohio.
Photo: Eeva-Inkeri.

102

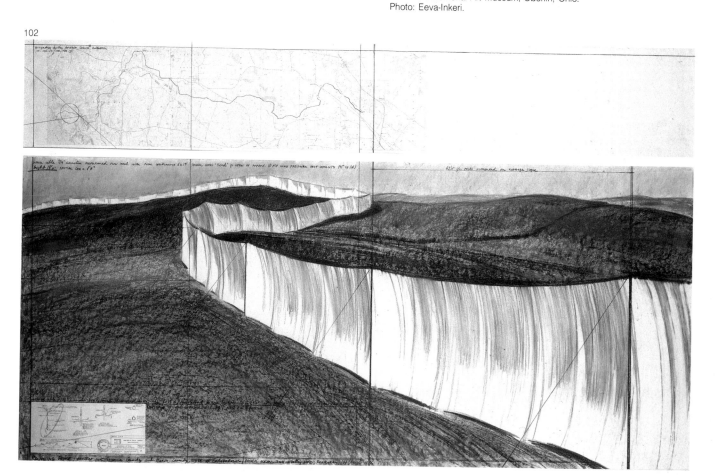

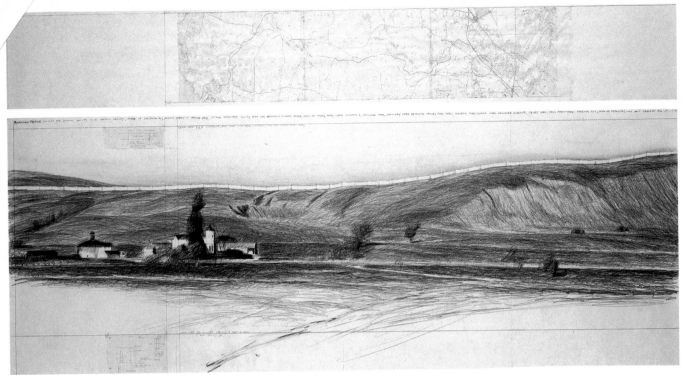

103

103. **Running Fence. Project for Sonoma and Marin Counties, California.** 1975.
Drawing in 2 parts: pencil, charcoal, white paint, technical data and map,
14×96 in. (35.5×244 cm) and 36×96 in. (91.5×244 cm).
Jeanne-Claude Christo Collection, New York.
Photo: Eeva-Inkeri.

104 to 110. **Running Fence. Sonoma and Marin Counties, California.** 1975.
Height: 18 ft. (5.8 m), length: 24¼ miles (40 Km).
Photos: Wolfgang Volz, figs. 104, 105, 108, 109 and 110.
Photo: Gianfranco Gorgoni, fig. 106.
Photo: Jeanne-Claude, fig. 107.

104

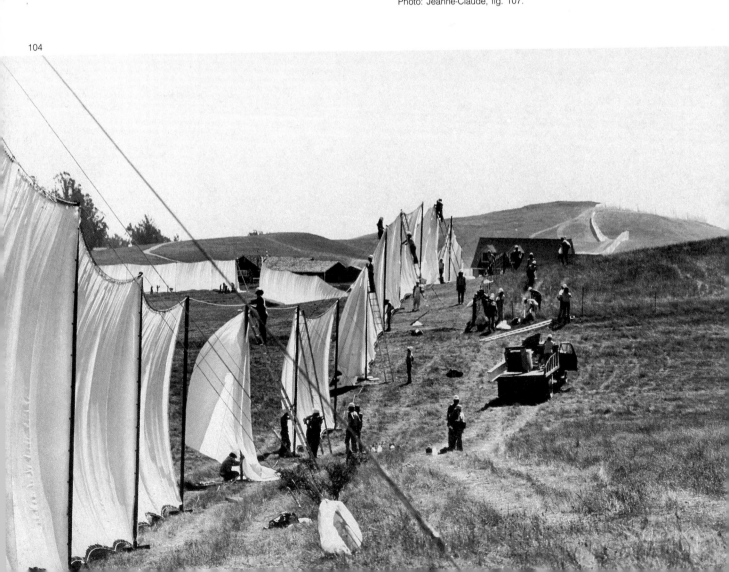

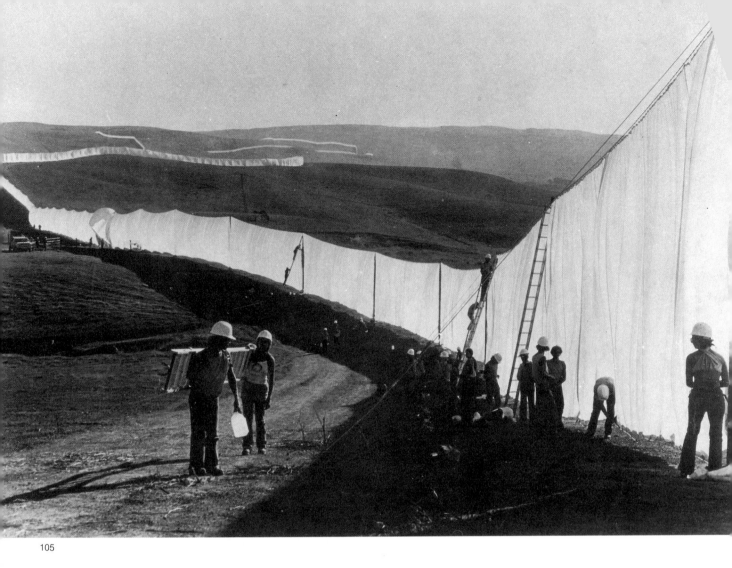

105

106

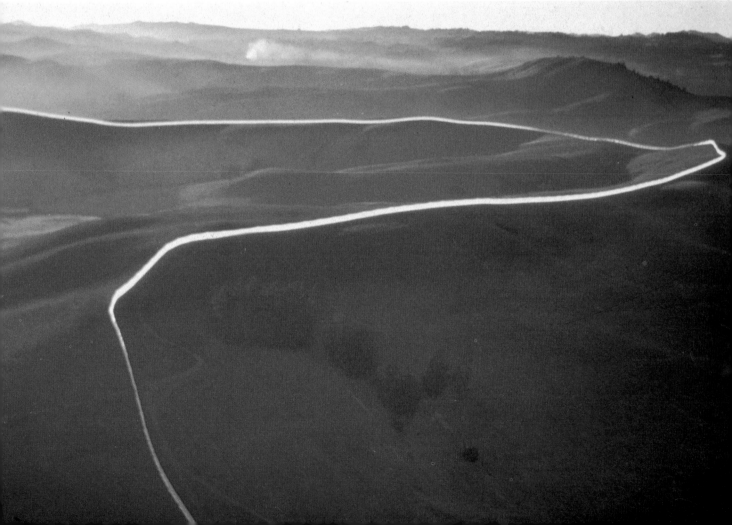

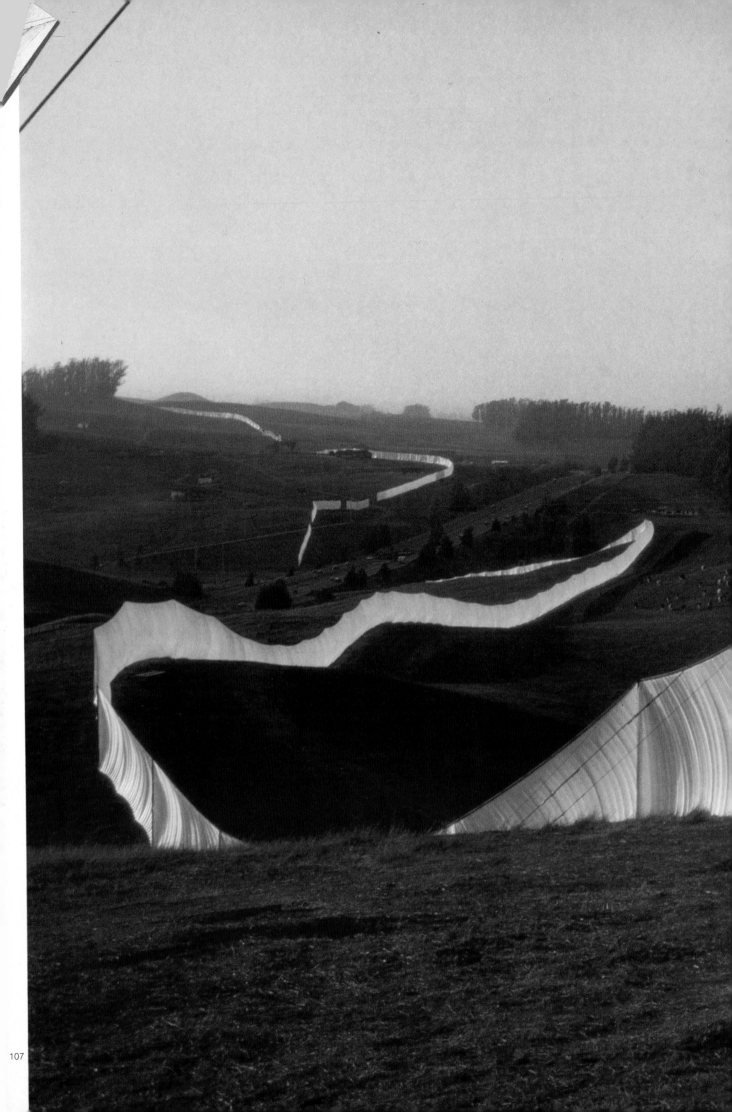

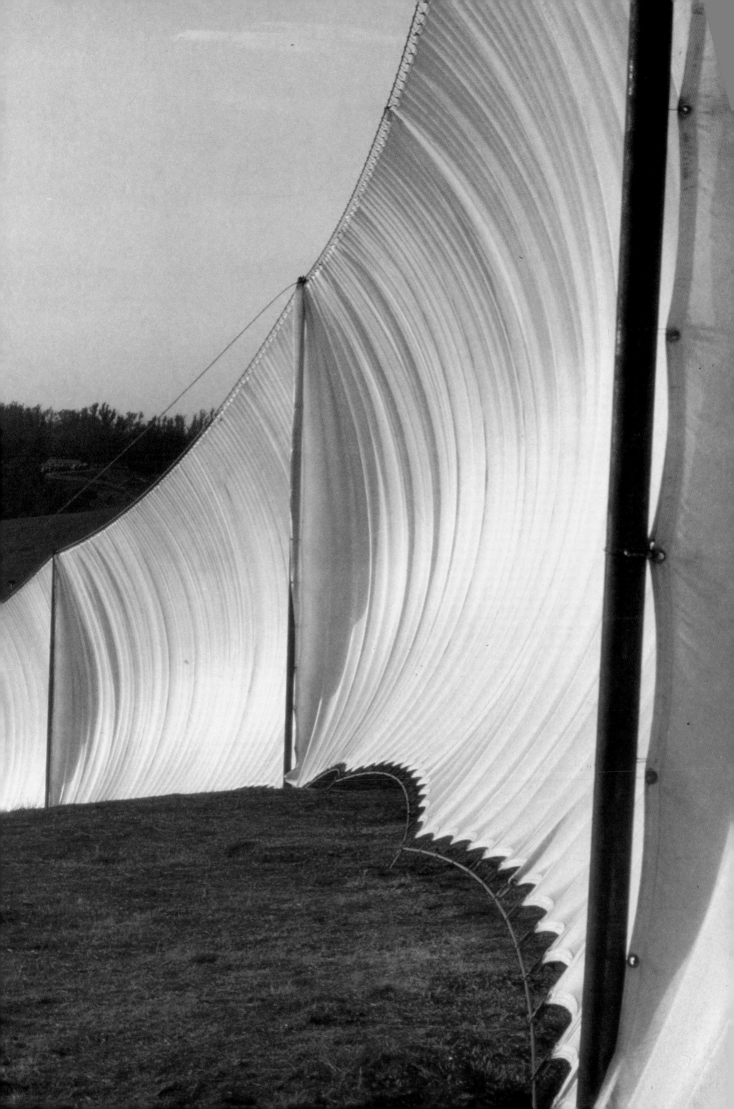

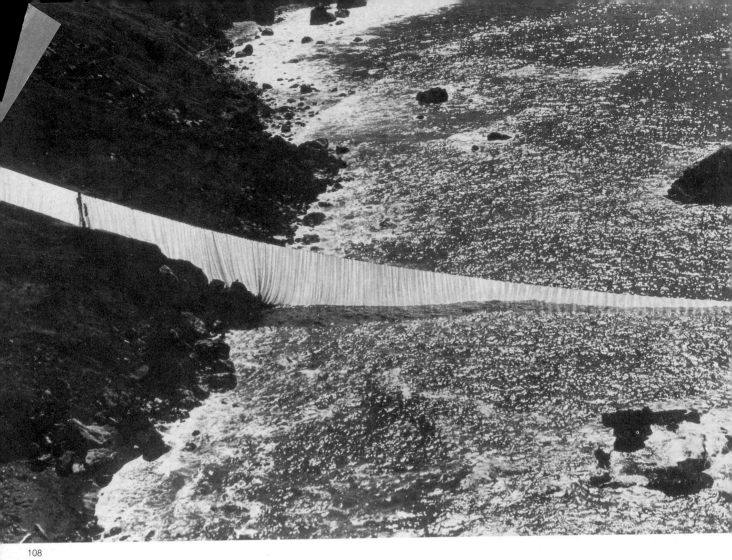

108

109

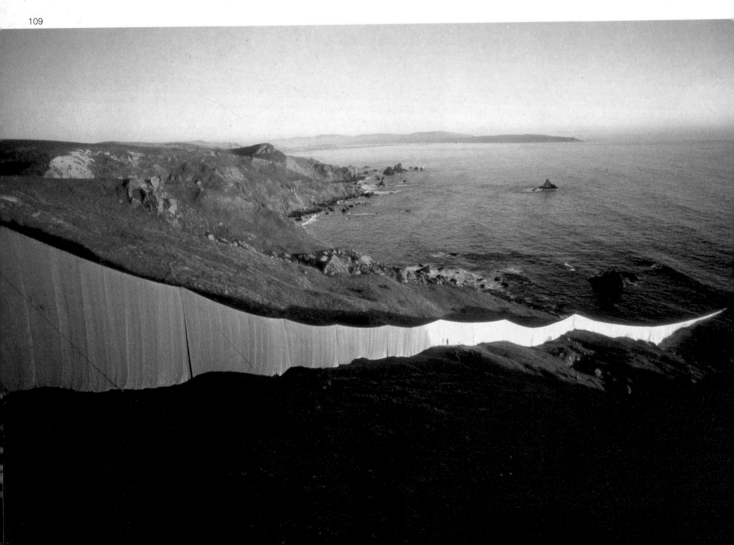

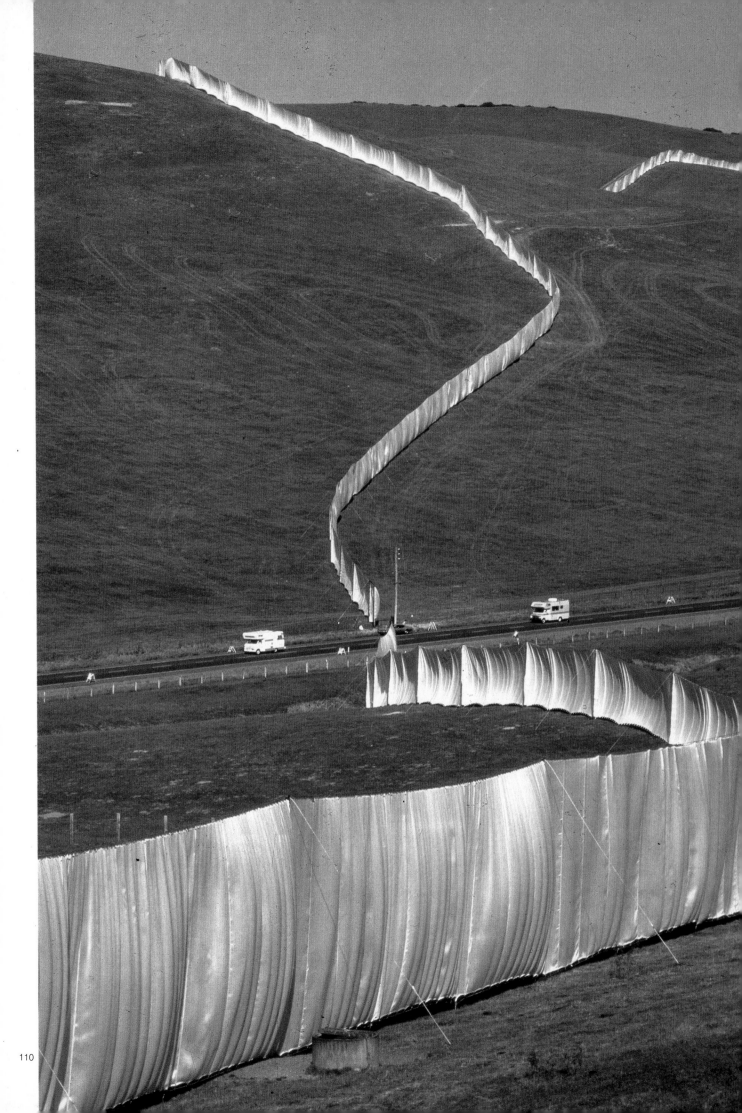

111

112

113

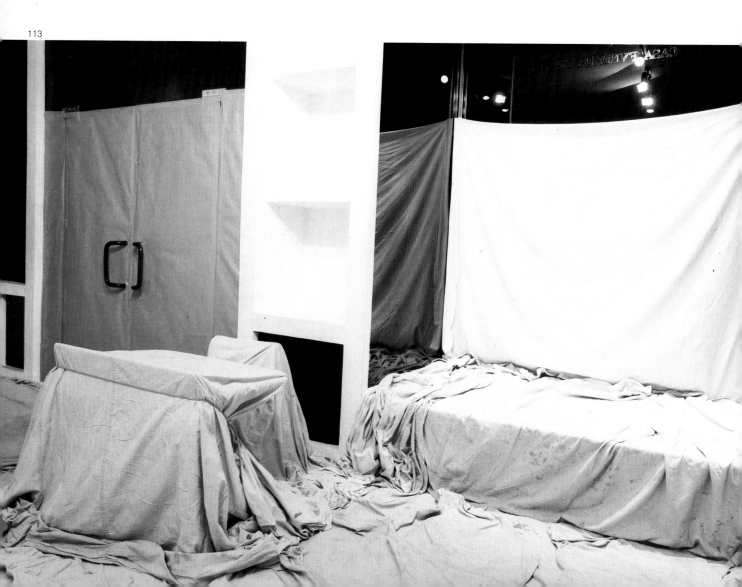

111. Store Front. Project for Galeria Joan Prats, Barcelona. 1976.
Collage: pencil, charcoal, fabric brown paper, photo stat,
blue print floor map,
28×22 in. (71×56 cm).
Satani Gallery, Tokyo.
Photo: Eeva Inkeri.

112. Wrapped Floor. Project for Galeria Joan Prats,
Barcelona. 1976.
Collage: pencil and fabric,
28×22 in. (71×56 cm).
Galeria Joan Prats, Barcelona.
Photo: Eeva Inkeri.

113 and 114. Wrapped. Galeria Joan Prats, Barcelona. 1977.
969 sq.ft. (90 m²) of drop cloths.
Photo: Martí Gasull.

114

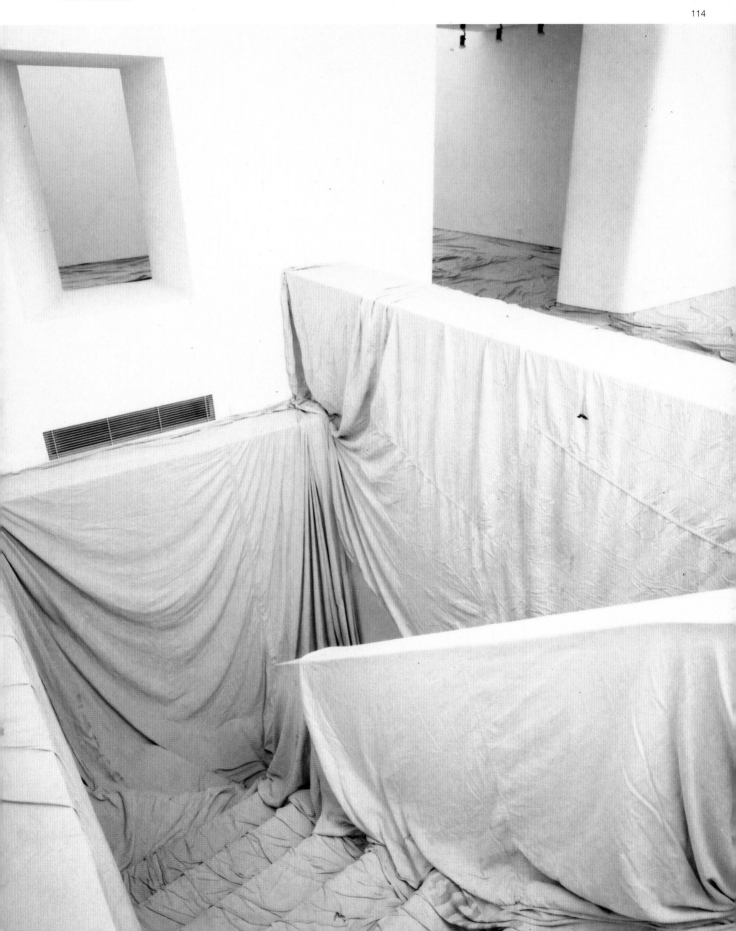

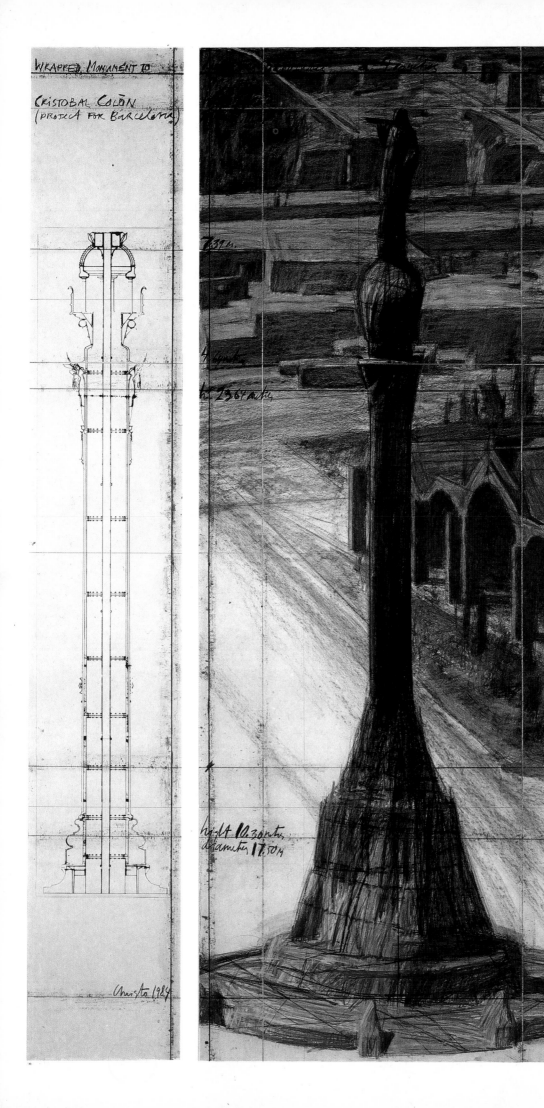

WRAPPED MONUMENT TO

CRISTOBAL COLÓN
(PROJECT FOR BARCELONA)

Christo 1984

115

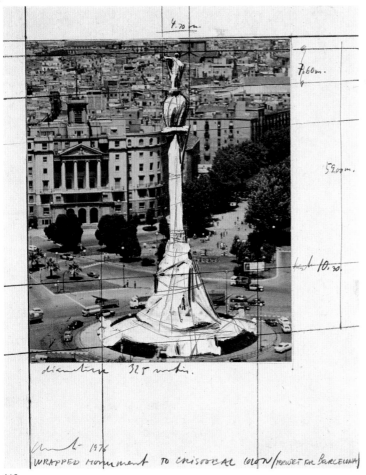

116

117

118

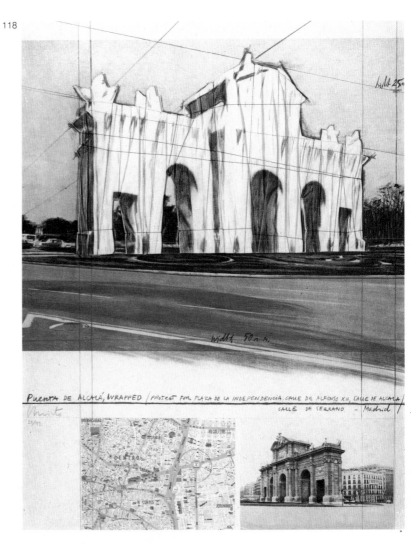

115. **Wrapped Monument to Cristóbal Colón. Project for Barcelona.** 1984.
Drawing in 2 parts: pencil, charcoal, pastel, crayon and technical data,
96 × 15 in. (244 × 38 cm) and 96 × 42 in. (244 × 106.6 cm).
Caixa de Pensions, Barcelona.
Photo: Eeva-Inkeri.

116. **Wrapped Monument to Cristóbal Colón. Project for Barcelona.** 1976.
Painted color photograph: enamel paint, crayon, charcoal, pencil on color photo by Wolfgang Volz,
12⅛ × 9½ in. (30.5 × 24.2 cm).
David Juda Collection, London.
Photo: Eeva Inkeri.

117. **Wrapped Monument to Cristóbal Colón. Project for Barcelona.** 1976.
Drawing: charcoal and pastel,
65 × 42 in. (165 × 107 cm).
Graphische Sammlung Staatsgalerie Stuttgart.
Photo: Eeva Inkeri.

118. **Wrapped Puerta de Alcalá. Project for Madrid.** 1980.
Collage: fabric, twine, photostat from a photograph by Wolfgang Volz, pastel, charcoal, pencil, photograph and map,
28 × 22 in. (71 × 56 cm).
Jeanne-Claude Christo Collection, New York.
Photo: Eeva Inkeri.

The Mastaba of Abu Dhabi, Project for the United Arab Emirates

The Mastaba of Abu Dhabi will represent:

—The symbol of the Emirate and the greatness of Sheikh Zayed, the Mastaba will be taller and more massive than the Cheops Pyramid near Cairo.
—The symbol of civilization of oil throughout the world.
—The Mastaba will be made of 390,500 oil barrels. The project has the most unique character. Nothing comparable has ever existed in any other country. Hundreds of bright colors, as enchanting as the Islamic mosaics, will give a constantly changing visual experience according to the time of the day and the quality of the light.
—The grandeur and vastness of the land will be reflected in the grandeur and majesty of the Mastaba which is to be 300 meters (984 feet) wide, 225 meters (738 feet) deep and 150 meters (492 feet) high.
—The only purpose of this monument is to be itself. The Mastaba of Abu Dhabi can become the symbol of the Emirate and of the 20th-Century oil civilization.

The Mastaba will be constructed of materials relative to the area: inside, natural aggregates and cement to form a concrete structure with a sand core; and outside, an overall surfacing of 55-gallon stainless steel oil barrels of various bright colors:

—All Barrels, on the 4 sides and on the top, will be installed so that they are lying horizontally on their sides.

—The two 300 meter (984 feet) wide sides will be vertical showing the circular heads of the colored barrels.
—The two 225 meter (738 feet) ends will be sloping at the 60 degree natural angle of stacked barrels showing the curved sides of the barrels.
—The top of Mastaba will be a horizontal surface 126.8 meters (416 feet) wide and 225 meters (738 feet) deep showing the rounded length of the barrels.
—The volume of the Mastaba will be such that many 48 storey skyscrapers could easily fit into its massiveness.

It is suggested that the Mastaba be situated on a slightly rising plain to allow viewers the full impact ot the grandeur of the Mastaba as they approach by foot, by automobile, or by airplane. There will be no ingress except for a passageway to the elevators to take visitors to the top, 150 meters (492 feet) above the ground. From there they will enjoy superb views, being able to see approximately 50 kilometers across the countryside.

The area adjacent to the walkways approaching the Mastaba will be like an oasis to the visitor with flowers and grass. There will also be planting of palm trees, eucalyptus trees, thorn trees and other shrubbery surrounding the Mastaba at a distance to serve as a windbreak minimizing the force of the sand and windstorms.

Within this distant area there could be a complex with a worship room, parking and facilities for the visitors and lodging for the curator and guardians.

CHRISTO, 1979

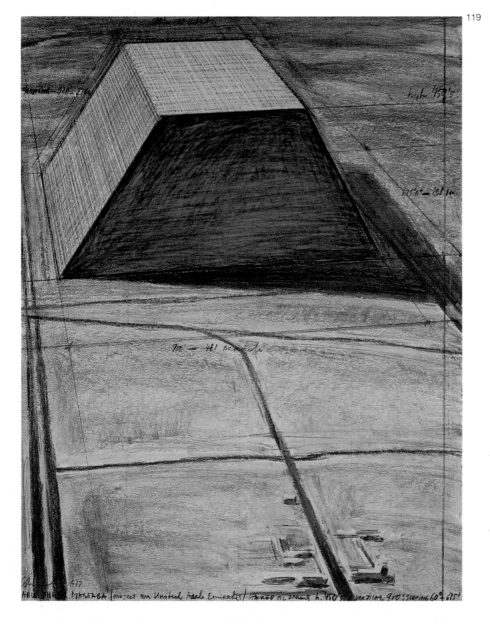

119

119. **The Mastaba of Abu Dhabi. Project for the United Arab Emirates.** 1977.
Drawing: pencil, charcoal, crayon and pastel, 28 × 22 in. (71 × 56 cm).
Jeanne-Claude Christo Collection, New York.
Photo: Eeva-Inkeri.

120. **The Mastaba of Abu Dhabi. Project for the United Arab Emirates.** 1979.
Collage: pencil, charcoal, photostat from a photograph by Wolfgang Volz, crayon, pastel and technical data, 31½ × 23¾ in. (80 × 59 cm).
Jeanne-Claude Christo Collection, New York.

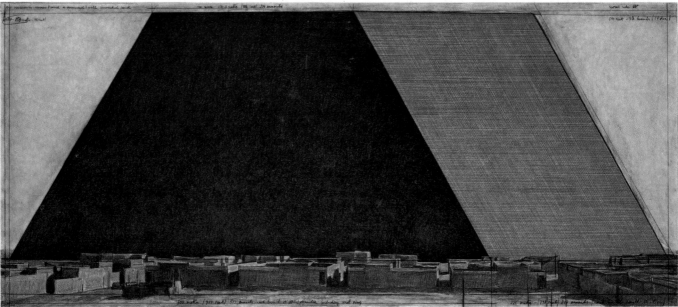

121

121. **The Mastaba of Abu Dhabi. Project for the United Arab Emirates.** 1979.
Drawing in 2 parts: pastel, charcoal, pencil, crayon, map and technical data,
15 × 96 in. (38 × 244 cm) and 42 × 96 in. (106.6 × 244 cm).
Jeanne-Claude Christo Collection, New York.
Photo: Eeva-Inkeri.

122. **The Mastaba of Abu Dhabi. Project for the United Arab Emirates.** 1979.
390,000 Stacked Oil Barrels.
Collage drawing: photograph by Wolfgang Volz, pastel, crayon, technical data and map,
31½ × 23¾ in. (79,5 × 59 cm).
Jeanne-Claude Christo Collection, New York
Photo: Eeva-Inkeri.

123. **The Mastaba Abu Dhabi. Project for the United Arab Emirates.** 1979.
Collaged photograph: superimposition of three-dimensional scale model on a color photograph by Wolfgang Volz,
22 × 14 in. (56 × 35.5 cm) (detail).
Jeanne-Claude Christo Collection, New York.

122

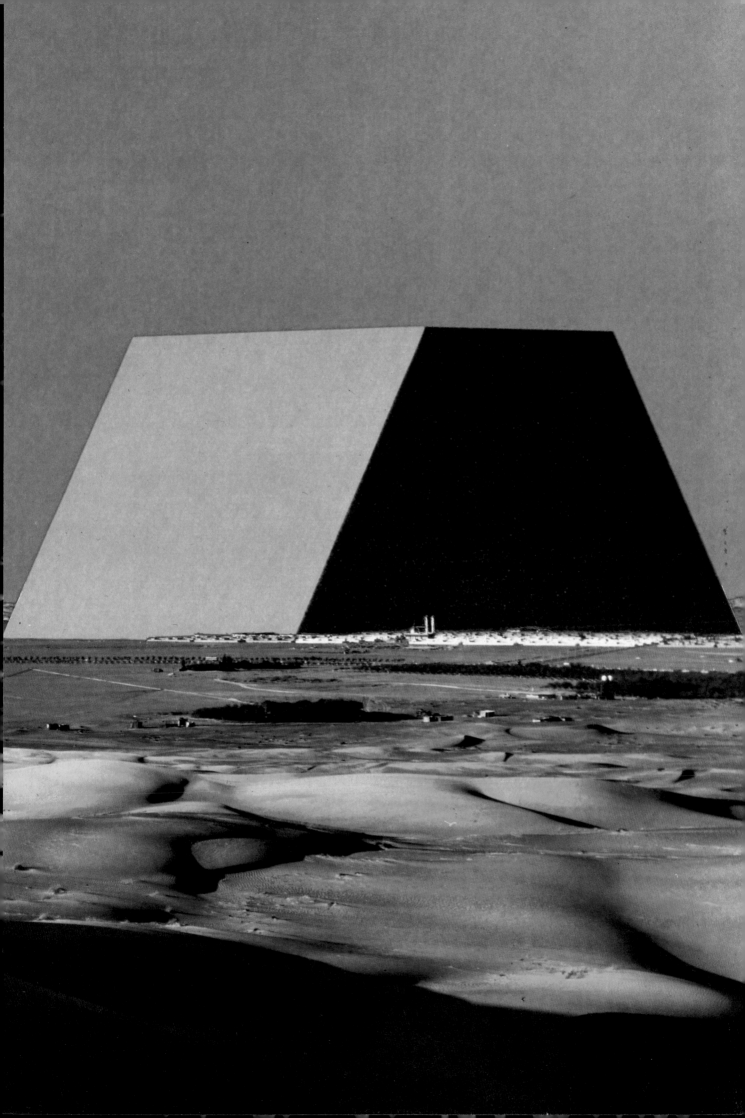

Wrapped Walk Ways

Wrapped Walk Ways, an art project by Christo in Loose Memorial Park, Kansas City, Mo., consists of the installation of 136,268 square feet (13,870 square meters) of saffron-colored nylon cloth covering 104,836 square feet (10,670 square meters) of formal garden walkways and jogging paths. Installation began on Monday, October 2 and was completed on Wednesday, October 4. Eighty-four people were employed by A. L. Huber and Son, a Kansas City building contractor, to install the material. Among others, there were 13 construction workers and four professional seamstresses. The cloth was secured in place by 34.500 steel spikes (7'' × 5/16'') driven into the soil through brass grommets in the fabric and 40,000 staples into wooden edges on the stairways. After over 32,000 feet of seams and hems were sewn in a West Virginia factory professional seamstresses, using portable sewing machines and aided by many assistants, completed the sewing in the park. The Contemporary Art Society of the Nelson Gallery, which was instrumental in getting the construction permits, is sponsoring an exhibition of Wrapped Walk Ways Ducumentation at the Nelson Gallery-Atkins Museum. Harry Abrams will publish a book about the project.

The project will remain in the park until October 16 when the material will be removed and given to the Kansas City Parks Department.

The project was financed by Christo.

124. **Wrapped Walk Ways. Project for Jacob L. Loose Memorial Park, Kansas City, Missouri.** 1978.
Drawing in 2 parts: pencil, chalk, pastel, charcoal and map, 15 × 65 in. (38 × 165 cm). and 42 × 65 in. (106.7 × 165 cm).
Jeanne-Claude Christo Collection, New York.
Photo: Wolfgang Volz.

125. **Wrapped Walk Ways. Project for Jacob L. Loose Memorial Park, Kansas City, Missouri.** 1978.
Drawing in 2 parts: pencil, charcoal, pastel, crayon and map, 96 × 15 in. (244 × 38 cm) and 96 × 42 in. (244 × 106.6 cm).
Bob Lilja Collection, London.
Photo: Wolfgang Volz.

124

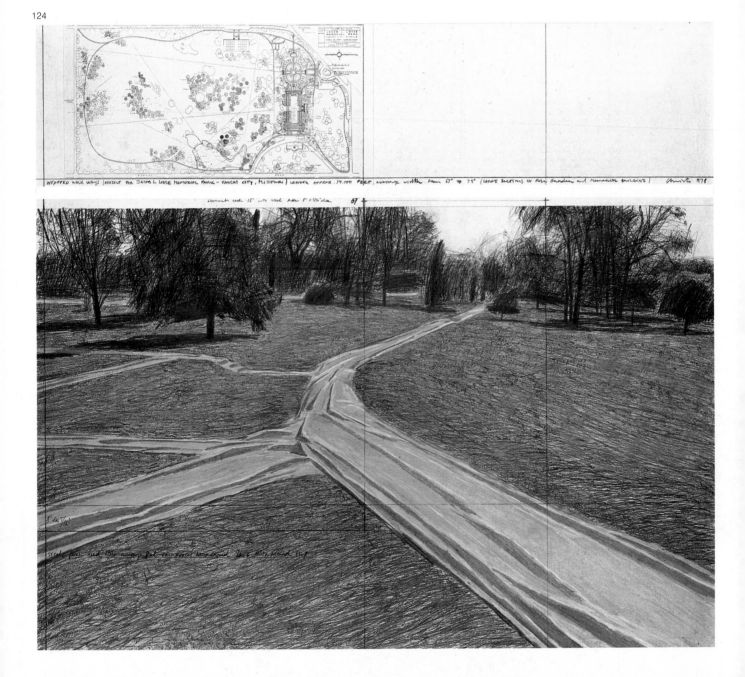

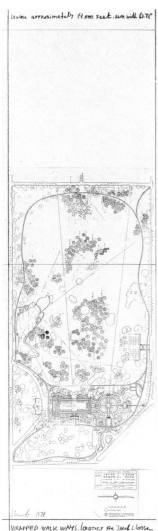

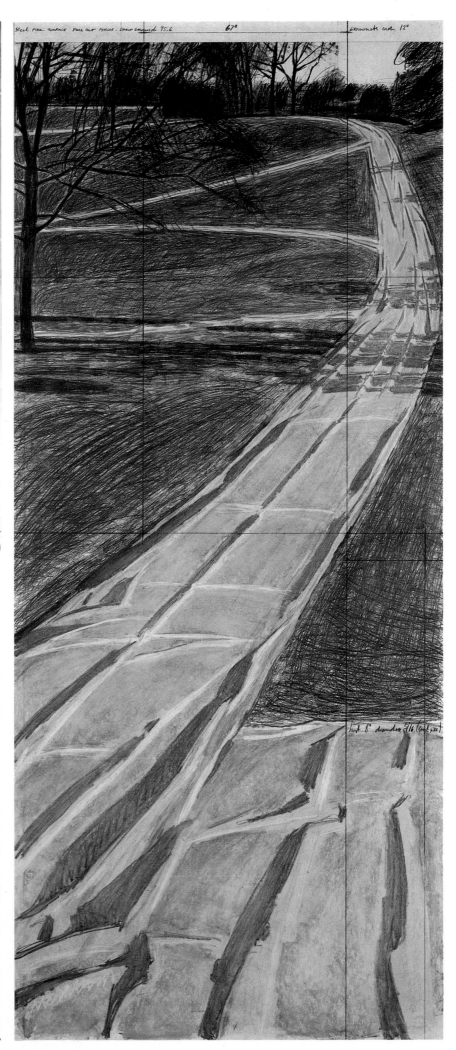

WRAPPED WALK WAYS. (Project for Jacob L. Loose
Memorial Park, Kansas City, Missouri)

126

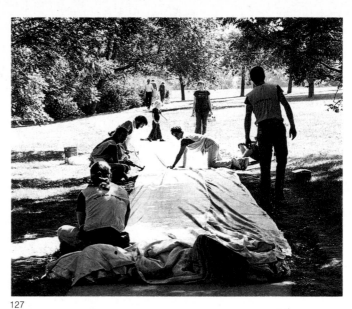

127

126 to 129. **Wrapped Walk Ways. Jacob L. Loose Memorial
Park, Kansas City, Missouri.** 1977-1978.
15,000 sq. yd. (12,540 m²) of fabric, over 2.8 m. (4,5 Km).
Photo: Wolfgang Volz.

128

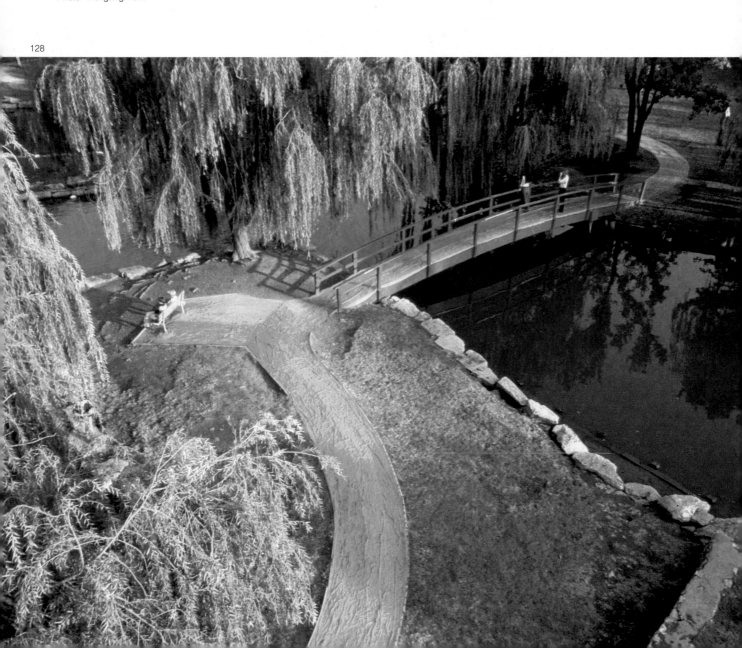

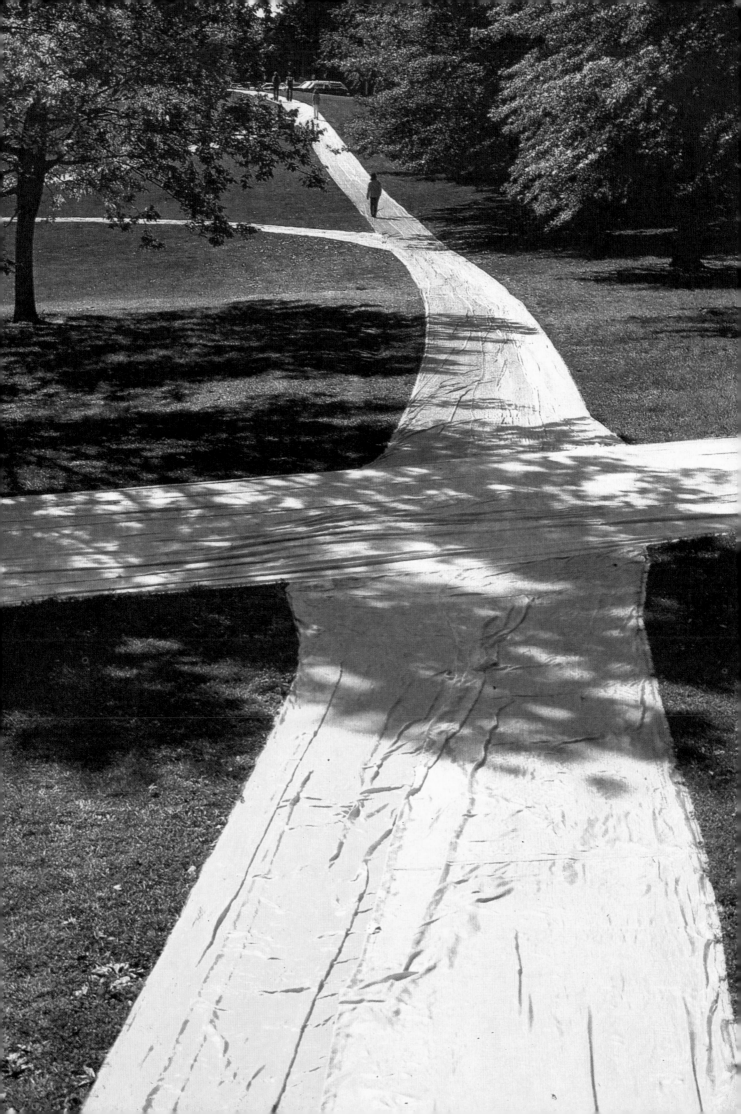

The Gates, Project for Central Park

The Gates will be 15 feet high with a width varying from 9 to 28 feet following the edges of the walk ways, perpendicular to the selected foot paths of Central Park. Attached to the top of each steel gate, spaced at 9 feet intervals, the fabric will come down to 5 feet 6 inches from the ground, allowing the synthetic woven panels to wave horizontally towards the next gate.

The Gates are planned to remain for 14 days in the last two weeks of October 1983 or 1984, after which the 27 mile long work of art shall be removed and the ground restored to its original condition.

The Gates will be entirely financed by Christo.

Neither the City nor the Park shall bear any of the expenses for The Gates.

A written contract shall be drafted between the Department of Parks and our organization based upon the agreements made in California with all relevant Governmental Agencies at the time of the construction of the Running Fence project, which brought complete satisfaction to the authorities and international attention to that area.

The contract shall require us to provide:

1) Personal and Property Liability Insurance holding the Department of Parks harmless.
2) Environmental Impact Statement would be prepared if requested by the Park.
3) Removal Bond providing funds for complete restoration of the ground.
4) Full co-operation with the Community Boards, the Department of Parks, the New York City Arts Commission, and the Landmarks Commission.

5) Employment of local Manhattan residents.
6) Clearance for the usual activities in the Park and access of Rangers, Maintenance, clean-up, Police and Emergency Service vehicles.
7) Direct cost of the Park's Supervision shall be charged to us.
8) The configuration of the path of The Gates shall be selected together with the Department of Parks.
9) No vegetation nor rock formations shall be disturbed.
10) Only vehicles of small size will be used and will be confined to the perimeter of existing walk ways during installation and removal.
11) Great precaution will be taken in the scheduling of The Gates so as not to interfere with any of the wildlife patterns.
12) All holes shall be professionally backfilled with natural material, leaving the ground in good condition and it shall be inspected by the Department of Parks who will be holding the Bond until full satisfaction.
13) Financial help shall be given to the Department of Parks in order to cover any possible additional clean-up task, secretarial work, or any expenses that might occur in direct relation to The Gates.

Full-size prototype tests are being conducted by our Engineers, on the steel frames, their bottom supports and the fabric panel connections.

By up-lifting and framing the space above the walk ways, the luminous fabric of The Gates will underline the organic design in contrast to the geometric grid pattern of Manhattan and will harmonize with the beauty of Central Park.

CHRISTO, 1980

130

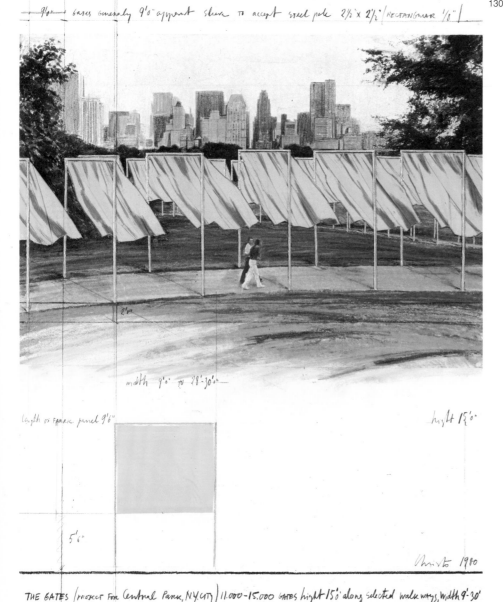

130. **The Gates. Project for Central Park, New York City.** 1980.
Collage: pencil, fabric, pastel, charcoal, photostat from a photo by Wolfgang Volz and fabric sample,
28 × 22 in. (71 × 56 cm).
Jeanne-Claude Christo Collection, New York.

131. **The Gates. Project for Central Park, New York City.** 1980.
Drawing in 2 parts: pencil, charcoal, crayon, pastel, map and photographs by Wolfgang Volz,
96 × 42 in. (244 × 106.6 cm) and
96 × 15 in. (244 × 38 cm).
John Kaldor Collection, New York.

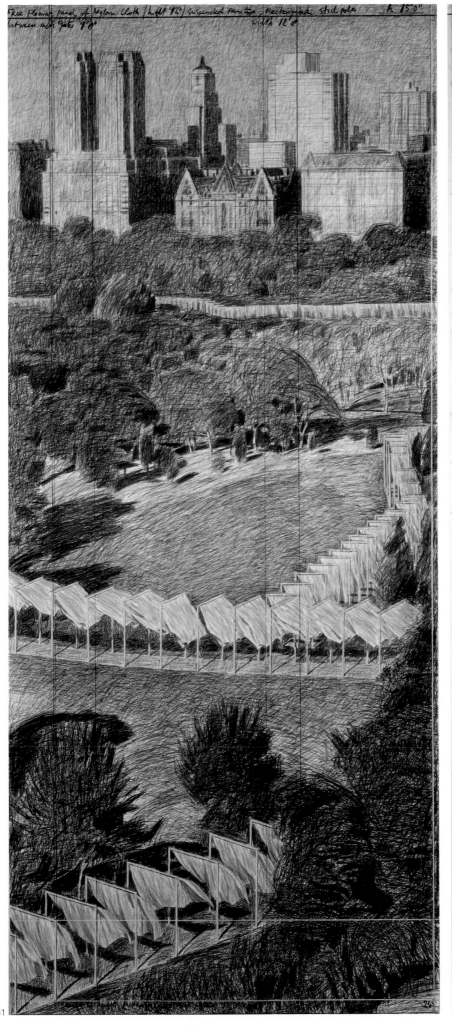

Free Flowing panel of Nylon Cloth (height 9'6") suspended from the Rectangular steel pole h. 15'0"
between each pole 9'6" width 12'0"

131 2/2

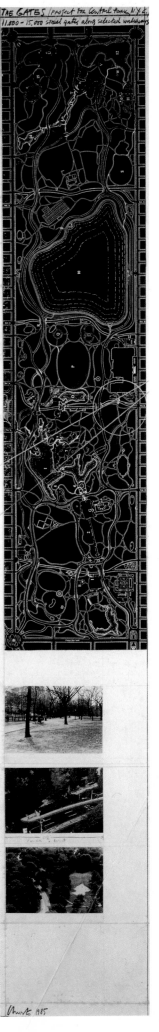

Christo 1985

Surrounded Islands, Biscayne Bay, Greater Miami, Florida, 1980-83

On May 7, 1983 the installation of Surrounded Islands was completed. In Biscayne Bay, located between the City of Miami, North Miami, the Village of Miami Shores and Miami Beach, 11 of the islands situated in the area of Bakers Haulover Cut, Broad Causeway, 79th Street Causeway, Julia Tuttle Causeway, and Venetian Causeway have been surrounded with 6,5 million square feet of pink woven polypropylene fabric covering the surface of the water, floating and extending out 200 feet. from the island into the Bay. The fabric has been sewn into 79 patterns to follow the contours of the 11 islands.

For 2 weeks Surrounded Islands situated over 7 miles altogether is being seen, approached and enjoyed by the public, from the causeways, the land, the water and the air. The luminous pink color of the shiny fabric is in harmony with the tropical vegetation of the uninhabited verdant islands, the light of the Miami sky and the colors of the shallow waters of Biscayne Bay.

Since April 1981 attorneys Joseph Z. Fleming, Joseph W. Landers, marine biologist Dr. Anitra Thorhaug, ornithologists Dr. Oscar Owre and Meri Cummings, mammal expert Dr. Daniel Odell, marine engineer John Michel, four consulting engineers, and builder-contractor, Ted Dougherty of A & H Builders, Inc., have been working on the preparation of the Surrounded Islands. As with Christo's previous art projects, Surrounded Islands is entirely financed by the artist, through the sale of his preparatory pastel and charcoal drawings, his collages, and early works.

Permits have been obtained from the following governmental agencies: The Governor of Florida and the Cabinet; the Dade County Commission; the Department of Environmental Regulation; the City of Miami Commission; the City of North Miami; the Village of Miami Shores; the U.S. Army Corps of Engineers; the Dade County Department of Environmental Resources Management. From November 1982 until April 1983, 6,500,000 square feet of woven polypropylene fabric were sewn at the rented Hialeah factory, into 79 different patterns to follow the contours of the 11 islands. A flotation strip was sewn in each seam. The sewn sections were accordion folded at the Opa Locka Blimp Hangar to ease the unfurling.

The outer edge of the floating fabric is attached to a 12 inch diameter octagonal boom, in sections, of the same color as the fabric. The boom is connected to the radial anchor lines which extend from the anchors at the island to the 610 specially made anchors, spaced at 50 feet intervals, 250 feet beyond the perimeter of each island, driven into the limestone at the bottom of the Bay. Earth anchors have been driven into the land, near the foot of the trees, to secure the inland edge of the fabric, covering the surface of the beach and disappearing under the vegetation.

The floating rafts of fabric and booms, varying from 12 to 22 feet in width and from 400 to 600 feet in length were towed through the Bay to each island. There are 11 islands, but in two areas Christo surrounded two islands together as one configuration.

On May 4, 1983, out of a total work force of 430, the unfurling crew began to blossom the pink fabric. Surrounded Islands is tended day and night by 120 monitors in inflatable boats.

Surrounded Islands is a work of art which underlines the various elements and ways in which the people of Miami live, between land and water.

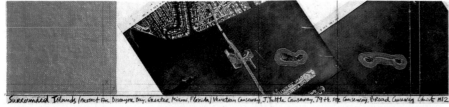

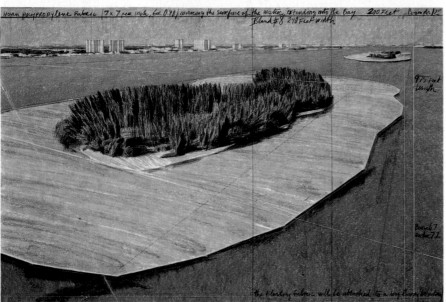

132. **Surrounded Islands. Project for Biscayne Bay, Greater Miami, Florida.** 1983.
Drawing in 2 parts: pencil, charcoal, pastel, crayon enamel paint, fabric sample and aerial photographs,
15 × 65 in. (38 × 165 cm) and
42 × 65 in. (106.6 × 165 cm).
Galerie Johanna Vermeer, Paris.
Photo: Wolfgang Volz.

133. **Surrounded Islands. Project for Biscayne Bay, Greater Miami, Florida.** 1983.
Drawing in 2 parts: pastel, charcoal, pencil, fabric sample, enamel paint and photostat,
96 × 15 in. (244 × 38 cm) and
96 × 42 in. (244 × 106.6 cm).
Jeanne-Claude Christo Collection, New York.
Photo: Wolfgang Volz.

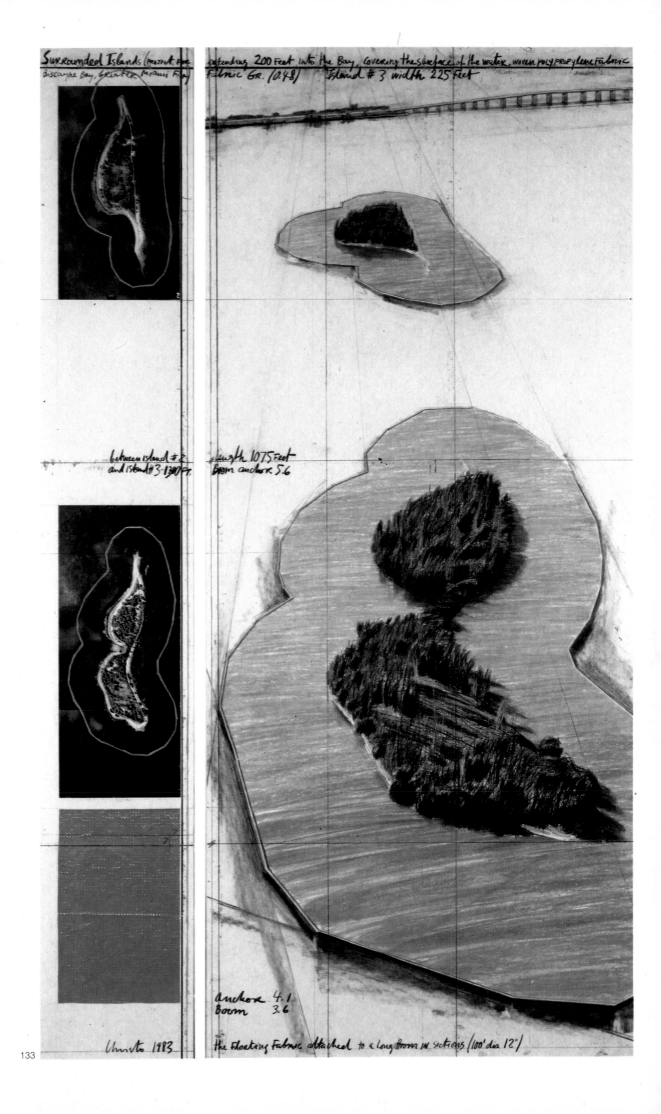

Surrounded Islands (project for
Biscayne Bay, Greater Miami, Florida)

extending 200 Feet into the Bay, covering the surface of the water, woven polypropylene Fabric
Fabric Gr. (0.48) Island # 3 width 225 Feet

between Island # 2
and Island # 3 - 1300 Ft.

length 1075 Feet
Boom anchor 5.6

anchor Gr. 4.1
Boom 3.6

the floating Fabric attached to a long Boom in sections (100' dia 12")

Christo 1983

133

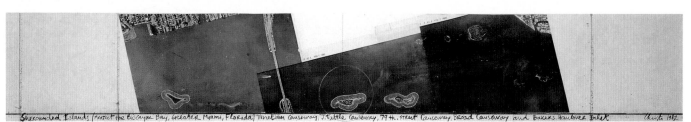

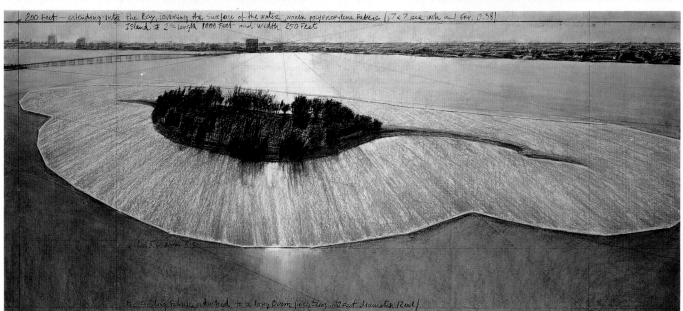

Surrounded Islands (Project for Biscayne Bay, Greater Miami, Florida) Venetian Causeway, J. Tuttle Causeway, 79th. Street Causeway, Broad Causeway and Bakers Haulover Inlet Christo 1982

200 Feet — extending into the Bay, covering the surface of the water, woven polypropylene fabric (7×7 per inch and GRV. 0.38)
Island # 2 = length 1000 Feet and width 250 Feet

the Floating Fabric attached to a long Boom (insertions 100 Feet diameter 12 mil)

134

134. **Surrounded Islands. Project for Biscayne Bay, Greater Miami, Florida.** 1982.
Drawing in 2 parts: pencil, charcoal, pastel, crayon, enamel paint and photostat,
15 × 96 in. (38 × 244 cm) and 42 × 96 in. (106.6 × 244 cm).
Theodor Jeansson Collection, London.
Photo: Wolfgang Volz.

135. **Surrounded Islands. Project for Biscayne Bay, Greater Miami, Florida.** 1982.
Drawing in 2 parts: pencil, charcoal, pastel, crayon, aerial
photograph, fabric sample, enamel paint and technical data,
15 × 96 in. (38 × 244 cm) and 42 × 96 in. (106.6 × 244 cm).
Private collection, Munich.
Photo: Wolfgang Volz.

135

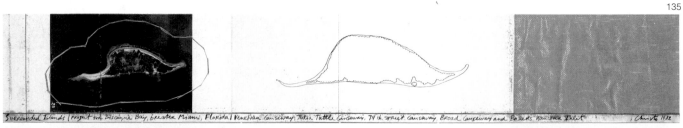

Surrounded Islands (Project for Biscayne Bay, Greater Miami, Florida) Venetian Causeway, Julia Tuttle Causeway, 79th. Street Causeway, Broad Causeway and Bakers Haulover Inlet Christo 1982

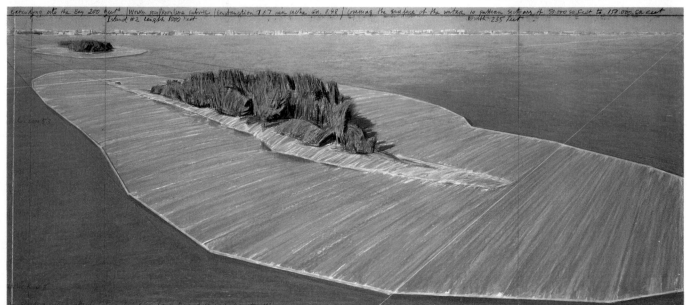

extending into the Bay 200 Feet Woven polypropylene fabric (construction 7×7 per inch GR. 0.48) covering the surface of the water in pattern sections of 50.000 sq. feet to 150.000 sq. feet
Island # 2 length 1000 Feet width 235 Feet

136.
Surrounded Islands.
Project for Biscayne Bay,
Greater Miami, Florida. 1983.
Painted photograph: enamel paint,
bic pen, photograph by Wolfgang Volz,
crayon and tape,
12½ × 13 in. (31.8 × 33 cm).
Jeanne-Claude Christo Collection,
New York.

137.
Surrounded Islands.
Project for Biscayne Bay,
Greater Miami, Florida. 1983.
Collage in 2 parts: fabric, pastel,
charcoal, pencil, enamel paint,
crayon, photograph by Wolfgang Volz,
fabric sample and map,
28 × 22 in. (71 × 56 cm) and
28 × 11 in. (71 × 28 cm).
Jeanne-Claude Christo Collection,
New York.
Photo: Wolfgang Volz.

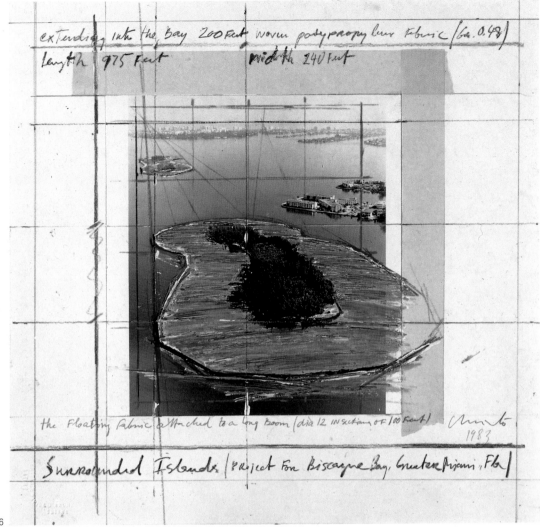

136

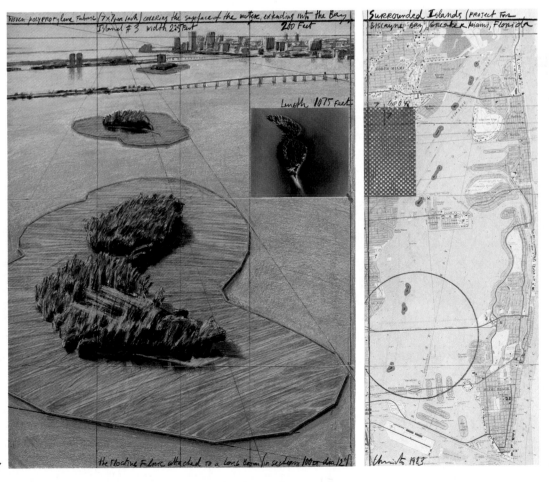

137

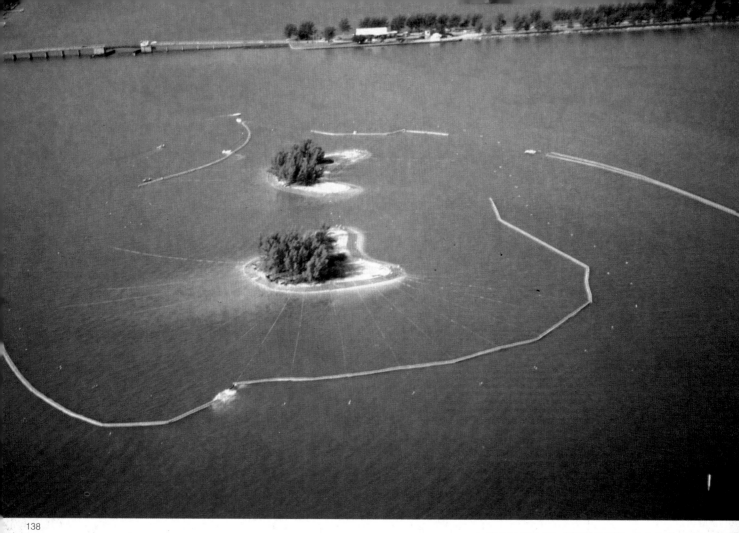

138

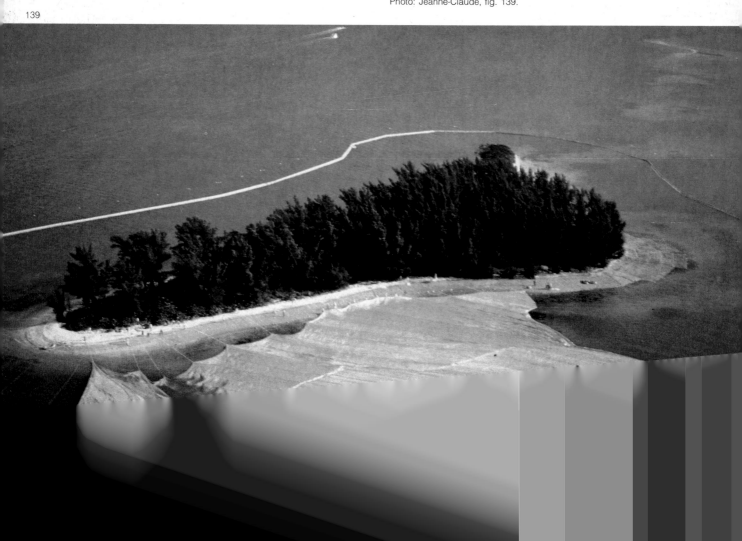

139

138 to 142. **Surrounded Islands. Biscayne Bay, Greater Miami, Florida.** 1980-1983.
6 million sq. ft. (557,400 m²) of pink woven polypropylene fabric. 11 islands.
Photos: Wolfgang Volz, fig. 138, 140, 141 and 142.
Photo: Jeanne-Claude, fig. 139.

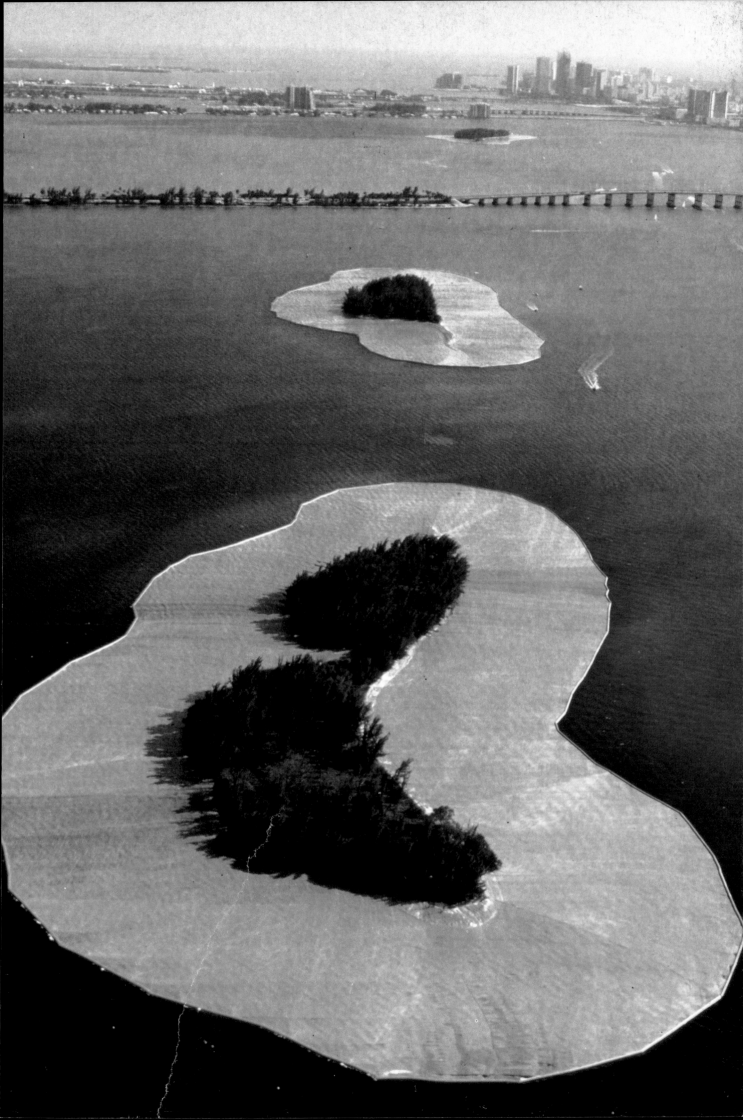

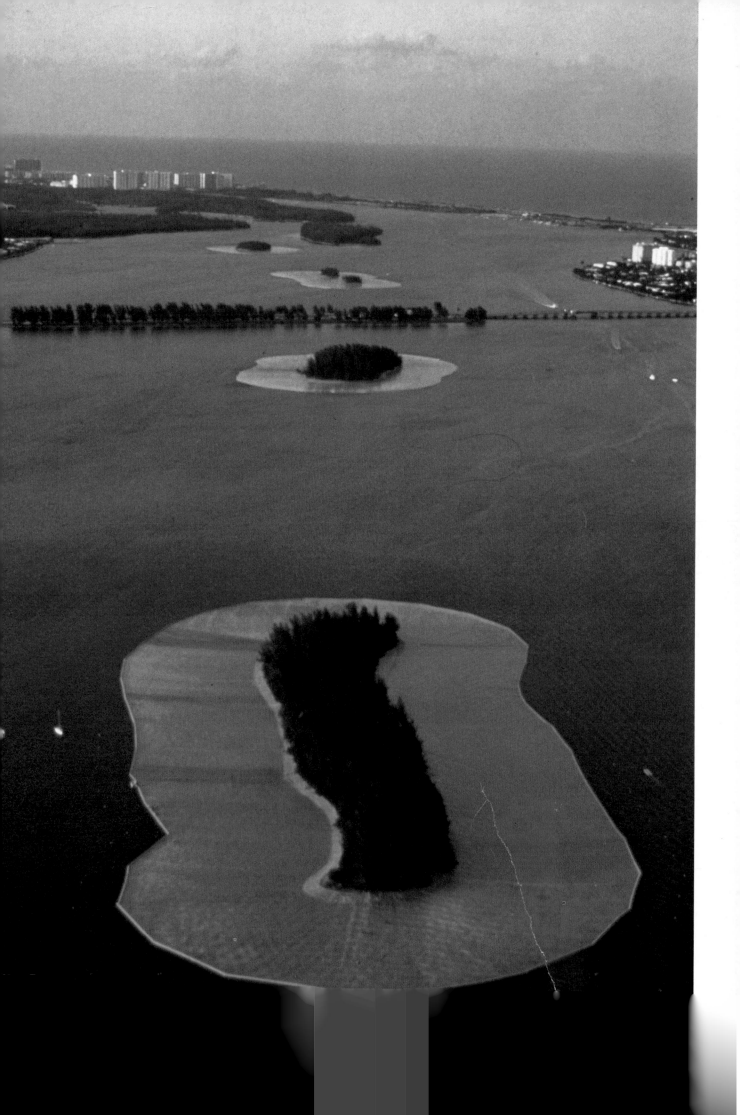

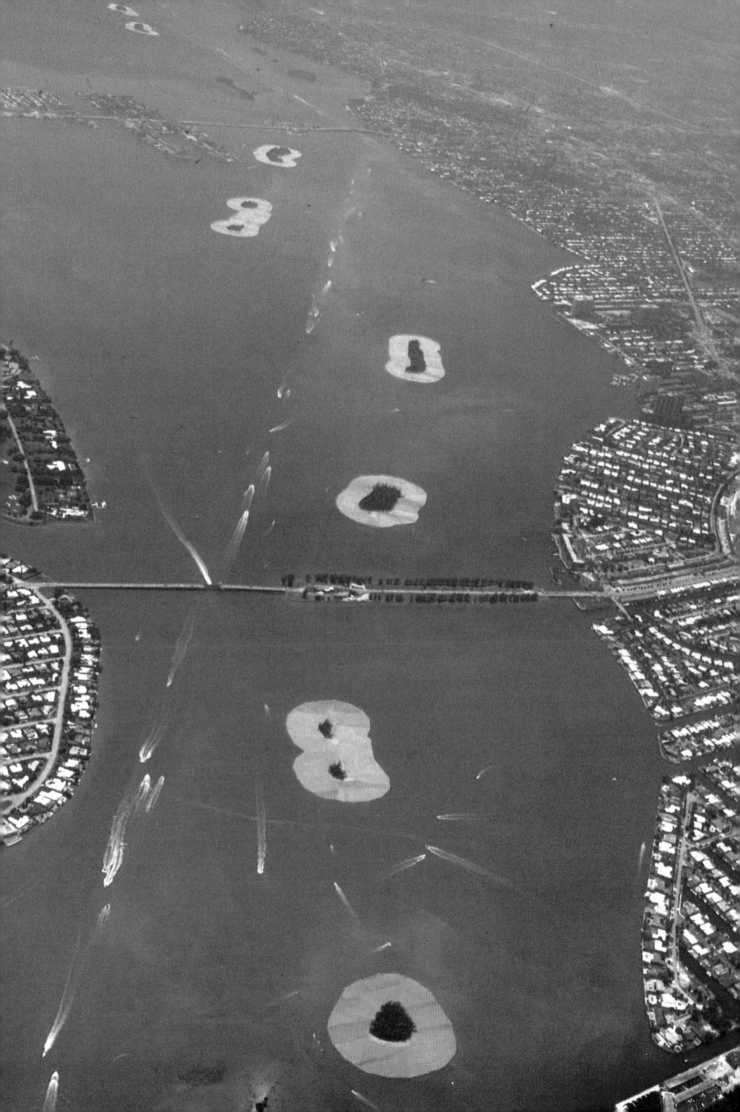

Wrapped Reichstag, Project for Berlin

The wrapping of the building of the German Reichstag will be a temporary work of art, to remain 14 days in September.

The choice of Berlin and specifically of the Reichstag, was born with the project itself: Berlin has the richest variety of texture of town anywhere in the world-physical encounter of two values of life and human existence: East and West.

The Reichstag is situated on the limit of that space and stands up in an open, strangely metaphysical area, related to its own changes from the late 19th century, burnt in 1933, almost destroyed in 1945 and restored in the sixties. The Reichstag was in continuous changes and perturbations, but always remained the symbol of Democracy.

A high-strength synthetic woven fabric that meets the prescribed standards of fire retardation and dacron rope will be used for the wrapping of the Reichstag. Each façade will be covered by five tailor-made fabric panels. Attachment points for the fabric and the ropes will be made using expanding columns that permit installation and removal without altering the building. All vulnerable statues and ornaments will be protected by specially fabricated cage-like structures.

The work will be completed in three phases. The first phase includes all off-site work such as cutting and sewing of the fabric panels and fabrication of the cages and attachment columns. In the second phase, the attachment columns and protective cages will be installed and the rolls of fabric will be moved and positioned on the roof-terrace.

With these low visibility preparations completed, the final phase can be undertaken in which the fabric is unfurled from above and secured in a matter of 4 to 5 days.

The shiny light-colored fabric will enlarge the size of the structure, it will be almost 30% more voluminous, the folds of the fabric will take the force and direction of the wind and will make the building strangely and constantly breathing. The day light will be reflecting and changing all through the day, altering the surrounding perspective of the old buildings and the new structures around the Tiergarden.

The Wrapped Reichstag project will be entirely financed by Christo: neither the City of Berlin nor the Federal Government of Germany shall bear any of the expenses of the project.

A written contract shall be drafted between the City of Berlin, the Bonn Authorities and our organization. The contract shall require us to provide:

1) Personal and Property Liability Insurance holding the City of Berlin and the Federal Government harmless.
2) Removal Bond providing funds for the complete and satisfactory removal of the wrapping materials.
3) Full co-operation with the community of Berlin, the various Departments of the City of Berlin, and the Federal Agencies in Bonn.
4) Paid employment of local residents.
5) Clearance and access for the usual activities in the Reichstag building.

The Wrapped Reichstag project represents not only a few years of efforts in an artist's life, but also years of team work. It involves politicians and businessmen, artists and people of all parts of social structures and people of West and East. The communal energy is an important part of the dialogue that has become vital for the Reichstag project.

The physical reality of the Wrapped Reichstag will be a dramatic and beautiful experience. The fabric is fragile material, like clothing or skin; it will have the special beauty of impermanence.

143

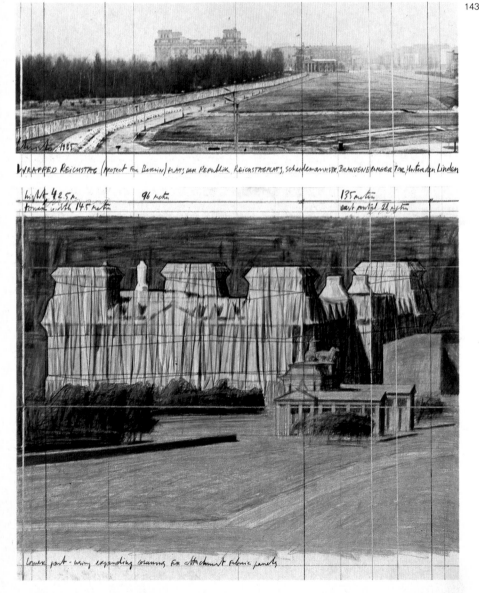

143. **Wrapped Reichstag. Project for Berlin.** 1985.
Collage in 2 parts: pencil, charcoal, fabric, twine, pencil colour, pastel and photograph by Wolfgang Volz,
12 × 30½ in. (30.5 × 77.5 cm) and 26¼ × 30½ in. (66.7 × 77.5 cm).
Galeria Joan Prats, Barcelona

144. **Wrapped Reichstag. Project for Berlin.** 1986.
Drawing in 2 parts: pencil, charcoal, crayon, pastel, map, technical data,
15 × 96 in. (38 × 244 cm) and 42 × 96 in. 106.6 × 244 cm).
Jeanne-Claude Christo Collection, New York.
Photo: Wolfgang Volz.

145. **Wrapped Reichstag. Project for Berlin.** 1981.
Detail of scale model: fabric, rope, paint and wood,
H.: 25½ × 60 × 76 in. (65 × 152.5 × 193 cm).
Base: 132 × 240 × 4 in. (335.3 × 609.6 × 10.2 cm).
Total area: 29½ × 196¾ × 169⅓ in. (75 × 500 × 430 cm).
Jeanne-Claude Christo Collection, New York.
Photo: Wolfgang Volz.

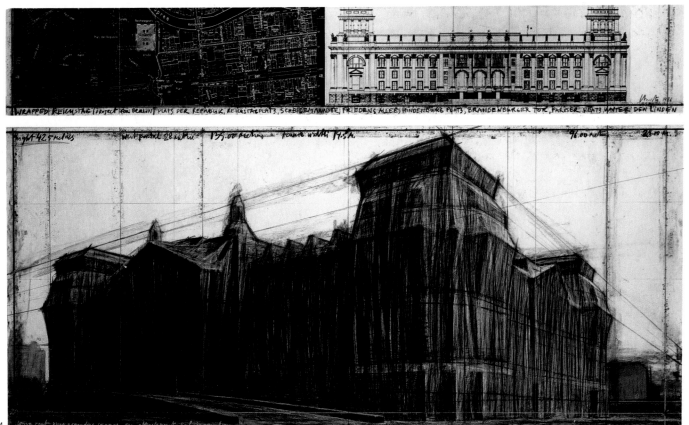

WRAPPED REICHSTAG (PROJECT FOR BERLIN) PLATZ DER REPUBLIK, REICHSTAGPLATZ, SCHEIDEMANNSTR., FRIEDENS ALLEE, HINDENBURG PLATZ, BRANDENBURGER TOR, PARISER PLATZ UNTER DEN LINDEN

144

145

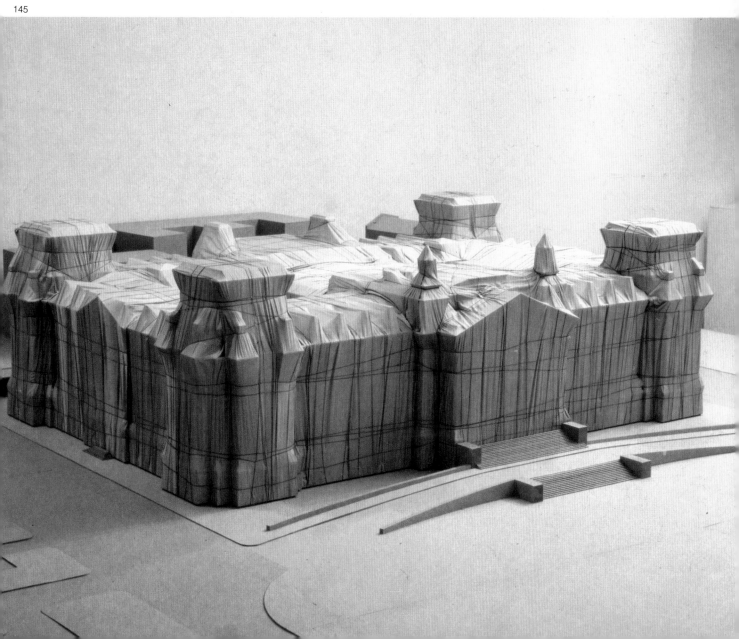

The Pont Neuf Wrapped, Paris, 1975-1985

On September 22, 1985 a group of 300 professional workers completed Christo's temporary work of art *The Pont Neuf Wrapped*.

They had deployed 440,000 square feet of woven polyamide fabric, silky in appearance and golden sandstone in color, covering:

—The sides and vaults of the twelve arches, without hindering river traffic.
—The parapets down to the ground.
—The sidewalks and curbs (pedestrians walk on the fabric).
—All the street lamps on both sides of the bridge.
—The vertical part of the embankment of the western tip of the Ile de la Cité.
—The esplanade of the ''Vert-Galant.''

The fabric is restrained by 42,900 feet of rope and secured by 12,1 tons of steel chains encircling the base of each tower, 3 feet underwater.

The ''Charpentiers de Paris'' headed by Gérard Moulin, with French sub-contractors, were assisted by the USA engineers who have worked on Christo's previous projects, under the direction of Theodore Dougherty: Vahé Aprahamian, James Fuller, John Thomson and Dimiter Zagoroff.

Johannes Schaub, the project's Director, had submitted the work method and detailed plans and received approval for the project from the authorities of the City of Paris, the Department of the Seine and the State.

In crews of 40, 600 monitors are working around the clock maintaining the project and giving information, until the removal of the project on October 7.

All expenses related to the *Pont Neuf Wrapped* are borne by the artist as in all his other projects through the sale of his preparatory drawings and collages as well as earlier works.

Begun under Henri III, the Pont-Neuf was completed in July 1606, during the reign of Henri IV. No other bridge in Paris offers such topographical and visual variety, today as in the past. From 1578 to 1890, the Pont-Neuf underwent continual changes and additions of the most extravagant sort, such as the construction of shops on the bridge under Soufflot, the building, demolition, rebuilding and once again demolition of the massive rococco structure which housed the Samaritaine's water pump. Wrapping the Pont-Neuf continues this tradition of successive metamorphoses by a new sculptural dimension and transforms it, for fourteen days, into a work of art itself. Ropes hold down the fabric to the bridge's surface and maintain the principal shapes, accentuating relief while emphazing proportions and details of the Pont-Neuf which joins the left and right banks and the Ile de la Cité, the heart of Paris for over two thousand years.

146. **The Pont Neuf Wrapped. Project for Paris. 1985.**
Drawing in 2 parts: pencil, charcoal, crayon, pastel, aerial photograph and technical data,
15×96 in. (38×244 cm) and 42×96 in. (106.6×244 cm).
Galeria Joan Prats, Barcelona.
Photo: Wolfgang Volz.

146

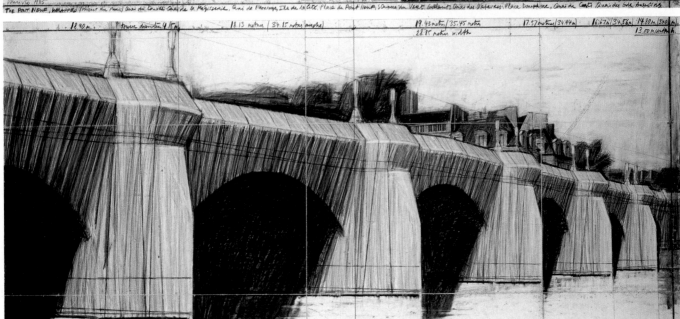

147. **The Pont Neuf Wrapped. Project for Paris.**
1985.
Drawing in 2 parts: pencil, charcoal, map,
bic pen, crayon and pastel,
15 × 65 in. (38 × 165 cm) and 42 × 65 in.
(106.6 × 165 cm).
Flach International Art, Stockholm.
Photo: Wolfgang Volz.

148. **The Pont Neuf Wrapped. Project for Paris.**
1985.
Collage in 2 parts: pencil, charcoal, fabric,
twine, pencil colour, pastel, fabric sample
and technical data,
11 × 28 in. (28 × 71 cm) and 22 × 28 in.
(56 × 71 cm).
Galeria Joan Prats, Barcelona.
Photo: Wolfgang Volz.

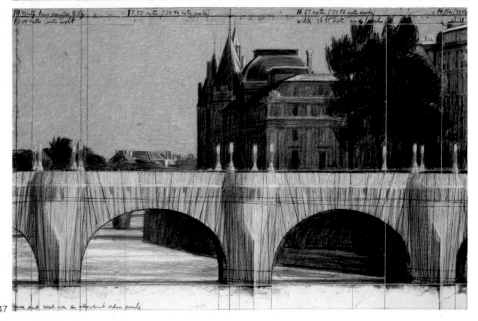

147

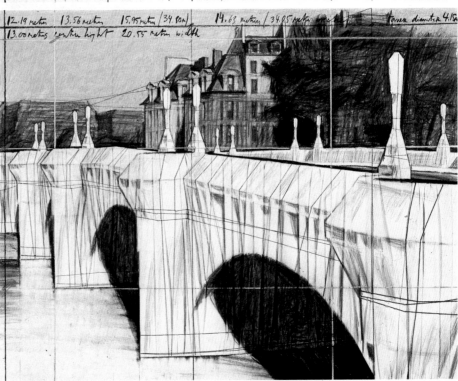

148

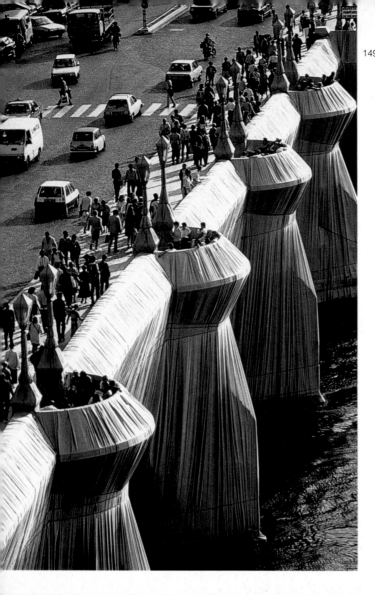

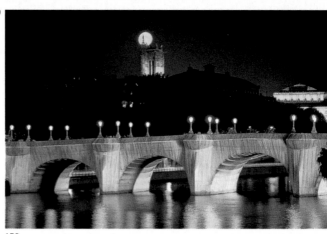

150

149 to 152. **The Pont Neuf Wrapped, Paris.** 1975-1985.
440,000 sq. ft. (40,000 m^2) of woven polyamide fabric
and 42,900 ft. (13,000 m) of rope.
Project Director: Johannes Schaub.
Photos: Wolfgang Volz.

151

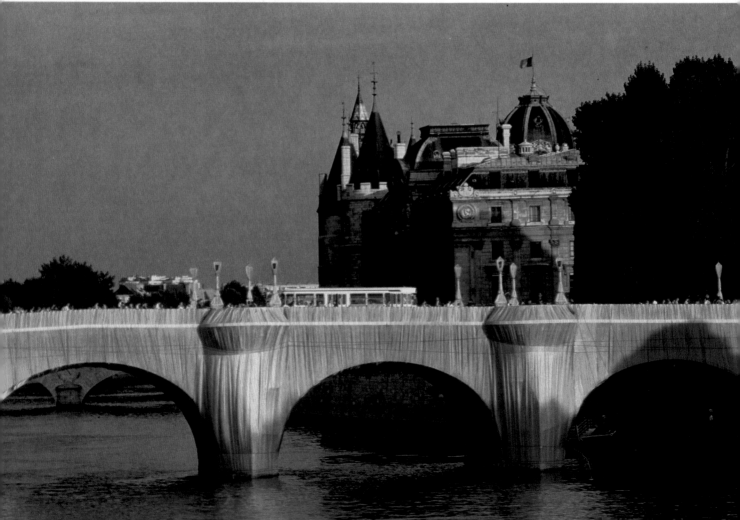

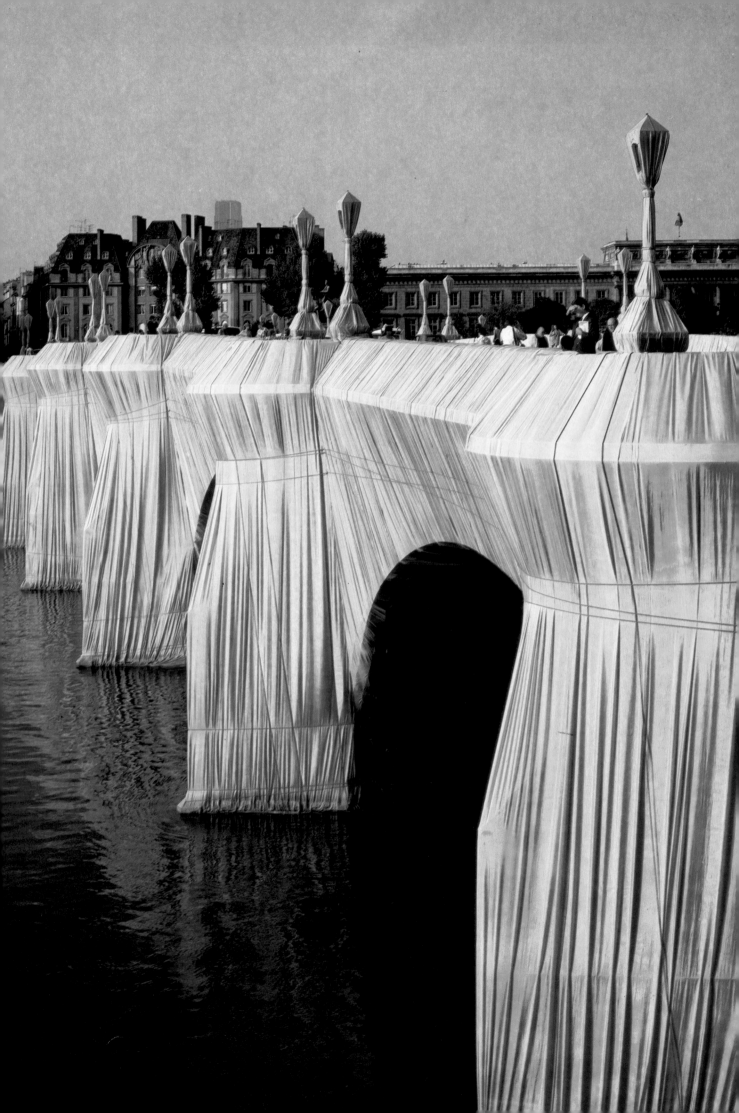

The Umbrellas, Joint Project for Japan and USA.

Thousands of umbrellas, 19 feet 8 inches (6 meters) high and 28 feet 6 inches (8.69 m.) in diameter, will meander in the landscape simultaneously for about 12 miles (18 kilometers) in Japan and 16 miles (25 kilometers) in the United States.

The fabric umbrellas will be blue in Ibaraki and yellow in California. They will be placed sometimes in clusters and covering an entire field, or deployed in a line, or randomly spaced from each other. They will occasionally tilt slightly according to the slope on which they stand. The octagonal umbrellas will run alongside roads, villages and river banks, crossing rural and suburban areas, fields and intersections in two inland valleys, one located 72 miles (120 kilometers) north of Tokyo, in the counties of Hitachi-Ota, Hitachi-Chi, and Satomi in the province of Ibaraki, around route 349, and the other one 60 miles (96 kilometers)· north of Los Angeles, in Kern and Los Angeles Counties, around Interstate 5 in Southern California. This Japan-USA joint art project will reflect the similarities and differences in the ways of life and the seasonal colors and light of the landscape in the two valleys.

Various prototypes are being built in order to advance the engineering feasibility studies. Completion date for this temporary work of art is projected for Mid-October 1991. Negotiations with the local authorities and land owners will start in July 1987.

As I have done for all my other temporary works of art, The Umbrellas shall be entirely financed by me, through The Umbrellas, Joint Project for Japan and USA Corporation (Jeanne-Claude Christo-Javacheff, President), from the sale of my preparatory drawings, studies, collages, scale models and early works.

For a period of three weeks The Umbrellas may be seen, approached and enjoyed by the public, either by car from a distance and closer as they border the roads, or on foot in a promenade route under The Umbrellas in their luminous shadows.

CHRISTO
New York, July 1987

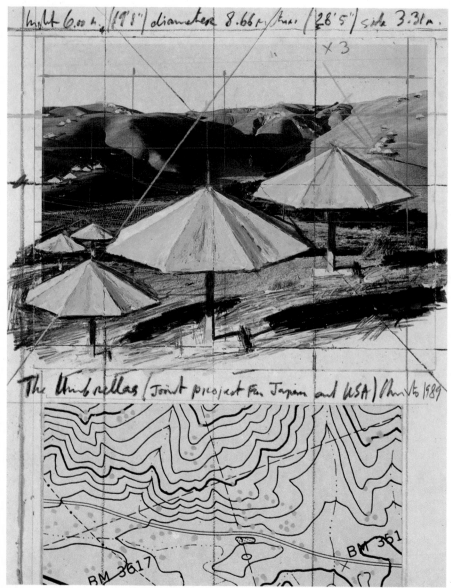

153. **The Umbrellas. Joint Project for Japan and USA** 1989.
Painted photograph: pencil, crayon, photograph by Wolfgang Volz, enamel paint, charcoal and map,
14 × 11 in. (35.5 × 28 cm).
Mr. and Mrs. Masahiko Yanagi Collection, New York.

154. **The Umbrellas. Joint Project for Japan and USA** 1987.
Painted photograph: pencil, charcoal, crayon, photograph by Wolfgang Volz and enamel paint,
26¼ × 14 in. (66.7 × 35.5 cm).
Jeanne-Claude Christo Collection, New York.

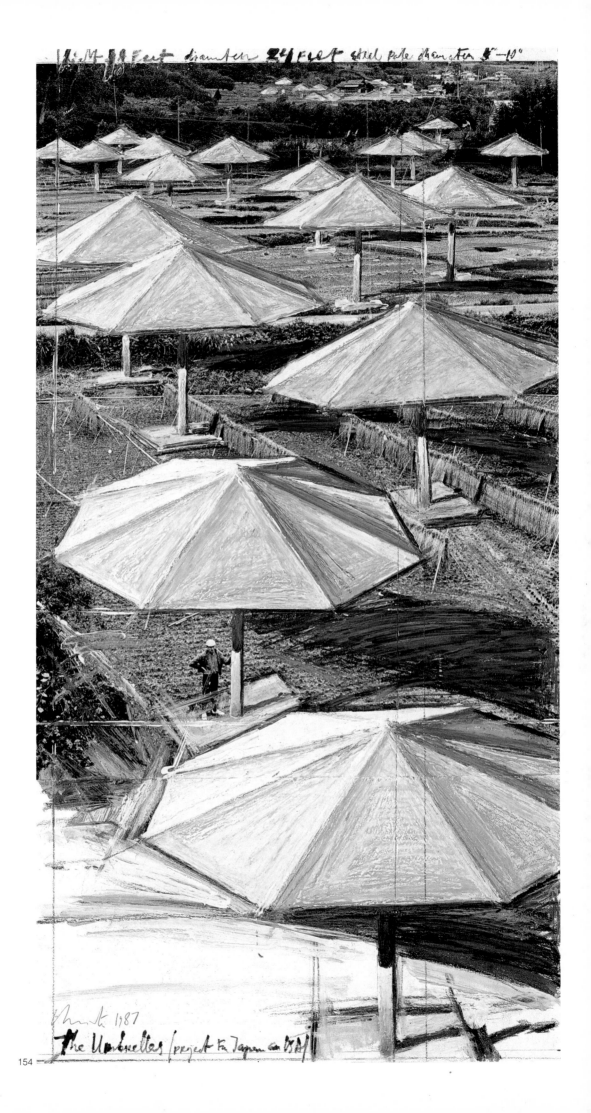

154

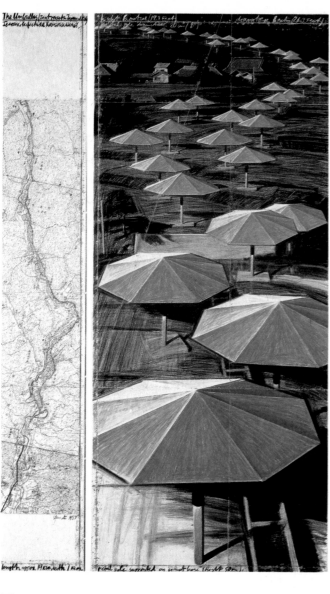

155

155. **The Umbrellas. Joint Project for Japan and USA** 1987.
Drawing in 2 parts: pencil, charcoal, pastel, crayon and map,
96 × 15 in. (244 × 38 cm) and 96 × 42 in. (244 × 106.6 cm).
Satani Gallery, Tokyo
Photo: Wolfgang Volz.

156. **The Umbrellas. Joint Project for Japan and USA** 1987.
Collage in 2 parts: pencil, charcoal, fabric, pastel, crayon,
map and enamel paint,
26¼ × 30½ in. (66.7 × 77.5 cm) and 26¼ × 12 in. (66.7 × 30.5 cm),
Madeleine and Dominik Keller Collection, Zurich.
Photo: Wolfgang Volz.

157. **The Umbrellas. Joint Project for Japan and USA** 1987.
Drawing in 2 parts: pencil, charcoal, crayon, pastel,
map and enamel paint,
15 × 96 in. (38 × 244 cm) and 42 × 96 in. (106.6 × 244 cm).
Satani Gallery, Tokyo.
Photo: Wolfgang Volz.

158. **The Umbrellas. Joint Project for Japan and USA** 1987.
Collage in 2 parts: pencil, charcoal, crayon, fabric,
pastel, enamel paint and map,
30½ × 26¼ in. (77.5 × 66.7 cm) and 30½ × 12 in. (77.5 × 30.5 cm).
Satani Gallery, Yokyo.
Photo: Wolfgang Volz.

156

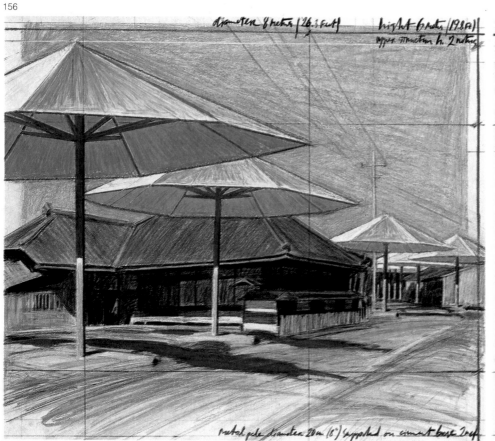

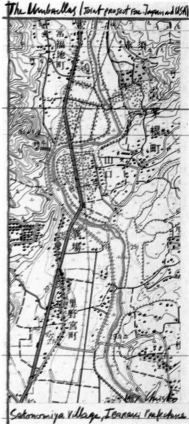

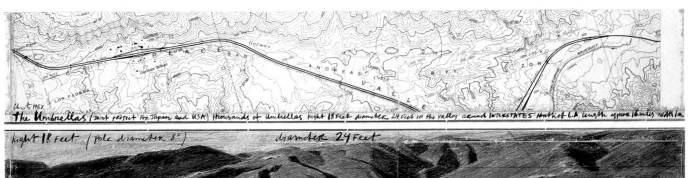

The Umbrellas (Joint Project For Japan and USA) thousands of Umbrellas hight 18 Feet diameter 24 Feet in the valley around INTERSTATES North of L.A. length approx 16 miles width 1 m.

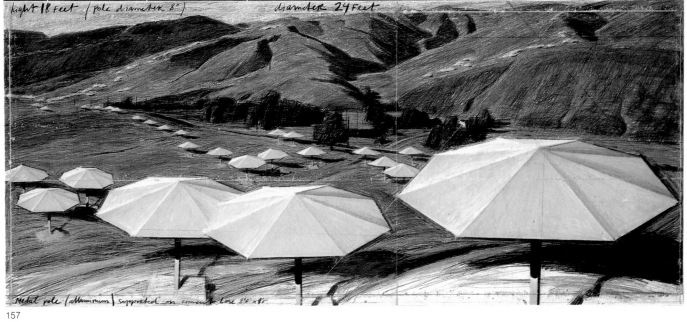

hight 18 Feet (pole diameter 8") diameter 24 Feet

Metal pole (aluminium) supported on cement base 8'0 x 8'0

157

158

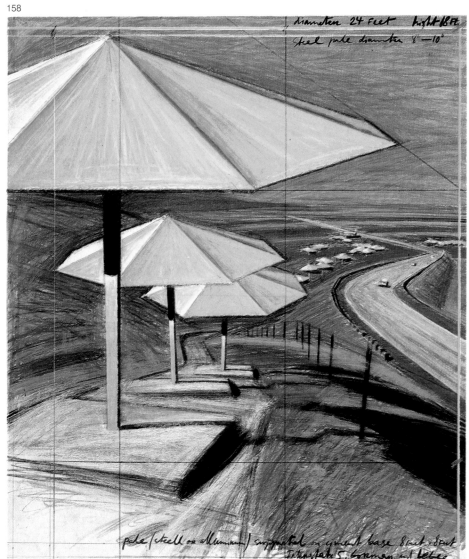

diameter 24 Feet hight 18 Ft.
steel pole diameter 8" —10"

pole (steel or aluminium) supported in cement base 8'x4' 8'x4'
Interstate 5, Gorman and Lebec

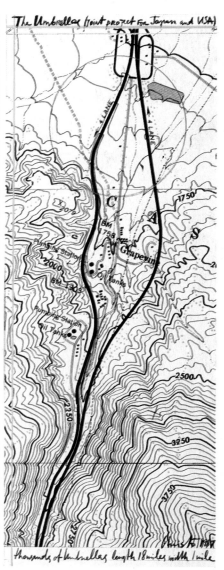

The Umbrellas (Joint project For Japan and USA)

thousands of Umbrellas length 18 miles width 1 mile

159. **The Umbrellas. Joint Project for Japan and USA** 1989.
Drawing in 2 parts: pencil, charcoal, pastel, crayon,
enamel paint and map,
15 × 65 in. (38 × 165 cm) and 42 × 65 in. (106.6 × 165 cm).
Guy Pieters Gallery, Gent.
Photo: Wolfganf Volz.

160. **The Umbrellas. Joint Project for Japan and USA** 1989.
Drawing in 2 parts: pencil, charcoal, pastel, crayon,
photograph by Wolfgang Volz, enamel paint and map,
90 × 42 in. (229 × 106.6 cm) and 90 × 15 in. (229 × 38 cm).
Mr. and Mrs. Richard Greer Collection, Tokyo.
Photo: Wolfgang Volz.

159

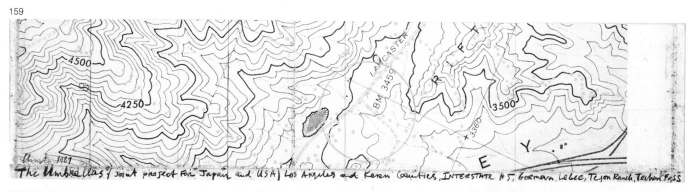

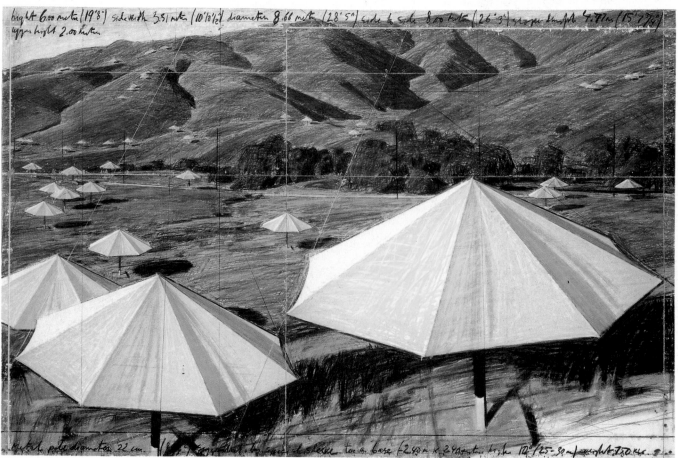

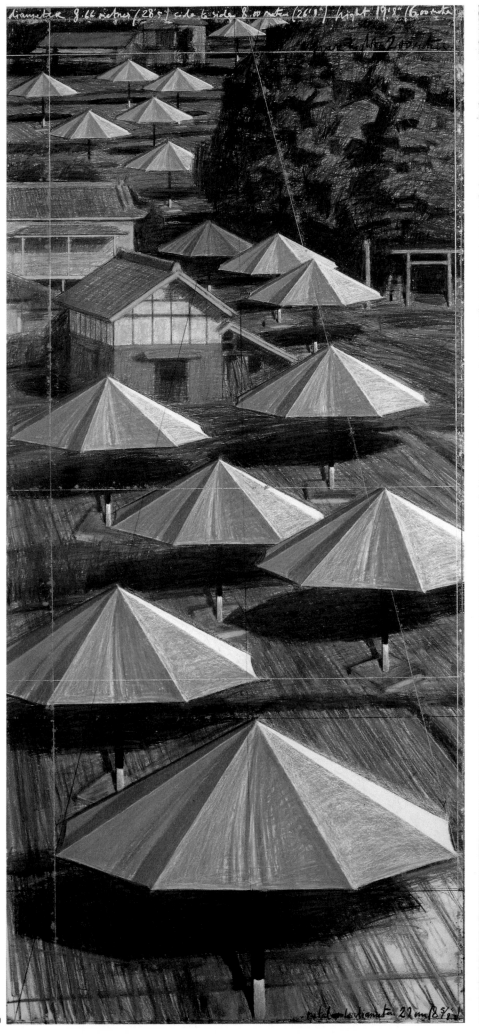

diameter 9.66 meters (28'5") side to side 8.00 meters (26'3") height 19'8" (6.00 meter

netal pole diameter 22 cm (8 5/8")

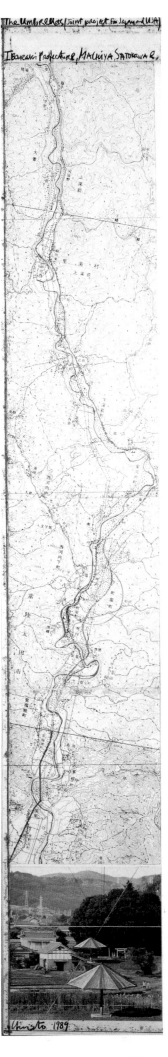

The Umbrellas (Joint project for Japan and USA)

Ibaraki Prefecture, MACHIYA SATOKAWA

Christo 1989

160

LIST OF ILLUSTRATIONS

73. Valley Curtain. Project for Rifle, Colorado. 1972.
Collage: pencil, fabric, crayon, pastel, technical data and bic pen.

74. Valley Curtain. Project for Rifle, Colorado. 1972.
Drawing in 2 parts: crayon, pencil, bic pen, graph paper, charcoal, map and technical data.

75. Valley Curtain. Project for Rifle, Colorado. 1972.
Collage: fabric, pastel, pencil, crayon, photostat from a photograph by Harry Shunk, fabric sample and technical data.

76 to 81. Valley Curtain. Grand Hogback, Rifle, Colorado. 1970-1972.

82. Houston Mastaba. Project for Houston-Galveston Area, Texas. 1969-1970.
Drawing: pencil, charcoal, crayon and pastel.

83. Otterlo Mastaba. Project for the Kröller Müller Museum, Otterlo. 1973.
Drawing: pencil, charcoal, crayon and enamel paint.

84. Otterlo Mastaba. Project for the Kröller Müller Museum, Otterlo. 1975.
Drawing: pastel, charcoal, pencil, enamel paint and crayon on cardboard.

85. 1,566 Oil Drums. Project for I.C.A., Philadelphia. 1968.
Drawing: pencil, charcoal, enamel paint, crayon on cardboard.

86. 56 Stacked Oil Barrels. Project for the Kröller Müller Museum, Otterlo, in Memory of Mia Visser. 1977.
Drawing: enamel paint, photostat, pencil and charcoal.

87. 56 Stacked Oil Barrels. Project for the Kröller Müller Museum, Otterlo, in Memory of Mia Visser. 1977.
Drawing: enamel paint, pencil, crayons and charcoal on wood.

88. 56 Oil Barrels. 1966-1967.

89. Ocean Front, Bay Cover. Project for King's Beach, Newport, Rhode Island. 1974.
Collage: fabric, pencil, charcoal, crayon and cardboard.

90. Ocean Front. Newport, Rhode Island. 1974.

91. Wrapped Floors. Project for Haus Lange Museum, Krefeld. 1971.
Collage: pencil, charcoal, crayon, pastel, brown paper and fabric.

92. Wrapped Floors. Haus Lange Museum, Krefeld. 1971.

93. The Wall. Project for a Wrapped Roman Wall, Porta Pinciana, Rome. 1974.
Collage: pencil, fabric, twine, pastel and bic pen.

94. The Wall. Project for a Wrapped Roman Wall, Porta Pinciana, Rome. 1974.
Drawing: charcoal, pencil, color pencil and bic pen.

95. The Wall. Project for a Wrapped Roman Wall, Porta Pinciana, Rome. 1974.
Pencil, charcoal and colour crayon.

96 to 98. The Wall. Wrapped Roman Wall, Porta Pinciana, Rome. 1974.
Woven synthetic fabric and rope.

99. Running Fence. Project for Sonoma and Marin Counties, California. 1975.
Painted photograph: pencil, charcoal, crayon, photograph by Gianfranco Gorgoni, tape and enamel paint.

100. Running Fence. Project for Sonoma and Marin Counties, California. 1975.
Collage: pencil, fabric, pastel, photograph by Wolfgang Volz, charcoal and crayon.

101. Running Fence. Project for Sonoma and Marin Counties, California. 1975.
Drawing in 2 parts: pencil, charcoal, crayon, pastel, map and technical data.

102. Running Fence. Project for Sonoma and Marin Counties, California. 1975.
Drawing in 2 parts: pastel, charcoal, technical data, bic pen and map.

103. Running Fence. Project for Sonoma and Marin Counties, California. 1975.
Drawing in 2 parts: pencil, charcoal, white paint, technical data and map.

104 to 110. Running Fence. Sonoma and Marin Counties, California. 1975.

111. Store Front. Project for Galeria Joan Prats, Barcelona. 1976.
Collage: pencil, charcoal, fabric brown paper, photo stat, blue print floor map.

112. Wrapped Floor. Project for Galeria Joan Prats, Barcelona. 1976.
Collage: pencil and fabric.

113 and 114. Wrapped. Galeria Joan Prats, Barcelona. 1977.

115. Wrapped Monument to Cristóbal Colón. Project for Barcelona. 1984.
Drawing in 2 parts: pencil, charcoal, pastel, crayon and technical data.

116. Wrapped Monument to Cristóbal Colón. Project for Barcelona. 1976.
Painted color photograph: enamel paint, crayon, charcoal, pencil on color photo by Wolfgang Volz.

117. Wrapped Monument to Cristóbal Colón. Project for Barcelona. 1976.
Drawing: charcoal and pastel.

118. Wrapped Puerta de Alcalá. Project for Madrid. 1980.
Collage: fabric, twine, photostat from a photograph by Wolfgang Volz, pastel, charcoal, pencil, photograph and map.

119. The Mastaba of Abu Dhabi. Project for the United Arab Emirates. 1977.
Drawing: pencil, charcoal, crayon and pastel.

120. The Mastaba of Abu Dhabi. Project for the United Arab Emirates. 1979.
Collage: pencil, charcoal, photostat from a photograph by Wolfgang Volz, crayon, pastel and technical data.

121. The Mastaba of Abu Dhabi. Project for the United Arab Emirates. 1979.
Drawing in 2 parts: pastel, charcoal, pencil, crayon, map and technical data.

122. The Mastaba of Abu Dhabi. Project for the United Arab Emirates. 1979.
390,000 Stacked Oil Barrels.
Collage drawing: photograph by Wolfgang Volz, pastel, crayon, technical data and map.

123. The Mastaba of Abu Dhabi. Project for the United Arab Emirates. 1979.
Collaged photograph: superimposition of three-dimensional scale model on a color photograph by Wolfgang Volz.

124. Wrapped Walk Ways. Project for Jacob L. Loose Memorial Park, Kansas City, Missouri. 1978.
Drawing in 2 parts: pencil, chalk, pastel, charcoal and map.

125. Wrapped Walk Ways. Project for Jacob L. Loose Memorial Park, Kansas City, Missouri. 1978.
Drawing in 2 parts: pencil, charcoal, pastel, crayon and map.

126 to 129. Wrapped Walk Ways. Jacob L. Loose Memorial Park, Kansas City, Missouri. 1977-1978.

130. The Gates. Project for Central Park, New York City. 1980.
Collage: pencil, fabric, pastel, charcoal, photostat from a photo by Wolfgang Volz and fabric sample.

131. The Gates. Project for Central Park, New York City. 1980.
Drawing in 2 parts: pencil, charcoal, crayon, pastel, map and photographs by Wolfgang Volz.

132. Surrounded Islands. Project for Biscayne Bay, Greater Miami, Florida. 1983.
Drawing in 2 parts: pencil, charcoal, pastel, crayon enamel paint, fabric sample and aerial photographs.

133. Surrounded Islands. Project for Biscayne Bay, Greater Miami, Florida. 1983.
Drawing in 2 parts: pastel, charcoal, pencil, fabric sample, enamel paint and photostat.

134. Surrounded Islands. Project for Biscayne Bay, Greater Miami, Florida. 1982.
Drawing in 2 parts: pencil, charcoal, pastel, crayon, enamel paint and photostat.

135. Surrounded Islands. Project for Biscayne Bay, Greater Miami, Florida. 1982.
Drawing in 2 parts: pencil, charcoal, pastel, crayon, aerial photograph, fabric sample, enamel paint and technical data.

136. Surrounded Islands. Project for Biscayne Bay, Greater Miami, Florida. 1983.
Painted photograph: enamel paint, bic pen, photograph by Wolfgang Volz, crayon and tape.

137. Surrounded Islands. Project for Biscayne Bay, Greater Miami, Florida. 1983.
Collage in 2 parts: fabric, pastel, charcoal, pencil, enamel paint, crayon, photograph by Wolfgang Volz, fabric sample and map.

138 to 142. Surrounded Islands. Biscayne Bay, Greater Miami, Florida. 1980-1983.

143. Wrapped Reichstag. Project for Berlin. 1985.
Collage in 2 parts: pencil, charcoal, fabric, twine, pencil colour, pastel and photograph by Wolfgang Volz.

144. Wrapped Reichstag. Project for Berlin. 1986.
Drawing in 2 parts: pencil, charcoal, crayon, pastel, map, technical data.

145. Wrapped Reichstag. Project for Berlin. 1981.
Detail of scale model: fabric, rope, paint and wood.

146. **The Pont Neuf Wrapped. Project for Paris.**
1985.
Drawing in 2 parts: pencil, charcoal,
crayon, pastel, aerial photograph and
technical data.

147. **The Pont Neuf Wrapped. Project for Paris.**
1985.
Drawing in 2 parts: pencil, charcoal, map,
bic pen, crayon and pastel.

148. **The Pont Neuf Wrapped. Project for Paris.**
1985.
Collage in 2 parts: pencil, charcoal, fabric,
twine, pencil colour, pastel, fabric sample
and technical data.

149 to 152. **The Pont Neuf Wrapped, Paris.**
1975-1985.

153. **The Umbrellas. Joint Project for Japan
and USA** 1989.
Painted photograph: pencil, crayon,
photograph by Wolfgang Volz, enamel
paint, charcoal and map.

154. **The Umbrellas. Joint Project for Japan
and USA** 1987.
Painted photograph: pencil, charcoal,
crayon, photograph by Wolfgang Volz and
enamel paint.

155. **The Umbrellas. Joint Project for Japan
and USA** 1987.
Drawing in 2 parts: pencil, charcoal, pastel,
crayon and map.

156. **The Umbrellas. Joint Project for Japan
and USA** 1987.
Collage in 2 parts: pencil, charcoal, fabric,
pastel, crayon, map and enamel paint.

157. **The Umbrellas. Joint Project for Japan
and USA** 1987.
Drawing in 2 parts: pencil, charcoal,
crayon, pastel, map and enamel paint.

158. **The Umbrellas. Joint Project for Japan
and USA** 1987.
Collage in 2 parts: pencil, charcoal, crayon,
fabric,
pastel, enamel paint and map.

159. **The Umbrellas. Joint Project for Japan
and USA** 1989.
Drawing in 2 parts: pencil, charcoal, pastel,
crayon, enamel paint and map.

160. **The Umbrellas. Joint Project for Japan
and USA** 1989.
Drawing in 2 parts: pencil, charcoal, pastel,
crayon, photograph by Wolfgang Volz,
enamel paint and map.